CBC
CURTIS BROWN CREATIVE

THE WRITING SCHOOL FROM THE
MAJOR LITERARY & TALENT AGENCY

Unleash your imagination & raise your writing game

WRITING SHORT STORIES
with Cynan Jones
6 weeks

WRITING LITERARY FICTION
with Tessa Hadley
5 weeks

WRITING POETRY
with Anthony Anaxagorou
6 weeks

Join an online course and hone your storytelling skills with advice from award-winning authors

Watch exclusive teaching videos and further your learning with practical writing tasks.
Find your writing community in our online student forum.
Study at times to suit you, wherever you are in the world.

Enrol today & take the next step on your writing journey
www.curtisbrowncreative.co.uk

GRANTA

12 Addison Avenue, London W11 4QR | email: editorial@granta.com
To subscribe visit subscribe.granta.com, or call +44 (0)1371 851873

ISSUE 166: WINTER 2024

p.253 'The Life, Old Age and Death of a Woman of the People' by Didier Eribon – working title for the forthcoming English translation – is an excerpt from *Vie, vieillesse et mort d'une femme du peuple*, Paris, Flammarion, 2023, which will be published in English by Allen Lane in the UK and Semiotext(e) in the US in March 2025; p.227 'Ricks & Hern' by Nico Walker is an excerpt from the forthcoming book *The Dark Empath*

MIX
Paper | Supporting responsible forestry
FSC® C023419

"I don't think my literary career would have survived without this financial aid. Not only did the RLF help patch things up, but the grants also bought me time to write."
MONIQUE ROFFEY

RLF

SUPPORTING
WRITERS
SINCE 1790

The Royal Literary Fund offers financial support, advice and earning opportunities across the UK, enabling writers to keep writing and to share their skills with others.

If you think we could help you, contact our Grants team today
+44(0)20 7353 7150
www.rlf.org.uk

CONTENTS

Oh, the time – that was the great thing!

– Henry James, *The Princess Casamassima*

Generations: is any sociological concept at once so derided and so indispensable? We move through the years alongside our age cohort. We are exposed to the same cataclysms, the same economic booms or busts, the same technological and medical developments, however unequal the access and experience. 'No generation has learned from another how to love, no generation can begin other than at the beginning,' Kierkegaard writes in *Fear and Trembling*. For the Dane, this did not mean that generations are mutually unintelligible: only by trying to understand the commitments and follies of the generations above and below can you discover those of your own. Generations: you shall know them by their passions.

Time is meaningful – think of it that way. Generations define us, perhaps not as strongly as other identities – class, religion, gender, profession, politics, nation – but in ways that may be among the most fixed. 'He tore me away from my generation, but I was not part of his,' Annie Ernaux writes in *Le jeune homme*, in which the narrator has an affair with a man three decades her junior. They share working-class origins, the signs of which are remarkably durable across time. 'His gestures and reflexes were dictated by a continual, inherited lack of money,' she writes. She notices his 'hickish' mannerisms – wiping his mouth with a piece of bread, covering his wineglass to signal no more – tics 'I knew I'd once had in me too.' But their separate passages through time make for differences in the quality of their emotion. Much of the woman's feeling is vicarious, much of the man's is inaugural, and there's no way around it.

The concept of a generation is not very old. For millennia, mass collective experiences marked people who shared the same upheavals at the same age, but they rarely had a distinctive binding effect. Exceptions to the rule applied to upper crusts of populations, such as the so-called 'final pagan generation', a wealthy stratum

of Roman society in the fourth century, who watched their zealot-children become Desert Fathers and Brides of Christ in the wake of Emperor Constantine's conversion. For the vast majority, in peasant cultures the world over, parents transmitted skills and values to their children who passed them on to their children in turn, with little to differentiate them. As late as the 1940s, Ernaux could find herself the first woman in generations of her family who no longer knew how to wash clothes with ash, or use the heat of a fire to dry plums.

Generations, as we now understand them, made a leap toward definition in the years after the French Revolution. To share biological age was only the first requirement, and not the most important. To forge a generation, the same age cohort had to share an experience more historically specific than a plague or a famine – something both fusing and modernizing. The armies of peasants that Napoleon marched across Europe accumulated experience and skills (such as how to read conscription orders) beyond the imagination of their fathers. Those who made it back to France were never the same.

Among French elites, the differences between the revolutionary and post-revolutionary generations were stark. The chasm was measured by the Yugoslav novelist Ivo Andrić in his novel *The Bosnian Chronicle* (1945) about two French consular officers stationed in a remote province of the Ottoman Empire in the 1810s. The older consul Daville finds his young assistant Des Fossés incapable of appreciating his values – 'the "fundamental things" which were the substance of Daville's life.' For Des Fossés, the monarchy is a fairy tale, the revolution is a dim childhood memory, and Napoleon's empire is the natural order of things. While for Daville, 'these three concepts represented an intense and complex knot of conflict, inspiration, exultation, brilliant achievements, but also hesitations, inner disloyalties and unseen crises of conscience, with no obvious solution, with increasingly little hope of being lastingly assuaged.' The picture emerges of mutual generational bewilderment.

Cycles of misapprehensions can make debates about art and politics from earlier periods appear disconcertingly familiar. When we see authors from Gen X write wistfully about the irony of the

1990s, it recalls Thomas Mann writing wistfully about the irony of the 1890s in his *Reflections of a Nonpolitical Man* (1918), in which he decries the return to sincerity, politics, and passion for humanitarian democracy. These trends were exemplified for Mann in the cult around Émile Zola, which grew throughout the 1910s, synonymous for Mann with a drearily censorious culture that has no place for art that wasn't already politicized. In his revulsion with those advocating humanitarian democracy, Mann supported German bourgeois nationalism – along with an aesthetic disengagement from politics. The younger generation of Germans below him would interpret his attitude as leading to Nazism.

We are all pop sociologists now, at least in the Anglosphere. The Silent Generation, Boomers, Gen X, Millennials, Zoomers: each has reached the point of caricature. The Silents, the generation born in the decade and a half before 1945, so christened by *Time* magazine for their 'still, small' flame (read: low expectations and steady discipline), have been an extraordinary force in the literary world. It is not simply the sheer productivity of novelists and writers born before the end of the Second World War that astounds – Alice Munro, John Edgar Wideman, Margaret Atwood, Cynthia Ozick, J.M. Coetzee, Fleur Jaeggy, Philip Roth, Toni Morrison, A.S. Byatt, Don DeLillo, Cormac McCarthy, J.G. Ballard, John Updike, Joyce Carol Oates, Joan Didion – but the naturalness and ease of their story-telling. It can lead you to wonder whether there was something in the water of the 1930s.

Materially, the Silents were on much closer terms with agricultural realities, as well as manufacturing ones. Silents often know how things are made. As children, they were left to wander through the wastes and scrapheaps of the post-war moment. To this day, they inspect food and mechanical objects differently. Many of the most celebrated Boomer pop figures are in fact Silents – Bob Dylan, the Beatles, Patti Smith, Leonard Cohen, Joan Baez – as if the consumption craze of the later generation had to be supplied by a cohort of indefatigable harvesters. Tonally, the Silents are distinguished by their assurance

and will toward objectivity, as well as their talent for hammering at fundamentals. It is difficult to imagine an author of a different generation writing about photography like Susan Sontag, who takes to the task like Aristotle, first taking care to tell how it differs from painting, etc. The Silents at their best are simultaneously vernacular and oracular, with a weakness for loftiness. You can feel the decisiveness of the typewriter in their prose, the balm of the cigarette.

The Boomers seem notable as a generation whose literary taste fed directly into their political passions. In their youths, they experienced the Cold War at its most glacial. They read the diaries of Anne Frank under the covers as children, Solzhenitsyn in their dormitories, Kundera on East European trains, and Ian McEwan on shabby chic sofas. Their object of worship was the dissident, literary or political; ideally both. The younger Boomers (and older Gen-Xers) experienced the fall of the Soviet Union as a moment of exultation and a promise of world liberation that has never quite receded. More than 1968, they were defined by this moment, evidence that the globe was actually malleable. For a generation that saw something as permanent-seeming as the USSR go up in smoke, petty dictators like Saddam Hussein and Gaddafi looked like disposable pawns. The Boomer vision of freedom stressed experimentation, tolerance, and hedonism, with the state figuring more often as foe than enabler. They experienced the mid-century economic boom not as deliverance, like the Silents, but as the natural order of things. The early *Granta* was a Boomer magazine par excellence. It nurtured many of the generation's leading Anglophone writers – Hilary Mantel, Pat Barker, Martin Amis, William Boyd. These authors came to move most comfortably on the stable flanks of historical fiction. Kazuo Ishiguro's tales of comically minor figures misreading their historical moment from odd angles now appear like sly intra-generational ribbing.

The trajectory of some Boomers from would-be establishment wreckers into effusive caressers of farmer's market vegetables was bound to feed the cynicism of the generation below them. The first thing Gen X learned in school was not to talk to strangers. Christian Lorentzen has described his levy – with his Gen X smirk and tossing

of the hands – as the generation that will never have to suffer one of its own members as the American President. Zadie Smith has done some quick moral accounting for her cohort: right about trying to get men to do childcare; wrong about the internet. If the Boomers flattered themselves as the chief protagonists of post-war culture and history, Gen X marveled at the hypocrisies of the generation above them – the way the Boomers had cast off their most signature accomplishments, from anti-war coalitions to independent cinema. Gen X was the last generation for whom Selling Out meant something (an attitude which Millennials like to suggest is luxury masquerading as principle). Gen X's signature lit mags were the anti-establishment *Baffler*, *McSweeney's*, which was a way of selling out by other means (inviting *New Yorker* writers into your upstart magazine, sometimes under pseudonyms), and the early *n+1*, when it prioritized author's voices over mappings of social movements. It was a generation for whom 'Victory for the forces of democratic freedom' was less a credo solemnly scrawled on placards than something David Foster Wallace's 'hideous men' compulsively spurted out during orgasms.

Galvanized in their youth by a financial crisis, the Millennials entered a world of short horizons, with political ambitions that had not been seen since the 1960s, but far fewer organizational vehicles at their disposal. Having come of age on social media, many mark themselves through the articulation of their opinions and identities. They are criticized for unwittingly serving the interests of their societies' elites through their appeals to institutional authority, but their plight, as a generation twice removed from the spoils of the *Trente glorieuses* (until a small fraction of them inherit from their parents), may simply be an instance of a cohort making do with the weapons of the weak. Their mobilization of morality hits their Boomer bosses in a particularly sensitive spot; it threatens to withdraw the very affirmation that Boomers most crave: that they are on the correct side of history. As Anton Jäger writes in this issue: Millennials move in 'a public sphere in which politics has clearly reclaimed its urgency, and collective notions of class have acquired a newfound plausibility. But the resultant posture is still fundamentally one of self-expression:

a [Sally Rooney] character may serenade her cleaner's proletarian credentials, another may declare she is a Marxist, but it's not clear what Marxist organization she's a member of.'

The Zoomers are from another country. Raised by Gen X, they may have inherited some of their parents' skepticism of Millennials. They are unique in finding the online and virtual worlds natural, while more willing to acknowledge the market, the geopolitical world order and actual nature as, at least in theory, open to revision. They can at times appear preternaturally practiced at making abstract critiques of existing systems, but these presentations are often followed closely by articulations of despair and depression in the face of these forces. If anything more can be hazarded about a generation whose youngest members are all but 11, it may be the gulf they feel between themselves and power. Their defining experiences may well have yet to arrive.

What about the world outside of the West? In this issue of *Granta*, the historian Yuri Slezkine uncoils the drama of several generations of Russian Soviets, from the 'Impatient Ones', who became Bolshevik Millenarians, brimming with political enthusiasm, to the all-too patient generation that grew up in the Brezhnev stagnation. In his memoir, 'Niamey Nights', Rahmane Idrissa paints portraits of several generations of the Sahel, where entire historical epochs seem to become compressed into his own youth. Few generational divides have been as deep and lasting as those of the People's Republic of China, which *Granta* will look at in more depth in the autumn. The sheer propulsion – and starts and stops – of China's modernization drive has meant that its elites experienced historical whiplashes on a scale unknown elsewhere. The *zhiqing* – the educated youth whom Mao 'sent down' to the countryside and who experienced a decade of extreme austerity – are at a vast distance from the generations below them, which includes both those who grew up in the boom of the last three decades, as well as those who have arrived in a China shorn of opportunity. The Chinese experience reminds us that the most salient generation-defining feature may be how far contemporary cohorts are from the utopian politics that flourished in the mid-

twentieth century. Close enough to be disillusioned or nostalgic? Or far enough away to be inspired – or irrevocably cut off?

The Generations issue of *Granta* offers different age cohorts a chance for mutual inspection. Andrew O'Hagan plays with the idea of a kind of moralistic DNA passed across epochs in a story in which a descendent of abolitionists takes a scalpel to *Desert Island Discs*. The French consuls Daville and Des Fossés are delivered by Nico Walker in the form of two American police. Samuel Moyn gives a historical tour of the gerontocratic fortress that threatens democracy everywhere. Didier Eribon re-sutures the wounded rift between the social sciences and literature, in an examination of generations refracted through class. Brandon Taylor, Sam Sax, and Lillian Fishman give us different shades of their generation's tones in three stories set in New York City. Gary Indiana, a titan of that place, reflects on what happens when you realize most of the people you ever truly liked are dead. Sheila Heti discusses with Phyllis Rose, our lone Silent, herself a careful listener to earlier generations, what one generation might learn from another about creating sturdier forms of love. ∎

TM

REPETITION

Vigdis Hjorth

TRANSLATED FROM THE NORWEGIAN BY
CHARLOTTE BARSLUND

It was late November, dark in the morning when I woke up and dark again by four in the afternoon, and if I then stepped out of the small cabin where I was, deep in the forest of Nordmarka near the capital of Norway, I wouldn't have been able see my own hand in front of me.

I had spent a week in the cabin and had been hoping to stay there for longer in order to read, to catch up on sleep and to dream, but the University of Oslo Symphony Orchestra was giving its annual carol concert in the capital's festival hall and I had promised a friend, who plays the viola, I'd go. Besides, I had just read that repetition is the reality and the seriousness of life, that repetition is the daily bread of everyday life, its blessing fills you up, and seeing as I had attended the orchestra's carol concert for three years in a row, I hoped that it would indeed prove to be a blessing.

I packed my things and tidied up and when I drove down the steep hills from Ringkollen to Klekken, it started to snow. Large snowflakes twirled slowly in front of my windscreen and headlights making it hard to see and driving on the unlit, narrow, winding road demanded my full attention; soon the world would be dazzling, white and

shimmering, and anything sharp and pointy would be smoothed over. It was something that happened every year at this time, it recurred and repetition is the reality and the seriousness of life. Hope is like a new garment – stiff, tight and glittering – but until you try it on, you won't know if it fits or suits you, and memory is like an old garment: no matter how pretty it is, it no longer suits you, you have outgrown it. Repetition, however, is like a durable garment which hugs you tenderly, but never constricts or swamps you. I was glad that I hoped for nothing, but why then this feeling of dread?

It was dark again when I reached Sandvika because there had been no snowfall here as there had been on higher ground. I took the exit east to Oslo rather than west to Kristiansand and Nesøya as I usually did, joined the main road and became a part of the heavy Sunday-afternoon traffic crawling with agonising slowness towards the city centre. At long last I was able to park underneath the festival hall and I walked through windy, Sunday-empty streets towards the main entrance, past glum figures wrapped up in heavy parkas and dark scarves, bracing themselves against the icy wind. As I approached the hall, I saw several people waiting on the steps outside, the doors were not open yet so we had to wait, and waiting is challenging, especially in the cold; I wished for the time to pass quickly. We wish for time to pass quickly. We have one single life on this earth, a split-second of earthly existence in the endless expanse of time, and yet we don't feel that it can pass quickly enough. Yes, I get it. It is hard to live your life in a way that matches that knowledge, perhaps it is impossible. I positioned myself so that no one could see my face, I closed my eyes and took a deep breath while I gave myself a reassuring talking-to, aware of the presence of my irritating, mortal fellow human beings, their breathing and the sounds they made when they moved, when they tried to keep warm by rubbing their arms, shifting their weight from one foot to another, how they moved up the steps as more people arrived, the queue compacted and closed up and it grew more crowded around the entrance, their impatience and their fears. There

are no people anywhere else, only here on our little planet; there may well be plenty of intelligent life out there, but there are no people, not in any of the billions of galaxies, we are a rare and threatened species, and so wicked towards one another. I heard a metallic click, I opened my eyes and saw the heavy doors glide open before I entered as one of the first.

The instruments were set out on the stage; I took a seat so that I could see the viola, third row to the left, the same seat where I had sat the year before, another repetition. The audience surged in, but spoke quietly just like last year, this space commanded solemnity. We began to warm up, some people took off their coats, there were couples and pensioners, families with young children, an adult daughter with an old mother, an adult son with his parents and vice versa, I alone was on my own. Young children climbed up onto their parents' laps, it made me emotional, I never went to a concert as a child, it wasn't in my blood, how might my life have turned out if I had been to a concert as a child and it had been in my blood? Then perhaps what happened next wouldn't have brought back the memory. There were empty seats to my right, a man stopped, behind him was a woman, behind her a girl aged fifteen or sixteen, their daughter, I thought, the invisible bonds vibrated. The man tapped the daughter's shoulder and pointed to the seats, she nodded and went to sit next to me, her mother followed, then her father, there was just enough room for them, they were so close that I could feel the girl's padded jacket against my arm, she wasn't happy. I couldn't insulate myself against her unhappy presence, she didn't want to be there, she had been made to come, squeezed in between her mother and a strange woman, staring at the programme while her mother looked at her with disapproval because she wasn't happy, because she wasn't grateful, her mother exchanged knowing glances with her father, no matter what they did, the girl wasn't happy, she wouldn't be happy, she stared at the programme in silent protest. At six o'clock the doors were closed, the lights dimmed, the musicians entered, I waved to the viola player, the hum in the

auditorium died down. The conductor took a bow, everything was silence and anticipation, the hands of the girl next to me with her eyes on the programme trembled as did mine, the conductor turned to the orchestra, raised the baton and the music began.

Carols from northern Norway, *Blessed be the day over the fjords, Blessed be the light over land,* the girl's mother wriggled out of her coat, unwrapped the chequered Burberry scarf from around her neck, folded it on her lap and patted it with restless hands, she didn't want to be there either, she was there for the girl's sake, but the girl wasn't grateful. The father had bought expensive tickets so the family could have a nice time together before Christmas, but the girl wasn't happy. *God's peace upon the mountain and hill, God's peace upon the animals in the stall.* The mother leaned towards the girl and whispered: *Take off your jacket,* she pinched her through it, bowed down to her ear, elbowed her, whispered more loudly: *Take off your jacket.* The girl closed her eyes, her mother hissed her name, my name, a hard sound, but the girl didn't want to take off her jacket, she was hiding inside it and that was why her mother wanted her to take it off, draw her out from her hiding place, her shelter, *We are unyielding, just like you, You bless with eternal words, The people who live here in the north,* we clapped, the girl didn't clap. Her mother glanced at her father who shook his head. *O holy night,* I couldn't take my eyes off them. The mother tugged at the girl's jacket, harder this time and closer to her, intruding on her personal space, why was that jacket so important? Because it had turned into a battle which the mother had to win. The girl unzipped the jacket, her mother yanked at a sleeve, her parents paid the bills, they paid for her keep although it couldn't cost them much given how thin she was, but they had paid for her jacket and could make demands, and no one else, the friends I hoped she had, was there, she was forced to be alone with her parents and for their benefit at the University Symphony Orchestra's carol concert so that they could exercise their power and feel reassured. Something had happened, something terrible had happened the week before which

had to be fixed, which had to be mended, her parents needed it to be. The mother's threatening gaze and a sudden gesture from the father that signalled: *Take off that damn jacket!* The girl slowly peeled the padded jacket off her left shoulder with her right hand, her elbow came near my elbow, she eased the jacket over her right shoulder using her left hand, but she didn't pull her arms out of the sleeves and the jacket ended up stretched across her back, half off, half on, like a weird straitjacket. She bowed her head towards the programme and closed her eyes, I could see that she was crying. She was trapped and paralysed and she couldn't stay where she was without foundering, but neither did she have anywhere to go or anyone to turn to, she was fifteen or sixteen years old and dependent. I wanted to put my arm around her and whisper in her ear that everything would be all right, but I couldn't know that, it probably wouldn't, it didn't look like it, and nothing I could say would take away her pain, *Lovely is the Earth.* I could do nothing for her, and even if I could, it wouldn't have made any difference because the people she longed to be understood by, the ones at whom her anxious hope was pinned, were her parents. *Generations will follow the course of generations*, and we are tied to our family from our first breath to our last, and the last carol had been played and we clapped and got up and the girl pulled her jacket back over her shoulders and they walked out in front of me, three lost, unhappy people, hopelessly entangled. Concert-goers pushed and shoved impatiently from all sides because life couldn't happen fast enough and I lost sight of them in the crowd. The musicians had gone backstage, but I didn't join them to say hello to the viola player, instead I stepped out into the cold and the dark while the girl continued to prey on my mind. I didn't go to the island where my house is as I had planned, but drove back to the forest because Grøndals vei had returned to me; my last November in the first-floor maisonette in Grøndals vei came back, the place where I spent my formative years, as people say, a lower-middle-class area on the lower side of Tåsenveien. On the upper side of the mighty Tåsenveien were smart villas with large gardens while on the lower side were smaller

houses with smaller gardens and several terraced houses and below them again the housing blocks for workers from the nail factory. On my first day of school we were asked to draw the place where we lived; later I wondered if the reason was that our drawings would tell our teacher a great deal about each child's socio-cultural background as I guess you would call it today. ■

IMAGE DESIGN: RSC VISUAL COMMUNICATIONS; IMOGEN HOLST, © BRIAN SEED/BRIDGEMAN IMAGES; BENJAMIN BRITTEN, ALEX BENDER/STRINGER/HULTON ARCHIVE/GETTY IMAGES

BEN & IMO

MARK RAVENHILL

BOOK NOW
rsc.org.uk

♪ TikTok | £10 TICKETS FOR 14-25s

New Work at the RSC is generously supported by The Drue and H.J. Heinz II Charitable Trust.
Presented in association with Michael Grandage Company

ARTS COUNCIL ENGLAND
Supported using public funding by

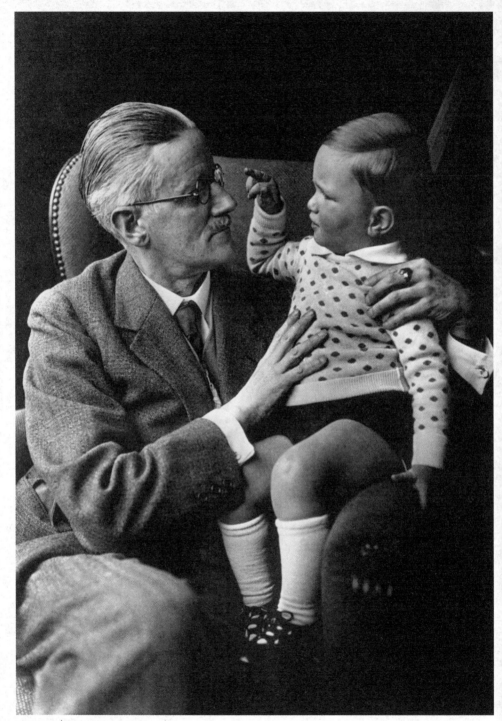

James Joyce with his grandchild, Stephen James Joyce, 1934

ECCE SENEX:
STEPHEN JAMES JOYCE

James Scudamore

In April 2014, a lawyer friend asked if I might consider ghostwriting a memoir for a client he described as a difficult man. Although several candidates had been rejected because they didn't meet the client's strict but unpredictable criteria, my friend had a hunch I might fare better because of an affectionate piece I'd written a few years before about my grandfather.

The client's reputation didn't so much precede him as ride out like a pillaging army. Stephen James Joyce (you had to use the full name): the executor of his grandfather's literary estate, who had become infamous for his ferocious sense of ownership. Who was said to be so litigious that he had stifled Joyce scholarship for two decades. Who had systematically withheld permission to quote from the work, or else demanded impossibly exorbitant fees, until most of it went out of copyright in 2012, when an article headlined 'Fuck You, Stephen Joyce' had been widely circulated online. Who according to D.T. Max in a 2006 *New Yorker* profile had said that academics should be exterminated 'like rats and lice' and had once warned a performance artist that he had probably 'already infringed' on the estate's copyright simply by memorising a portion of *Finnegans Wake* – surely a unique instance of someone threatening legal action for an unlicensed copy of a literary work in someone's head. When

I asked around, two responses stood out. A novelist who'd lived in Dublin told me he was rumoured to skim cash from the Joyce-linked bars there like a protection racketeer. And a venerable French editor said, 'He threatened to kill me! And several of my friends. You must have nothing to do with him.'

Worst of all, this descendant of one of the twentieth century's most famously censored writers had destroyed material. In 1988, following a legal tussle over a book which described his Aunt Lucia's life in the Northampton psychiatric hospital where she spent the last thirty years of her life, he stunned the attendees of a Joyce symposium in Venice by announcing that he'd burned all of Lucia's letters. Also consigned to the flames were three items – a telegram, a card and a letter – written to Lucia by her former lover, as well as the best man at Stephen's wedding in 1955, Samuel Beckett. His written response to the outraged scholars contained a cold threat: 'I have not destroyed any papers or letters in my grandfather's hand, yet.'

It was perhaps understandable that this descendant should feel more protective than most. The sheer – and Joycean – pungency of the 'dirty letters' Joyce wrote to his wife Nora Barnacle, which Stephen fought to suppress, might make any grandson want to pull up the drawbridge. Few of us can know how it feels to read that your grandfather called your grandmother his 'brown-arsed fuckbird'.

As a tour of Joyce's sexual topography in all its farting, flogging and frigging, the letters make for intriguing reading. They are also endearingly devoted, and however you feel about the content, skilfully written. We can't know whether or not Joyce would have destroyed them himself if he'd had the chance. But Stephen's view, as he'd tell me many times, was that anything too personal was 'nobody's goddam fucking business'. 'Do you have children?' he'd once asked a *New York Times* journalist. 'Well thank God I don't either. Can you imagine trying to explain certain things to them? That would be a nice job, if their whole family's private life was exposed.'

It was curious that this man wanted to write a memoir.

There were hoops to jump through before we could speak. He only received documents via a fax machine he kept in an outbuilding of his cottage on the Île de Ré, which he sometimes forgot to check. Eventually it was established that he'd read the five articles I had sent, and approved of them. The next step was a conversation. I'd been warned to expect fits of coughing. They would sound, I was told, as if he was about to expire. But I should simply ignore them, just as his wife Solange apparently did while sparking up yet another of her forty a day. There was one in progress when I made the first call. I could hear him spluttering and moaning in the background as she went to fetch him.

His voice was gravelly, with an East Coast American accent, and a snarl he deployed for emphasis. He swerved into French whenever it suited what he wanted to say. The question of who I was seemed, as it would during every subsequent conversation, to be entirely secondary to the opportunity I presented for him to grind his axe.

'I was born in February of 1932,' he said, 'which means I am now eighty-two years old. And I am descended from one of the most famous authors in the world. Although between you and me, I'm more of an Oscar Wilde man. But, as a human being, I loved him dearly, and to me he will always be known as *Nonno*.'

I started to respond with some waffle about the special bond between grandparent and grandchild, but he cut me off.

'Let me put it like this. I have taken shit *all my life* from so-called intellectuals, and other people who know nothing about the real world. And so, before it is too late, I would like to set the record straight. The amount of nonsense talked about *Ulysses* in particular never ceases to amaze me.' He pronounced the book's name with a particular, dogged emphasis on the y. 'So, I am looking for what the French call a *nègre*, though I imagine we're not supposed to use that term now. A ghostwriter. But I warn you that you would have to deal with a very prickly character.'

The book would comprise two parts. Part One would cover a period of about a year, from 1939 when Stephen went to live with his

grandparents in the village of Saint-Gérand-le-Puy, to their departure for Zürich the following year and Joyce's death there in January 1941 following surgery on a perforated ulcer. The aim of this part would be to capture the relationship that had existed between them, which he remembered perfectly even though he'd only been eight years old.

'Now,' he said. 'Some people – idiots – will tell you that the recollections of a near nine-year-old, at a distance of over seventy years, are not to be trusted. *What do little boys remember?* they say. Well, I would say to them that it depends entirely on the little boy. I was his little darling, *ce que l'on me reproche le plus.* They hate that, these people. The fact is that nobody can rival me in terms of knowing the man. But the way I have been treated . . . this is what gives me pause.' This brought us to Part Two: 'what James Joyce's memory has been subjected to'. In other words, a rundown of the monstrous injustices he'd had to bear.

The list of grievances would become very familiar. There were many of them, but four in particular to which he kept returning. The first was a commemorative €10 piece in silver, issued by the Irish Central Bank, which had been struck with a misquotation from *Ulysses* – a rogue 'that' in the passage beginning 'Ineluctable modality of the visible' – and a portrait of Joyce on which Stephen had not been consulted. He'd described the coin, which had been issued on the anniversary of Nora's death, as 'one of the greatest insults to the Joyce family that has ever been perpetrated in Ireland.' The second was an offshore patrol vessel which, again without consultation, had been named the *James Joyce* by the Irish Minister for Defence, 'who's a prime asshole'. The third was that the Irish government had sent no representative to attend his grandfather's funeral in Zürich. The fourth was that a children's story called *The Cats of Copenhagen*, written by Joyce in a letter to his grandson, had been published when it entered the public domain in 2012, even though Stephen claimed he'd never laid eyes on the letter in question.

We arranged a conference call with my agent to hash out the finer points. I could feel his *froideur* from the moment she came on the line. Too much attention to detail. Too many probing questions on the topic of whether, in fact, he had enough material to make a book. But together we got him to agree a date for my visit and to concede, in principle at least, that a contract would at some stage be required.

My flight to La Rochelle was booked for the 26th of August. Ten days before, he called to fire me.

'May I ask why?' I said.

'I'm having trouble with my eyes. As you know, this is something that runs in the family. And it is *impossible* to get hold of a good doctor in regional France.'

I expressed sympathy, and asked when he might be in a position to proceed.

'With the way the world is going now . . . the terrible things that are happening . . . I'm just not sure when there will be a time. You see, I *know* about the world. I am a student of *history*. Are you going on holiday?'

'Yes, I think I said: we're going to Corfu.'

'That's right, you told me, you're going to the south of France. *À bientôt.*'

I rang my lawyer friend to tell him the trip was off, expressing irritation at the fact that my flights weren't refundable. Then I thought, why not just go anyway, and see what happens?

When I called him the next day, he started ranting before I'd had a chance to speak. 'I have two things to say to you, and I warn you that they are not pleasant.' The first was that he had severed all contact with my friend's firm following an unexpected bill, and was further incensed that the firm had brought up the issue of my non-refundable flights. The second, almost an afterthought, was that he now had someone else in mind to ghostwrite his memoir. I told him that I didn't need reimbursing for the flights, since I now planned to come to the island anyway to do some work of my own.

'That sounds very nice,' he said. 'And obviously we would be delighted to take you for lunch.'

'Where in the hell did you come from?' he said, when I found him and Solange sitting at the La Rochelle airport café.

I explained that I had somehow been channelled straight out of the terminal with the other passengers and had had to come back inside to find him.

'Fucking idiots. There is *nobody* at the airport who'd give you information. The *barman* gave me information!'

I already knew how frequently his statements contained their own contradiction. Knew also how infectious his mood-swings were if you were trying to be deferential: because he was indignant, I became so too.

'It's crazy,' I said. 'They don't even have anybody checking you in these days. I did it all through a machine.'

'Welcome to the stupid future.'

By now his face was familiar from photographs. Behind his sunglasses and well-kempt beard, there was a strong family resemblance. But he'd reached a far greater age than Joyce had. As we shook hands, I wondered how many hands were left in the world that had once held his grandfather's. My attention kept returning to his cane. Was it an heirloom? The famous ashplant? He wore a red jumper, grey slacks and suede loafers with no socks. Around his neck hung a silver necklace on a metal chain – a circle with horns coming out of it. When I asked him about this, he muttered something about it being the symbol for Jupiter, but I checked later and found that it looked much more like the symbol for Taurus. Was it a stretch to think he was casting himself as the bull-monster in the labyrinth of the all-powerful architect, Daedalus?

We drove straight to lunch in their little Citroën, which was filled with Solange's cigarette smoke and the tinkle of a classical radio station. He was impatient with toll queues and impolite about pedestrians, especially if he thought they were overweight. But he was full of admiration for the dogs we passed.

At the restaurant, while he grappled with the parking outside, I asked Solange how long they'd lived on the island. She told me they'd started coming in 1974, and before they bought their house had always used to stay in the hotel I'd booked. But then there had been a falling-out with the owner, after which her husband had refused to set foot in the place.

'Do you drink?' he said, once he'd joined us. 'Good. I don't like people who don't drink.' We were offered water, and he joked that it was only good for washing. When Solange accepted some, he said, 'You ill, or something?' After the waitress had left, he said, 'I hate to be served by girls that are not good looking. And she is one of the best-looking on the island.'

'He's very spoilt,' said Solange.

He told me how much his grandfather had liked a wine from the Swiss canton of Neuchâtel, and that 'following his example', he and Solange had got into the habit of importing it.

'What I really like is a white Burgundy,' he said. 'The problem is, I like the white, but the white doesn't like me.'

I mentioned the scene in *Ulysses* where Bloom orders the glass of Burgundy and the gorgonzola sandwich.

'Well, if I'd have been him, with a gorgonzola sandwich, I'd have had a *red*.'

I said I couldn't remember if it was specified in the book or not.

'Check it.' The glare blazed for a moment, then he relaxed. 'Of course, *Ulysses* is not my favourite book. And that's where all Joyceans go wrong.' He noticed a dog under a nearby table, and brightened. 'Oh! *Il y a un cousin par terre!* We've had one dog in our lives. A long time ago. And we never wanted another one because we had that dog, and that dog was special. We used to ship her back and forth from Africa as excess baggage.'

He declared that from a young age he'd vowed never to write creatively. 'When you have an ancestor such as I have – no. I think it's stupid to try.' Together, we tried to think of counterexamples, getting as far as Dumas *père et fils* and Kingsley and Martin Amis. You should

only do it, said Solange, if you have something to say – and even then, under a different name.

For the next forty-eight hours he kept me under watch. That afternoon he came to my room to talk, growling as he arrived about the 'bloody bitch' he'd fallen out with years before, who almost certainly hadn't worked at the hotel in years. In the evening he called to vent spleen about an article in the *New York Times* which suggested that the decline of Joyce's eyesight was caused by syphilis. ('If *Nonno* had syphilis, why didn't his wife have syphilis? Why didn't his son have syphilis? I won't go on.') The following morning, he appeared unannounced at my room, rapping on the door with his cane, and we talked over croissants. Then he took me out for the rest of the day.

He prefaced any discussion of the memoir with, 'If we do the book', though he warned me that if he chose to proceed it would probably be with someone else. And there was less than a 50 per cent chance of that. He said he didn't have the words to say how important the subject matter was to him. But he knew he would receive negative attention. He might perhaps have managed to cope with that when he was younger, but had always chosen not to, 'in view of the way I have been treated'.

He did not, he insisted, think he was exceptional. Merely that, 'by an accident of birth, I happen to be the grandson of one of the most famous, I never say the most famous English-language writer of the twentieth century.' He added that he was always careful to refer to his grandfather as a 'British writer of Irish origins' rather than simply as an Irish writer.

'Have you ever wished all this hadn't been thrust upon you?' I asked, remembering that at one point he'd said that what he should have been in life was a sports commentator.

'Seriously? No. I may have at times thought, *my God, how would I have lived if I hadn't been who I am?* But you see, what *always* wins out, is the relationship we had. You can't beat that.'

Not that he had done nothing with his life, in spite of what

everybody thought. 'They say, "Here the bastard sits, judging us. He's never done a single day's work." But this man they think sits raking in royalties had a thirty-plus year career as an international civil servant.' He seemed happiest reminiscing with Solange about all the travelling they'd done with his job (when he wasn't talking about dogs). Spain. Yugoslavia. Greece. But mainly Africa. 'In Senegal,' he said, 'we were friends with everyone from our driver up to the President. The President used to wink at us!'

He was 'a Joyce, not a Joycean', yet considered himself the supreme arbiter of what constituted valuable Joyce scholarship. At the same time, he admitted that he rarely read anything in full. Richard Ellmann's book, for example, hailed by Anthony Burgess as *the biography of the century*, 'has major flaws in it as far as I'm concerned', even though 'I've never been inclined to read 900 pages about my old boy.' He damned Joyce's friend Arthur Power for having claimed to quote his grandfather word for word thirty years after his death: 'Now, I don't know anybody who has that type of memory. And until I had my stroke – my light stroke – several years ago, I had about as good a memory as anybody can wish for, because I had a Joyce memory, which I inherited.'

In the same breath, he told me that his own account wasn't always to be trusted. He'd been lamenting the fact that there was no penicillin around to save Joyce from his perforated ulcer, and I asked him how lucid his grandfather had been at the end.

'He was lucid on his *deathbed*,' he said. 'And, if I write the book, I'll tell the story. I wasn't there. The last time I saw him, he was being carried out of the *pension*. And, of course, stupidly, when I was young, I said he was strapped to the stretcher and squirming like a fish, and some idiot got hold of that and it went out.'

'Is that in the Ellmann biography?'

'Probably. You can forget that. That's a little boy's imagination. But he was obviously in pain. I will explain all that in the book – if I write it.'

His exasperation seemed to peak whenever the topic of the supposed 'difficulty' of the work came up. 'If you build a house, you

start with the foundation and you build up! You don't start with the third floor and build down. Any normally constituted young man or woman can read *Dubliners* and *A Portrait of the Artist as a Young Man*. But if you start with *Finnegans Wake*, you've got *real problems.*'

He hadn't read *Ulysses* himself until he was close to fifty, because he'd always been told it was an 'impossible book'. Then, one winter, he'd taken it off to a cabin he and Solange owned in the Swiss Alps and read it in eight or nine days. 'And I said to myself, what is all this crap they talk? I may not understand everything, but I certainly haven't found it a *boring* book. As a matter of fact, I've enjoyed it.'

We returned to his detestation of academics. 'Who does a writer write *for*?' he asked. 'Not for critics. For the reading public. I don't want to go analyse this stuff! *What did he mean by this* and *what does this mean?* I want to enjoy myself. I want to go back to being a little boy and reading *Peter Rabbit* and *Winnie-the-Pooh*. No, really! *How cold my nose tiddely pom, how cold my toes tiddely pom*, and things like that. That is what is enjoyable.'

When I told him I'd recently met someone who was working on a Mandarin translation of *Finnegans Wake*, he leaned forward and fixed my gaze as if he were issuing a death threat. 'Listen to me. If you're ever in a meeting again where someone is discussing a translation of *Finnegans Wake*, you can quote me directly: it is untranslatable. That does not mean that you cannot have it in other languages. But you must call them adaptations. And frankly I would say the same thing about *Ulysses.*'

All translations were flawed, anyway. He reminded me that he was fluent in three languages, which wasn't very many ('my grandfather had command of at least twelve'), his third being Swiss German ('a sort of throat disease'). And when he'd worked at the Organisation for Economic Cooperation and Development, he'd listened to the finest interpreters in the world producing 'utter crap'.

Mistakes were an inevitability. Take the poem 'Ecce Puer', written to celebrate Stephen's birth, which came less than two months after the death of Joyce's father: 'In any book of poems you pick up, there

are two mistakes in it, which no Joycean found, but I did. Because I've got the manuscript.' He took his responsibilities very seriously, along with his co-trustee, Sean Sweeney, whom he described as his 'oldest friend'. And if a request for use contained even the smallest mistake, the answer was no. 'If they can't even copy a text, that's it. Finished. I'm not interested.'

This too was the danger of talking to journalists: they always got things wrong. Every article written about him over the years was plagued with inaccuracies. But as Sean had said when one of them upset him: the articles are unimportant. All you have to do is look at the photographs and you know the whole story. 'The little boy looks at the old man and the old man looks at the little boy. And you understand that there is a special tie between them. It's there. It exists. But you see, we live in a world of lies, falsehoods, cheats, crooks, pimps – whatever negative you want to call them.'

The topic of France invariably sent him berserk. He was, he said, 'thoroughly fed up' of living there. This led to perhaps his most striking declaration of all: that he had lately been in touch with the governments of several unnamed European countries to try to cut a deal whereby he and Solange would be given a place to live for the rest of their lives, of at least 150 square metres in size, with a garden, or large terrace. In exchange for which, when they died, that country would receive 'my entire Joyce collection. Free. In my view it is worth somewhere between 15 and 20 million. Not pounds. But let's say it is worth a lot of money. I don't recall another offer like it.'

'Would you impose any conditions?'

'Oh yes. There are conditions. Certain people will not be allowed to view the material. Those who have done me dirty. With the letters and things.'

'About the letters,' I said.

'My aunt had a bad enough time,' he snapped. 'The last thing she needs is for people to go raking through her life looking for muck. There was no literary value in those letters. Anyway, it was done at Sam's express request.'

'What about the more . . . private ones? The ones written to your grandmother?'

He was driving at the time. I braced myself for him to veer off the road in a fury. But his attention had alighted on a Cairn terrier that was pissing against a lamppost. 'That's a real dog,' he said, laughing. 'Not one of those stinking rats.'

Referring to Beckett as 'Sam' was characteristic. He was a fervent dropper of other names, who liked mentioning his friendship with Merlin Holland (Oscar Wilde's grandson), or the fact that he'd shared rooms at Harvard with Paul Matisse (grandson of Henri, and stepson of Marcel Duchamp) – but whenever Beckett came up in conversation, he would pointedly withhold the surname. He told me he'd been insulted ever since he got married for having chosen 'someone, and I won't tell you who', as his best man, 'who didn't like public ceremonies. I was accused of *lèse-majesté*. "How could the little bastard do that?" It certainly didn't bother the person concerned.'

Funny that he'd be such a dog person, given Joyce's love of cats ('Mrkgnao'). And especially given that the two stories Joyce had written for him were called *The Cat and the Devil* and *The Cats of Copenhagen*. When he came to my hotel room on the second day, he brought a copy of the former for me, published as a modest illustrated pamphlet by a Swiss youth organisation. This was 'his' Joyce book, so he'd signed it, and written a dedication to my son. He pronounced it 'one of the best children's stories ever written', but he didn't approve of the title, having crossed it out and changed it to *The Cat, the Devil and the Lord Mayor*.

He angrily lamented what had happened to *The Cats of Copenhagen* when it entered the public domain: 'People who think they are Joyceans will do *anything*. Someone went to the Zürich James Joyce Foundation and found a children's story there in a letter, copied it, and decided to publish it as a book. The Foundation had got hold of it from my stepbrother. The letter was supposedly addressed to me. I would swear in *any court of the world* that I had never seen it until

it was sent to me in book form, with illustrations. Since then, I have received a photocopy of the manuscript, which has no opening and no closing greeting. Very strange. And this thing is selling like hot cakes all over the world! What do you do?'

His house, a fisherman's cottage tucked down one of the cobbled alleys of La Flotte, was called *An Bairneach* – Gaelic for The Barnacle. When we got there, he ushered me straight through and into the garden, since he could no longer trust anyone enough to take them into the living room, where his 'Joyce collection' was kept. While Solange and I were admiring the wild strawberries outside, he appeared in the doorway holding his grandfather's death mask over his own face. Solange said she found it indecent.

'That's the way he was,' he said, handing it to me. 'Though they never asked my permission to make it.'

'You were a little young,' said Solange. 'Your opinion didn't count.'

'If it ever has,' he said.

I kept thinking of the glorious cry of affirmation which ends *Ulysses*, and how all he ever said was no. Maybe all those years of referring to Joyce as *Nonno* had taken their toll.

On the way to the market that morning, he'd said, 'As soon as I open my mouth, the whole island trembles.' When we got there, he'd gone from stall to stall pretending to machine-gun the vendors with his cane, all of whom had obligingly convulsed as if riddled with bullets. As each subsequently greeted him by name, he'd said, 'You don't understand what it's like for me. People come up to me in the street and tell me who I am.'

Over drinks at the hotel on my last night, he wondered aloud how much time they had left. 'I think what I would consider a reasonable limit is ninety for her, and eighty-eight for me.'

'Oh dear,' she said. 'I've got five more years.' (In fact she had only two, passing away in 2016, but he was less than a month off his eighty-eighth birthday when he died in January 2020, ten days after the anniversary of his grandfather's death seventy-nine years before.)

'Come on,' he said. 'You've still got your original head of hair.' He jokingly lamented the fact that their diamond wedding anniversary was coming up. 'I think I'll do nothing.'

Solange laughed her irresistible smoker's laugh. 'That's the best way of celebrating.'

'What was the date of your wedding?' I asked.

The coldness slammed in. 'Look it up in a book, my friend.'

On the morning of my departure, he brought the offending €10 Joyce coin for my perusal over coffee in the hotel bar. 'Look at it,' he fumed. 'A cross between a baboon and an orangutan. I went out in the street and asked people who they thought it was, and I got everything under the sun, including Groucho Marx. They made 10,000 of these, and look what my number is: 9,979. They pretty much gave me the last one. Listen: I love the Irish people. But I am not going to do this book unless I can *clobber* the Irish government. There are dozens of Irish men and women who not only fought for independence, but gave their blood, their suffering, goodness knows what for their country. *They* are the ones who should be on the coin. Bloomsday was a day, then it was a week. Now it's a month, for all I know. It is not done for Joyce. It's done to make money for the Irish state. And the way I'm treated by them is not just pissing on me, it's *shitting* on me.'

'Have you ever been to Bloomsday?' I said, without thinking.

His voice was eerily quiet. 'You must be kidding. Me? Go in with those garbage collectors? You haven't *got* me right, my friend.'

'I just thought, perhaps, once . . .'

'No! What for? I am a Joyce. Not a figure of ridicule for these people. This is . . . a biscuit or sugar?'

'It's a piece of chocolate.'

'I'll always eat chocolate.'

'If I do the book,' he said on the way to the airport, 'I've been thinking it could start with everything he did on the morning I was born. Which of course I was told about by my mother and father.

And possibly the fact that he gave me his name. By the way, do you prefer to be called James, or Jamie?'

'I don't mind.'

'I get called both too. Anyway. I give you permission to write about me. People might be interested to know: what is this monster called Stephen Joyce really like when you sit down and have a quiet talk with him about things? And don't underestimate the draw of the old boy.'

At the airport, he got out of the car to say goodbye. 'If you have any trouble and your plane doesn't go, give me a call.' He said he would be in touch, and drove off to La Rochelle to collect his new glasses.

A few days after I got home, I received an envelope in his shaky, boxy handwriting. It contained a copy of the Romansh edition of *The Cat and the Devil* which he'd promised to send me, and no accompanying note. This time, he hadn't adjusted the title. ∎

A "SILENCE" TOWER AS A BUILDING'S "CORE": THE B.B.C.'S NEW HOME.

DRAWN BY OUR SPECIAL ARTIST, G. H. DAVIS.

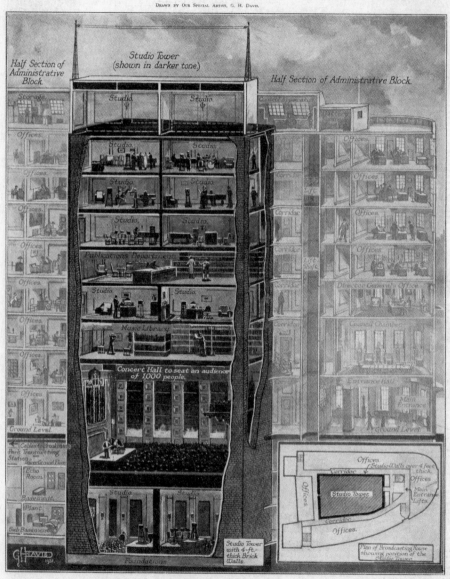

THE UNIQUE CONSTRUCTION OF BROADCASTING HOUSE: A MASSIVE CENTRAL TOWER WITH WINDOWLESS BRICK WALLS, ENCLOSING TWENTY STUDIOS ISOLATED FROM EXTERIOR NOISE, AND FORMING A "KERNEL" WITHIN THE "SHELL."

Broadcasting House, now under construction in Portland Place, London, which in due course will become the headquarters of the British Broadcasting Corporation, will be the finest building of that character in the world. It will have all the latest devices for transmitting, and it will be connected with the great station at Brookman's Park by a mass of underground cables. Its outstanding feature is the huge Studio Tower which is being constructed in the centre of the building and will be separated from the administrative portion by four massive walls, approximately four feet thick, so that the studios inside this tower will be completely isolated from all outside noises. This tower is without windows, so that artificial light will be used night and day, and it will also have mechanical ventilation. In order to shut out all exterior sounds, the tower is wholly built of solid brickwork without stanchions. Altogether there will be no fewer than twenty studios (twice the present number at Savoy Hill), some for talks, and others for music. The main feature of the tower's interior is the large concert-hall studio to seat a thousand. The administrative offices form the outer ring (illustrated in light tone) round the tower (shown in darker tone). The B.B.C. expect to occupy their new home before Christmas. The architect is Lieut.-Colonel G. Val Myer, in association with Mr. M. T. Tudsbery, civil engineer to the B.B.C. The builders are Messrs. Ford and Walton.

Diagram by G. H. Davis showing the new Broadcasting House in Portland Street, London, 1931

THE SENSITIVITY READER

Andrew O'Hagan

Before it occurred, the drama on the Piccadilly Line, I was one of those people employed to clean up the radio archives at the BBC. I'd written a book called *Muriel Spark and the Comedy of Fact* and was still smarting from the silence surrounding its publication. People talk such garbage about failure. They say it's the attempt that counts, that failure is a great teacher. All I know is that success improves your life, and when it doesn't come you're left with a sense of premeditated injury. I joined a part-time MA in journalism at City University, where some of the students had tattoos, nose rings and pale blue hair. We yearned to report on the inner reaches of ourselves. All data was of course credit data. All reporting was surveillance. In good journalism you get to see what happened, but in the best you also get to see what might have happened instead.

'You guys want to believe that stories belong to the people they're about,' the professor said one cold evening in the lecture hall, 'but that's just not true. History is merely a chronology of accidents and journalism a perpetual clean-up operation.' His accent was strong. Welsh. The hall smelled of damp wool. The students seemed super-alert. Outside the window, the lights of Clerkenwell glowed through the rain.

'I don't *think* so,' the young woman sitting in front of me said. Professor Madoc behaved as if all opposition was enjoyable. You had the impression he kept his deepest professional experiences to himself, and that he doubted your capacity for reality. I admired him, perhaps more than I should have. I like the idea that minds improve by confronting difficulty, not by meeting reassurance.

'Look out for that form of sentimentality known as privacy,' he said to the hall. 'It's redundant. Your job, your only job, is to expose the truth, with no regard for special interests, the special interests of corporations as much as individuals.'

'I'm not sure that's right,' I said, with my hand up (an old habit). 'Surely it's not okay to harm or offend people just to get information?'

He came straight back at me. 'Offence is merely a by-product of good reporting,' he said. 'People's feelings are irrelevant.'

'That's over the top,' I said to the students rather than to him.

'Speak up!' he shouted. 'I can take it.'

'That's really questionable,' I said, a little louder. 'You're making it sound like reporting is a form of exploitation.'

'You're saying you can't cope with it?'

'You're framing the whole thing as an immoral act.'

I couldn't tell if the other students knew that Madoc and I had become friendly. I was a little older and already hired by a corporation, which may have annoyed them. He had a tendency to pick me out. Over drinks, he had told me I should be thinking about long-form. I suppose most of them imagined we were just two blokes in a

competition to mansplain, but Madoc could be insightful. I thought he could help me.

'In a time when all information is gathered and controlled by potentially bad actors,' he said, 'we can still believe in the power of the individual witness to circumvent that control. I don't know if you believe that, Mr McAllister. You're from the United States, no?'

'I won't deny it,' I said, putting down my pencil. 'Philadelphia.'

'Home of *The Philadelphia Inquirer*. Well, people either believe in journalism or they don't, Michael. They either like the truth, or they hate it. Some of you want to be activists, yet you're frightened of offending anyone. But, let me tell you: objectivity takes a degree of courage, and this business is not a niceness contest. It's brutal. It should be brutal.' I think the students were put off by his categorical way of speaking. Some of them looked at me, as if I might know how to make him less like that.

There was a loner-guy in the second row. That evening, he seemed especially agitated, pulling his headphones on and off, the music suddenly blaring from his cans while Madoc continued to speak. There's nothing more insistent than other people's music. It was a jagged sound, thrash metal or whatever, and its discordance began to feed an anxiety already there in the room. 'Fucking bullshit!' the guy shouted, pushing the headphones back on.

'I think you should leave the hall,' Madoc said.

'Like you know *anything*.'

'Just leave.'

The guy provoked confrontation yet seemed to hate the attention.

I'd often see him craning round to look at me during the class. A week on, it must have been him that stuck a Post-it note on the bench where I sat. I found it when I came in and could see the back of his head, nodding with his cans on. Then he laid his head on his folded arms for the whole hour. 'SPEAK UP!' the note said.

I'd come to Broadcasting House after two years at HarperCollins as a sensitivity reader. By my count, I'd saved twenty-six authors from making jerks of themselves or being cancelled, and now I was in this open-plan office on the fourth floor, trying to sort out the archives of *Desert Island Discs*. Archive cleansing was hardly my life's ambition – a frontline assignment was the aim, or a serial podcast – but they allowed me to work flexible hours, and it calmed the mind to be assessing old recordings and listening to the variously intelligent and prejudiced questions of Roy Plomley and Sue Lawley.

'What've we got?' my boss Lillian asked me one morning, as she peeled a banana by my desk.

'Well, there's the interview with Ian Fleming from 1963 –'

'What's wrong with it?'

I looked down at the notes in my iPhone. My habit was to listen everywhere, at the shaving mirror, in bed at night, jogging at Fitness First, and the stuff I noted was relevant and to the point.

'The way he describes the sex life of James Bond. Might sound a bit rapey.'

'Oh, really?'

'The problem's the presenter. He says how lucky it was for 007 to be meeting "these lovely and cooperative girls".'

'Oh dear.'

'Like, can we even say "cooperative"?'

Lillian went to the *Shorter Oxford English Dictionary.*

'It suggests a certain amount of coercion,' I continued.

She found the page. 'Working together, acting jointly,' she said, looking up. 'It says "willing".'

I told her I thought it would be safer to cut the question. The archives were full of holes and omissions – missing tracks, speech breaking off, material lost or damaged. Deletions in the recordings were unlikely to be noticed.

Broadcasting House is filled with old sound. When I walked the corridors and peered into the empty studios, there was always something of a distinguished echo, a combination of past laughter and bulletins. Maybe the cue lights on the green baize offered a sense of occasion. Nostalgia. The air in all those rooms and in the entire building was tense with spoken things, as if what had been said on the airwaves still lingered in particles and spores. That's how it struck me anyhow. You think you can hear Orwell and the 1930s poets, and there remains in the elevator lobbies the smell of shoe polish and stewed tea.

Our section – the Department of Misspeaking, as our waggish colleague Nicholas Winslow-Brown called it – was one of the newer ones sprouting up all over the place. Lillian used to work on the *Today* programme, and she had been seconded to us, aged sixty-four. She had incredible news sense and you had to admire her experience. Nick was an archivist of sorts. He cycled in from South Norwood three days a week. His life's passion, if that's not too

strong a word, was British comedians of the 1970s. He never found anything offensive: all subjects were good for a laugh. He collected old recording equipment and could bore you out of your mind when talking about radio frequencies. He was the God of Easy Listening, but his lightness made us grave.

'Okay. What else?' Lillian asked me.

'I'm not sure it's cool that Joseph Cotten says he once kicked Hedda Hopper in the ass. Random violence towards women. And . . .'

I scrolled down my list of notes.

'Victoria Wood introducing a track by the Weather Girls? She describes them as "two enormous black women"?'

'Yes, cut that.'

'And the novelist Beryl Bainbridge saying women can never be equal to men.'

'She was eccentric,' Lillian remarked. 'Nobody could take that seriously.'

'It's up to you.'

'I understand the task, Michael,' she said.

Lillian was inconsistent. She wanted the Corporation to meet improved standards, but she wasn't persuaded by my own efforts. She said I had the brain of a single man and that I reasoned like somebody who didn't have kids. She wasn't wrong but her remarks were inappropriate, I thought.

'There's an interview here from 1968,' I said, 'with Louis Armstrong. Fairly upsetting.'

'I'm really not keen to cut a contributor of colour,' Lillian told me. 'We have too few, especially from those years.'

'Of course,' I said, swiping to get to the offending section.

'You're about half the size you were when I last saw you,' the interviewer was saying. 'I've been getting too much to eat,' Armstrong replied, 'but I've learned the psychology of leaving it all behind me every morning. You understand?'

Lillian was nodding. The interview continued.

'You don't need it after the taste is gone,' Armstrong added.

I stopped the recording and scanned Lillian's exhausted face. 'That sounds like an advertisement for bulimia,' I said.

Two weeks later, the thing started. I was perched at the counter of a sushi place in Regent Street, when suddenly I got the feeling I was being watched. When I looked up from my tray, there he was – the loner-guy from City. I'd like to say his presence was unexpected, but somehow it wasn't. He sat down on the stool next to me, licking a cigarette paper and blinking crazily. I say crazily: I don't mean to judge him, but he absolutely seemed like he had mental-health problems. When he spoke, it became clear that he had this little fund of second-hand knowledge; he knew, for instance, that Professor Madoc was married with kids, and he knew about my work with the BBC, casually dropping it into the conversation as if gathering such information was a hobby of his.

'How do you know that?' I asked.

'It's on your Instagram bio, dude,' he replied. 'It's not rocket science. You were a sensitivity boffin for a major publishing house.'

He spoke about 'testing reality' and 'making things happen'. When he lit the cigarette he'd been rolling, the manager came over and asked him to leave. Pointing at me, the student said it was stupid to trust pilots from countries where they believe in the afterlife. 'I'm telling you, brother,' he said, 'when it comes to pilots, you're much safer when they don't.'

The manager started jostling him. 'Let's move,' he said.

'People's minds, man,' the student said. 'You never really know what's going on in there, do you?'

That afternoon, Lillian wanted to go over some of the fixes. Winslow-Brown was with us, serving as comedy's great advocate. Her desk overlooked All Souls Church on Langham Place, with Regent Street beyond. 'The word has come down,' she said. 'We need to incline more towards Michael's approach.'

Nick cocked his head and smiled. 'Expunge all the bad attitudes?'

'I don't like it either,' Lillian said. 'Desert Island Crimes. The Big Bigots Conventicle. I feel like we're rubbing out history, all in the name of –'

'Social awareness?' I offered.

Nick sniggered into his travel mug of coffee.

Lillian tapped a pencil on the edge of her desk. 'Well done,' she said. 'Management is happy with what we're doing. I don't pass all your suggestions up the line. I tend to agree with Nick, that human nature is not improved by concealment, especially when it comes to the past. But management wants a bit more … Em, *attentiveness*. Your latest points …'

She touched her laptop and read aloud. '. . . Sondheim is belligerent, defensive, immodest.'

'And that's now considered out of order, is it?' Nick asked. 'That's now banned, a person demonstrating his character?'

'It would appear so,' Lillian said.

I tried to adopt a more junior tone. 'Guys. You employ me to listen and tell you what I think. My notes are only suggestions.'

Lillian flicked her trackpad. 'Yes. I listened last night to a few of the latest things you flagged. Natalie Wood speaking in a faux Mexican accent. "You dirty gringos, et cetera". She's having a bit of a joke, no?'

'Possibly,' I said. 'But 150 million Mexicans aren't laughing.'

She nodded, reading on. 'The travel writer Wilfred Thesiger. He talks about areas of Arabia being "pacified". He shot lions in the Sudan.'

'I've heard that one,' Nick said, his bottom lip out. 'Isn't it all about sweet-smelling roses at the edge of the desert, the beauty of shifting sands?'

'That's not the worrying part,' I said. 'We don't punish clichés.'

'He's a *type*,' Lillian said, staring at her screen. 'We can't uninvent him.'

'It's just over, I guess.' I was trying not to sound irked. 'A white man, schooled at Eton, trying to be funny about the dance moves of Ethiopians. I don't know how harmful it is, but I can tell you it's offensive.'

'Rex Harrison,' she continued, 'ticked off for blacking up in a play by Eugene O'Neill.'

'Not for doing it,' I said, 'that's none of our business. For talking about it light-heartedly on a programme we are making available for rebroadcast.'

'Quite so,' she said, with a tight smile. Lillian seemed to hate her job and blamed me for helping her to do it properly.

'Roald Dahl, of course. Everybody's taking great chunks out of Roald Dahl.'

'For fuck's sake!' Nick said. 'He was an *entertainer*.'

'And so were the Black and White Minstrels,' I said, 'but you're not proposing to stream them all over the place, are you?'

M y father used to say the important stuff happens when you're looking the other way. You're fast asleep or busy worrying about the car insurance or what to cook for dinner. I'm not sure I can agree with him. I trained myself early on to recognise big events, and keep my own preferences out of the picture. News is like that: it's other people, most of the time, though I increasingly fear that everything's subjective. I mean, you arrange your perspective according to who you think you are.

In the late 1980s, my father learned his people were related to the abolitionist who owned the McAllister farm south-east of Gettysburg. He visited the US from Scotland in search of his American roots, and he met my mother in Philadelphia. They went to work for *The Inquirer*. He left us on my sixteenth birthday. He returned to the UK and to a sort of oblivion. When I was in my senior year at Yale, I received a letter in which he said there were too many things he didn't

get right. 'Your mother deserved better than me,' he wrote, 'but I just couldn't make it and I'm sorry about that.' When he died, his second wife sent me a freezer bag containing a tartan scarf and a harmonica. 'I thought you might like these,' her note said. 'Your father was always sad not to have known you better.'

I left Broadcasting House at three o'clock that day and walked down to St James's Square, where I sat on a bench under the plane trees, making notes on an episode from 1979. 'Is it okay for the playwright Peter Shaffer to talk about possessing the spiritual essence of the Inca?' I walked over to Haymarket to get coffee and was aware of eyes at a certain point: a familiar person passing by, then a clear view of him, the guy from class. It was like he wanted to look at me or say something, and I was confused by it and sort of spaced out. If you're built for it, all attention is a sort of aphrodisiac. He disappeared again and it was close to five when I got to the underground station. A guitarist was playing in the tunnel and the music echoed. On the crowded platform, I heard the shots. People ran and screamed. I took out my phone.

'*Oh my God!* He's going to shoot people!'

I remember a woman yelling that. A train came in on the other platform and everyone rushed towards it as I saw him firing at the ceiling.

I was already filming when he walked towards me. It was as if the commotion was soothing to him. One of the Transport for London workers was shouting into a digital loud hailer. 'All passengers please clear the platform!'

The student turned to me, stepping closer.

'I'll record it for you,' I said. 'Don't shoot.'

'It's hard to work out the maths and the physics,' he said casually. 'The acoustics, I mean. Trying to figure out what's right.'

There was a pinkness to his eyes. He wore a backpack and jerked the gun in the direction of the steps.

'Just science,' he said.

I stared at him. My hand was shaking. He was careful in the way he reached into his backpack – he had fingerless, mesh gloves – and put what I think was another cartridge into the gun and hammered it in with his palm.

'Keep your camera on,' he said.

My eyes tried to focus, and the place seemed emptier. I can remember the posters behind him and the noise of an alarm going off.

'Stop this,' I said. It came out as a whisper.

He seemed exhausted. He seemed like he'd overthought everything. I remember how he let his firing arm flop down to his side. He walked closer and I thought I was finished, but all he did was hand me a plastic key card.

'Room 204. Premier Inn. Heathrow. Terminal 3,' he said.

I put the card immediately into my pocket. There was a sound of radio crackles, and I could see a number of people coming up behind him.

'Thank you,' he said. 'Sometimes you need help.'

I lifted the phone with a sense of purpose, using my thumb and

forefinger to zoom in on his face. He looked sensitively into the camera before raising the gun again, at which point he was pulled by several people to the ground.

They've had a bunch of war reporters on *Desert Island Discs*. The photojournalist Don McCullin was one, interviewed in 1984. He spoke of being in Beirut a year earlier trying to photograph a woman. 'She was very cross, and she punched me,' he said. The woman then went round the corner and was killed by a car bomb. 'I wished the woman would have punched me ten times as hard,' he said, 'to somehow exonerate my misjudgement that day.' A lot of the other reporters who came on the show are now forgotten, people like Godfrey Talbot, a broadcaster who had been embedded with allied troops at El Alamein and Cassino. 'I don't know of any assignment that is so rugged as a major royal tour,' he said, with what I take to be a 1950s sense of proportion.

Nobody was hurt that day at Piccadilly Circus. The young guy was arrested. I don't know what to say about randomness or predestination or whatever. When they took him away, a female officer asked if I was okay, and I nodded. They would check the CCTV, I supposed, and have more questions later. The station was closed and cordoned off, so I couldn't take the Tube to my destination. It was dark when I emerged onto Piccadilly, into the blue lights. I was worried the police might come at any moment and take my phone away for analysis. I emailed the footage to Madoc, and hailed a cab on Haymarket, feeling the guy's key card in my pocket.

I had reached Hammersmith when Madoc called.

'Are you okay?' he asked. 'You were right there, man. That's the nutter from our class.'

'Yes,' I said. 'I saw everything.'

'That's insane. Was he trying to . . . ?'

There was nothing to say to him. It was all on the recording. What the guy did and what he didn't do and what he might have done. The police later found him on CCTV footage from weeks before, asking the security guard at Broadcasting House how to get work in the media. He posted screeds about our course on Reddit. The police would say he'd sent me an email after reading my first published article in *Prospect*, but I never saw it. They now say he was a fitness fanatic who had spent months trying to buy a firearm. He'd put a message about me in a BBC suggestions box. 'The guy wants to be a reporter,' it said, 'and he needs a story.'

'There's obviously something wrong with him,' Madoc said that night, 'but I didn't think he was capable of anything like this. Where are you now?'

I didn't tell him. He asked me what I wanted to do with the video. I wasn't sure. 'I know a producer at CNN here in London,' he said. 'They'll pay you for it, but they'll want to interview you as well.'

Passing over the Hammersmith Flyover, we encountered roadworks. They drowned out most of what Madoc was saying. I told him to take care of the footage. He should do whatever he thought was right.

He was waiting for me to say something else. 'Do you want me to come and get you?'

'I'm good,' I said.

'We just don't know what's in people's minds.'

I think that's what he said. That's what the guy had said, too.

U nless you happen to enjoy the journey to a journey, the airport run feels like the first link in a chain of dislocation. The short-term parking, the shuttle between terminals, the say-hello-wave-goodbye routine of coffee bars and trinket shops: it makes you wonder if you were ever on solid ground. Going down the M4 feels austere. I think of those highways as among the final staging posts of royal funerals, where the mourners line the route as the cortège makes its way from the historic centre to the resting place.

Terminal 3 had an atmosphere of purpose. Maybe it was the drag of wheelie-suitcases over wet gravel. The smokers outside the building looked like they were going everywhere and nowhere at the same time. Piccadilly already seemed like an urban myth. The cab had dropped me off at the terminal building, so I walked past multi-storey car parks to find the hotel. When I reached it, the Premier Inn felt like a place I'd been getting to know all my life.

I knew I had to reach the room before the police got wind of it and turned up to investigate. I went straight past reception and up in the elevator to the second floor. At 204, a 'Do Not Disturb' sign hung on the door handle; the lock was released with a knowing click. Inside: drawn curtains. The bedside lights were on, and the bed looked as if it hadn't been slept in, but there was an impression on the white duvet, just about my length and with a dent in the pillow. I found a pair of AirPods in the bathroom and put them in my pocket. A computer charger was plugged into the wall and a neat pile of books sat on the desk. Open by itself was a copy of my own book, held flat by a mug of cold tea. ■

The Soviet Republic in Munich: revolutionary men blocking the train station entrance during the Spartacist uprising, Germany, January 1919

THE MILLENNIAL MIND

Anton Jäger

What does it mean to be a 'millennial' today? The generation born in the West between 1981 and 1996, first baptized with a semi-official term in 1991, has been routinely castigated as moralistic, incorrigibly literalist, and intolerant of ambiguity, in contrast to the allegedly post-ironic cohort of zoomers and the self-ironizing individualists of Generation X. Culturally, the differences are not hard to spot. While millennials grew up with the internet and observed its early evolutionary travails, zoomers seem blissfully born into it; while millennials publicly enlisted in generational battles (Occupy, the Great Wall of Gammon, etc.), Generation X had been conditioned to abjure any collective endeavor altogether; while boomers could live off the fruits of the *trente glorieuses*, millennials surfed on the artificial waves of the credit boom until the hammer fell on them after the 2008 crash.

Compared to other cohorts, millennials appear trapped: they enjoy neither the effortless asubjectivity of Generation Z, nor the historical arrogance of the baby boomer. Born with the promise of globalization in the 1990s, which liberated the planetary flow of goods and information and augured a new civil society, the post-1981 age group entered the new century with hopes that could hardly be met.

The ardor and blockage of millennials is not without precedents. In the Weimar Republic, generational politics was often a lethal affair. As Germany recovered from the First World War, movements stratified along generational lines battled over the future of the post-war order: younger Communists strove for a republic of councils rather than parliaments, while older social democrats were satisfied with the resignation of the emperor who had goaded them into the conflict. In 1926, 80 percent of the German Communist Party's (KPD) leading functionaries were below forty, 30 percent below thirty and its average age was thirty-four. Leaders of the Social Democrats such as Karl Kautsky and Eduard Bernstein worried that the influx of young farmhands would swell the ranks of the older industrial proletariat.

On the German right, the divide was hardly less stark. In Thomas Mann's *Buddenbrooks*, the generational decline of a conservative mercantile dynasty seems to obey quasi-biological laws, while two decades later the Nazi ranks swarmed with youngsters who had no experience of the 'civilizational break' induced by 1914. The same generation would become the 'youth without God' portrayed in Ödön von Horváth's novel about his stint as a schoolteacher during the Third Reich. 'Thinking is a process they hate,' Horváth complained about his pupils, 'they turn up their noses at human beings. They want to be machines – screws, knobs, belts, wheels – or better still, munitions – bombs, shells, shrapnel . . . To have their name on some war memorial – that's the dream of their puberty.'

When the German sociologist Karl Mannheim first drafted reflections on the so-called Generation Question – *Generationsfrage* – in the middle of the 1920s, the examination of age cohorts was still a relatively novel way to study society. Mannheim did not subscribe to the idea of generations as simple chronological slots. His generations were compound constructs, born out of the clash of a biological continuum with a sequential order of events, which meant that the entity in question had to share a cultural-political

experience, not just a year of birth on a passport. 'The sociological phenomenon of generational cohesion,' Mannheim claimed, was undoubtedly 'founded on the fact of the biological rhythm of births and deaths'. But he was careful to emphasize that the biological base needed a political-cultural superstructure: a generation 'holds within itself an underivable superadditive', a type of shared experience that catapults the group from natural into human history. Mannheim gave the example of French peasants at the time of Napoleon. Those who did not join Napoleon's armies remained cloistered in the mental world of their parents and grandparents, where customs and traditions were passed down from father to son. By contrast, the young men who experienced the military campaigns, victories, and defeats of Napoleon, acquired a common generational experience that divided them from those who came before them and those who followed.

A generation-in-itself was not a generation at all; only by acquiring consciousness for itself, and by pitting itself against other cohorts, could it become worthy of its name.

In Mannheim's time, generational fighting did not yield obvious victors: neither the dream of a Nazi Empire nor the dream of a council republic ever took sustained shape in Europe, even if Europe's post-war welfare state embodied some of the concessions made to the working class at its militant, pre-war peak. The same holds for that other contrapuntal peak in twentieth-century generational warfare: May 1968, when bourgeois parents and bourgeois children found themselves 'on opposite sides of the barricade', as French critics claim. For later *soixante-huitards* reminiscing about the experience, 1968 might have looked like a youth victory in terms of mores and values, but the victors are now aged hoarders of wealth, more skilled at shutting out the youth than their own adversaries in the 1960s.

Today, once again, generational debates carry something fatally unwinnable about them. Millennials protested more than any generation before; in fact, there are estimates that in the years

2008–2022 we have witnessed a global record in protest activity. Unlike the cohort of Gen Xers who were deeply averse to group membership and found political engagement tasteless or outré, millennials were more than willing to bargain by riot. At the same time, the long decade of protests also partook in, and accelerated, the decline in organizational life that has marked the era of free-market dominance. In a world in which culture warring, digital demagoguery, and fleeting clicks have become the main mode of political engagement, the millennial presents a strange type of militant: dedicated to institution-building and collective action, but hardly inhabiting the strong organizational forms of Mannheim's radicals.

The potent blend of loneliness and agitation might go a long way in explaining the distinctly moralistic sensibility for which the millennial generation has become notorious. To be millenial demands a strong moral posture, but it offers very few tools to channel the commitment in question into anything sustainably collective. Moralism alternates between a luxury and a deprivation for those who do not have to aggregate and publicly negotiate their preferences. Millennials were confronted with a distinctly new mode of interaction between public and private: energetic yet diffuse, modeled on the fluidity of the online world. The mass politics which Mannheim witnessed is hard to detect today; as is the post-politics so characteristic of the 1990s, when Gen Xers openly disavowed any political commitment and proclaimed the end of collective life. The difference between the generation-standard-bearing novelists David Foster Wallace (Gen X) and Sally Rooney (millennial) is a telling indication of the change. In Wallace's world political conflict has been evacuated from a public sphere in thrall to commercialism and advertising, with only madcap terrorists actively dissenting. The result is a void that can only be filled with acts of individual re-enchantment or therapeutic group therapy. Rooney, by contrast, operates in a public sphere in which politics has clearly reclaimed its urgency, and collective notions of class have acquired a newfound plausibility. But the resultant posture is still fundamentally one of self-expression: a character may serenade her

cleaner's proletarian credentials, another may declare she is a Marxist, but it's not clear what Marxist organization she's a member of.

The concept of 'hyperpolitics' may offer some clues for the post-2008 era in which millennials first acquired generational consciousness. Hyperpolitics is the dominant mode of political engagement in our twenty-first century: polarizing and intense, yet fleeting and diffuse; blurring the boundaries between private and public, but hard to translate into durable affiliation or commitment. In contrast to the mass politics of the twentieth century, hyperpolitics is an abidingly 'low' form of politics – low-cost, low-entry, low-duration and, all too often, low-value. The George Floyd protests mobilized millions only to disperse afterward; the climate strikes rocked schools from Germany to the US; a few months later, little but a memory of the movement remained. Like the short cycles of financial markets and new media, today's public sphere spasmodically convulses and contracts, without ever crystallizing into lasting organizational infrastructure.

Spatially, millennial hyperpolitics can be related to a society in which citizens find it easier to jump from one institution to another. Except for the workplace, leaving a family, relationship, party, grouping, or friendship circle has become a less demanding process than in Mannheim's time. Temporally, these exit options create a society in which all levels of our social life are increasingly subject to short-term logics. Friendships, marriages, jobs, and political engagement play out across smaller time spans. The changing coordinates of our working lives further incentivize hyperpolitical behavior: employees with no access to permanent jobs or savings will approach the world like investors approach the stock market, sinking and withdrawing their funds once the returns are no longer guaranteed. Atomization and speedup go hand in hand: people are more depressed in the new century, but also more excited; more atomized, but also more connected; more righteous, but also more confused.

The signature blend of loneliness and agitation has bedeviled many of the political projects in which millennials appeared to thrive, and even at times, lead. In the case of the Labour Party of Jeremy Corbyn, the secular decline in British union power forced young Corbynites to make a long leap over the institutions, all while building a political vehicle designed for quick electoral victories. Inside the party and its electorate, the gap between indebted millennials and asset-rich boomers could only exacerbate the tensions over political questions. Their shared opposition to the dogmas of austerity also hid difference: the coming wealth transfer would re-stratify the millennial cohort itself to a degree not seen since the 1980s, as assets are passed on to the wealthier members. The result is a long-term '*Buddenbrooks* effect': boomer wealth will trickle down to those lucky enough to acquire it, after which a comparatively smaller section of millennials will give it to their own children.

Millennials seem doomed to generational warfare: without the organisations and categories that once sought to treat the problem of inequality on its distinct, class-based terms, a fight between generations is now the only plausible option. The irony is that the increasing salience of generational categories provides a sociology for a world that has become less sociological: when all other forms of affiliation and belonging have become weak, generational divides are bound to resurface as a last resort. Together with race, gender, or ethnic background, generational markers imply a crisis of collective life rather than a remedy for it. As Mannheim himself never forgot, the persistence of generational thinking means that humanity hasn't fully liberated itself from biology: the struggle between generations, in this sense, is just another instance of the struggle of species. ∎

Eve Esfandiari-Denney

Nearly White Girl Girling on Behalf of Sonic Fluency

After purchasing a copy of translated poems by Forugh
Farrokhzad and a blue ceramic plate wrapped in white tissue
paper, I head home cold through the snow's mist-shapen road
forming one blank turn. It is early March, and as usual, I hope
to hear the spirit of my mother's native pessimism faintly pass
through a line of translated poetry. *If you break the speed of sound,*
sound itself disappears.
So as expected, I couldn't hear her. The translation just a weird
bird of itself sounding internet. However, it is easier to listen
without the intention of trying to know, so I wait in case something
is silvering through. The tube to Bethnal Green in seven minutes
and the poem speeching like:

<p align="center">★</p>

'Dark are lamps of relationship / Dark are lamps of relationship.'

These lines are ok. They remind me of two dimmed out hearts,
or beyond a dark garden on a private road. And it's not exactly like
my mother was clear in her relationships, nor were her
relationships a way to pile dead stars in the drawer.
But 'I am depressed / I am depressed / I go out on the verandah'
doesn't quite scratch her itch.

★

The first time I visited her bedside at the psychiatric hospital,
I was six. It later became an ongoing habit to roll down a green hill
beforehand. I try to forget how hard it was to do, but it did instil
trust in me that the sound of my body on the earth, was a parable
of speed to the earth. My fluent and fast rolling was to believe
If you break the speed of sound,

★

sound itself disappears. I gather some momentum to say, if my
mother wasn't dead it would no longer depress her to be first to
the municipal swimming pool, towel down. First to the public
event programming meeting involving an ongoing saga with the
local council, a nearby wet hat wrapped in a split plastic bag,
needing to be replaced by another plastic bag. It was ultimately
things like her refusal to trust white psychiatrists, or when she
brought an entire cucumber to ride the London Eye that would
cue my Nan, or my Madar-joon, to mispronounce the situation as
'the London Eyes'.

★

One afternoon we found ourselves together on this monument's
rotation. Madar-joon expressed what seemed to be a particular
Persian serenity, followed by anxiety, as she tried to take in
the entire view all at once.

I can't approximate where Farsi fell most silent here,
but there was a draft in my cheeks.
I broke the speed of sound to Madar-joon like, *you don't need to
memorise it all, Madar-joon.*

I would do this for her fear of calories, her fear of wearing a
certain pair of shoes in the living room while the news was always
on, and the smell of boiled white rice remained unventilated.
Madar-joon wanted to mention how a distant cousin Soraya has
a friend dating the George Michael of the Arab world, Amr Diab.
But it's difficult to do that. *Dardet to joonam* means *may your pain
hit my body.* It is a way to say 'I love you' in Farsi, and I've
wondered if that is indicative of how Persians are so ready
to receive love.

★

Yet here I am in my dilutions, light-skinned and eating a yogurt, so far away from my cousin on the sofa telling me I open fruit wrong and shouldn't put *Dardet to joonam* in a poem, with no further explanation. I didn't contest this at the time, but I am now.

I would like her to know, there's something to be said for how a gene might bend to its historic desert, or bend to a stack of found letters documenting a husband's affair leading to a succession of women with the same strong calf muscles.

★

My face is an archive of my previous faces by this logic. Therefore, when its Sunday afternoon and I'm in *Spa room 3*, about to undergo an appointment with a vortex healer, his specialism in co-morbid depression, I refer to my 'past lives' as all the lives that lead to my singular life. Whereas the vortex healer, a man called Andrew with a voice that behaves like a deep blue light, is saying the soul reincarnates beyond the bloodline. Despite our spiritual differences, I lie down on his white-paper table as he confirms I was once an ethereal Sumerian servant who never had the opportunity to speak.

★

And it's not like this news results in a cycle of seasons in me, but
as his hand hovers over my throat chakra it has me wondering
If you break the speed of sound,
sound itself disappears. Is poetry, then, just like the line of silence
behind me, is it an indirect impulse to speak. And is my real
speaking containing a condensed software of breaths, the
knowledge of my voice just under this finally and waiting, leading
up to this, to this wanting to break the speed of, to this so nearly
white.

★

When the tube arrives at Bethnal Green, I look down at my lap
to see the white tissue paper has begun to unfurl from the plate.
Meaning, the coloured plate is visible, its blue shine holding light
like a lacquered ghost. Despite feeling unqualified, and in a bid
to return home, I remove the plate from the shopping bag. I raise
it above my head inside the cramped carriage to show anyone
the pre-emptive sound it expresses, as if articulated by
materialised form; it's unrestored, nearly white circumstance.

ADAM WHYTE
Untitled

YR DEAD

Sam Sax

I can't make heads or tails of it, the goat on the corner of Union and Metropolitan. Of course, I've seen stranger things, living in this city: the Chabad men dragging a straw effigy down Myrtle Avenue cursing each other in Yiddish, the woman selling infant-sized dolls made out of her own human hair, the apartment fire at the popular Chelsea orgy – flames licking up the side of the building like the cheap wig of some messy god. But this goat, mottled gray coat with a short white beard, is just standing on the corner chewing on some long grasses that appear to materialize in his mouth as he chews. It's 7 a.m. and commuters walk past without noticing. A group of boys run by on their way to school, trailing their baseball gloves behind them like giant leather hands. The elder waitress in ancient caked-on makeup smokes outside the terrible twenty-four-hour diner, looking deep into the distance, not about to be bothered by goats.

I pause only a moment; the twin slits of its pupils reflect back traffic, pedestrian and automobile alike, all seemingly uninterrupted by the wildlife. And though I can't be sure, it almost seems as if people are passing straight through its still body. All I've ever wanted is to belong somewhere, and all I can ever feel is how out of place I likely appear. So, in this spirit I too walk past the goat as if it were a normal part of the landscape; I too accept what's in front of me and

what is to come as I head down the subway steps. I leave behind the borough, and the animal, and that older man's fancy apartment, wearing his stolen French shirt after abandoning my own, pit- and popper-stained on his bathroom floor, knowing full well I'll never have to see any of this ever again.

Weekends we drink forties on the flatbed of Edwin's stepdad's blue pickup. Behind the 7/11 after dark, anything is possible. The we's always me, Edwin, and whatever collection of shitheads decide to gather that particular evening. I say shitheads but mean only boys. I say boys and mean some kind of mollusk, hard-shelled with tender meat inside. We get the beer with Edwin's fake – says he's from Iowa, twenty-nine, and his newly grown mustache offers a little wink. I use the money from my allowance, even though he's got more, and we sit and drink until the police are called or we get bored.

These nights are endless, years blended into a stretch of asphalt, into Olde English bottles smashed into showers of light, into shadowboxing as our shadows cast huge kissing shapes below the parking lot's uniform sodium streetlamps. And Edwin smirks through all this like nothing could possibly touch him unless he invites it. Timid grin, fat lower lip, thick eyebrows below his midnight-blue Yankees cap. At night in bed, when there is only my dark ceiling looking down at me, his face floats there, taking up the whole faux stucco surface, unnaturally big, eyes like two dimming headlights, his mouth a car door opening as if to say: Get in, queer, doesn't matter where we're going, I'm driving.

My final year coincides with the Clarion dung beetle being wiped clean off the surface of the earth. The last beetle was a spinster living beneath a stone bench in Calvary Cemetery you can see for a second crossing the Kosciuszko Bridge out of Queens. The beetle has no offspring and prefers to be left alone, so when this one dies it takes

its genetic line with it. We're both the last of our families. This year is filled with bad news about the weather. News about new diseases in birds and mosquitoes. This year I illegally sublease a basement apartment in a giant pre-war building in Queens at least four degrees from the original leaseholder and thumbtack photos of all my friends, those I've lost and the ones I've haven't yet met to the drywall. They're either Polaroids or photos I print out using an app that makes the pictures look like old-school Polaroids. Outside my window is a Citgo sign I pretend is a rotating orange and blue moon. Late at night I kill the lights and look up at the men gathered below it bumming cigarettes, talking shit, listening to each other's voices, responding with their own, I laugh along with their jokes. Do my best at performing the human ritual. Some nights I add my own humor to the darkness: Get this, guys. Knock knock: this is it.

At the last protest before my last protest I grow nauseated by the pageantry – the photo-op signage, the 300 dollar jackets with political slogans pre-sewn-in, the mind-numbingly repetitive chanting. Maybe the problem is that I understand too well. This is a salve for practitioners and the easily sated. Supermarket sheet cake for the choir. We're gathered outside one of the president's many towers, a handful of barricades have been prearranged for us to march in circles inside. We are yelling in this penned-in section of fencing while traffic moves freely around us, demanding justice as business goes on undisturbed. And even as we say these same words over and over, it's clear we each have different definitions of what justice, and freedom, and power mean. What I know for sure is any word repeated enough ends up meaning nothing.

A group of friends ask me to take their picture. They're laughing until the lens is trained on them and then, behind their signs, they make serious and severe faces for the internet. One of the girls compliments my anti-cop shirt (which I bought on Amazon) but not my makeup (which I stole from Sephora). There are official cameras

surveilling us. The cameras stand in for police while the actual police sip free coffee in their cruisers.

To be here is to be alone surrounded by people – at once watched and invisible. Over these two hours we keep inquiring what democracy looks like, who owns these streets, and whether, if the people are united will they ever be defeated? The answers to me are clearly: not this, not us, we're not, and, inevitably, we will be. The demonstration ends after about the length of a movie, and everyone goes home feeling better – as if we've done something, as if something's been done.

I go home sick. Throw up my Burger King into the toilet. Check Twitter to see the protest trending for a moment, then gone.

It's happened again. This time at the small grocery store on Grand. I'm minding my own business, trying to navigate the labyrinth of dry-goods' bins and discounted plums, dodging new fathers failing to pilot their strollers and shopping carts at once. I have a red basket and am swinging its empty shell in my left hand like a small pendulum, a little metronome that keeps me grounded in the rush-hour chaos. I just wanted to pop in for something small to tide me over: bread and cheese, pre-bagged apples. But it's so busy, it now seems I've somehow committed to living here and am scared I might start getting charged rent. I'm standing in the checkout line for what might be several lifetimes before I see him. Stupid, I think, stupid and shake my head until the produce blurs into oil paint. I go ahead and bury myself in my phone: open the grid of hungry torsos, twenty likes from some new stranger on Instagram, rearrange some candies. By the time it's my turn in line, it's clear the cashier boy both is and equally cannot be Edwin – I triple take, blink hard again, and yes, the nose is slightly different across the bridge, and he has those thick glasses that make his eyes seem bigger, almost like an insect's. He's still in his early twenties which of course he wouldn't be now after all these years, smiling; not being dead.

Even our most direct family line is split like a tree with a vast underground root system. One living organism of quaking aspen in Utah, for instance, stretches out across 108 acres. Each trunk represents a whole life. You can trace your finger across the knotted roots and pass through different worlds. Most of my dad's family lore ends half a century ago with a drunk, so he invents for me older odd folk tales, but if you do the simple math, just four generations back requires sixteen different people who suffered and laughed and made love out of nothing. They fled Russia, Poland, Yemen, Lithuania, and then there were thirty-two. On paper at least, when we left Egypt, there would have been tens of millions, though inbreeding and genocide throw a wrench in the lugwork of that math. According to biblical testimony, which is always to be trusted, it was 603,550 Israelites who fled to wander the desert, which outside a miracle could never support that much life. But what else is life? Besides blood, what ties us? Sometimes miracle is just another word for naming precisely what already exists. Thus, the villages and cities are many trees and many of them are gone, felled by time and fire, but the root system spread across Yiddishland and Palestine and Egypt and France and Brazil and Argentina and here in America.

When at last I die my xylem floods with all these stories at once and I'm so full I break into scripture, into sweat, into four unique seasons.

I'm wearing a sweatshirt that says USA. It's red and the text across the chest is blue and white. I buy it off a street vendor, and even though it's only 9.99 I offer him the whole contents of my wallet. Nod my head up and down at his look of surprise. I unbutton that man's expensive shirt with its elegant French cuffs and stand there a moment, shirtless on the street. No one looks twice. I try folding the garment neatly but it keeps catching the wind so instead just lay it on top of a trash can in case anyone else might want it. I watch it fill and deflate as if a line of ghosts are passing through it. It's February, and

the weather is in terrible heat. Central Park's spilling over with families like a net filled with some species of iridescent fish. The light is light but not enough. I lift the sweatshirt over my head and put my arms through it how you'd dress a child. For a moment, my whole head is under the cheap garment, and it's almost as if I'm in a different world – a place where nothing is hurt, just a head moving slow through its red-cloth portal – and maybe on the other side we'll find a country safe and orderly, perfectly formed as an egg. But my head emerges through the hole, my arms slide through the sleeves, and I'm still here. Midtown, with all these two-legged fishes moving around me, staring into their phones. Tourists ordering hot dogs and snapping selfies in front of Bergdorf Goodman. People in athleisurewear barking into the same blue-glowing angler headphones. The shops thrive as the world burns, selling expensive nothing: Swarovski crystal chandeliers, computer wristwatches, designer pig-leather hats. I can hear the drums in the near distance. I can feel the accelerant, heaving and sloshing, at the bottom of my bag. ∎

Subscribe to *The Drift*!

"The lit mag of the moment."
— *The New York Times*

"A new gold standard for the literary magazine."
— Jorie Graham

"I feel implicated by this but it's terrific."
— Michelle Goldberg

thedriftmag.com/subscribe

SUSAN TAYLOR
Protecting The Crab, 2019

A GOOD FIRST MARRIAGE
IS LUCK

Sheila Heti in conversation with Phyllis Rose

P *arallel Lives: Five Victorian Marriages* by Phyllis Rose was first
published in 1983. Charting the lives of a group of famous
Victorians, the biography stood apart from other books of its kind.
Rose told the story of five relationships, following Jane Welsh and
Thomas Carlyle, Effie Gray and John Ruskin, Harriet Taylor and
John Stuart Mill, Catherine Hogarth and Charles Dickens, and
finally George Eliot and George Henry Lewes, at various points in
their marriages. The accolades, achievements and artistry of these
figures are well known, but what Rose chose to do, which was less
common and far riskier, was to take seriously the romantic events
underpinning their lives. In her prologue, Rose wrote that 'gossip
may be the beginning of moral inquiry, the low end of the platonic
ladder which leads to self-understanding', and her writing argued that
romance – the crushes, companionship and heartbreaks that inform
a life – is of equal, if not greater importance, than a person's career.

Parallel Lives has remained in print in the US for the last forty
years, but temporarily fell out of circulation in the UK. It was reissued
in 2020 by Daunt Books and the new edition featured an introduction
by Sheila Heti.

SHEILA HETI: I love *Parallel Lives*. I read it first in my early twenties, on the cusp of my marriage to another writer – a marriage which only lasted a few years. It's so different to reread it now, in my mid-forties. It's a much sadder book than I originally felt it to be. The situations we get ourselves into, the effect of the world's expectations on us . . .

I was hoping to ask you some questions about the book's creation, and yourself at the time you wrote it. To start, I'm wondering about the state of literary criticism and biographical writing, especially about the Victorians, and especially about unwritten women's lives, at the time you were conceiving this book.

PHYLLIS ROSE: During that first wave of seventies feminism, merely telling women's stories was a political act, and deeply refreshing. All information about women was a gift. This was the moment of great excitement about the diaries of Anaïs Nin, for example. And then Virginia Woolf's *A Writer's Diary* – such a pitiful sample of her whole diary, but so important when it was all that we had. So few autobiographical texts by women existed that it's hard to imagine now, when there are so many available.

Everybody (that is, every bookish little girl) had read Simone de Beauvoir's *Memoirs of a Dutiful Daughter*. Its very title was liberating: a daughter's duties merited being put up to the light and examined? There was also Mary McCarthy's *Memories of a Catholic Girlhood* and Anne Frank's diary and not much more. The same was true for biography. There was so little that every biography of a woman to appear caused great excitement. R.W.B. Lewis's biography of Edith Wharton was a landmark.

It quickly became clear that the biographies of women by men, however well done, did not hit the particular nail on the head women wanted to have hit. This had personal meaning for me because I had recently finished a biography of Virginia Woolf (published 1979) and I knew that Quentin Bell's biography was due to be published before my own book, *Woman of Letters: A Life of Virginia Woolf*. I was

convinced he would say all the things I had to say – how important it was that she was a woman, how important her feminism was to all of her work. But he didn't! It was a great biography, never surpassed in many ways, but it presented Woolf as a neurasthenic problem child. She was about to become the great feminist heroine of the 1980s, but Quentin Bell did not respond to that side of her at all. It was an important lesson, because I thought his book was a model of thoroughness and dedication.

Later, books about women's lives started coming out: Brenda Maddox's *Nora*, Stacy Schiff's *Vera*, biographies of Thackeray's daughter, Frida Kahlo, Willa Cather. I reviewed as many as I could, and you can find them in a little book Wesleyan University Press published called *Writing of Women*, which I gave the subtitle 'Essays in a Renaissance', because I thought there was a renaissance of writing about women. I also wrote about this (the flowering of women's autobiographical writing) in the introduction to *The Norton Book of Women's Lives*.

HETI: Were there specific books that influenced your writing of *Parallel Lives*? Besides the Quentin Bell, any models or anti-models; books you thought were well or badly done, or that yours was a reaction to?

ROSE: Lytton Strachey's *Eminent Victorians* was crucial to my understanding of how to use biographical narratives to make a general point. However, I also felt I needed to articulate some of those points and I am naturally averse to abstraction. So I made myself study Christopher Lasch's *The Culture of Narcissism* to learn to get comfortable in the realm of generalizing. I couldn't have written the preface without it! I would also mention Diane Johnson's *The True History of the First Mrs. Meredith and Other Lesser Lives* (about Mary Ellen Peacock, the wife of George Meredith), which pointed out that there was always someone else in the room besides The Famous Writer, someone who felt as intensely as The Great One but whose feelings tended not to be noticed or recorded.

Diane Johnson's work had a huge impact on my approach to biography – providing a model of biography with a feminist underpinning that was not didactic or ideological. The power is in the choice of subject, the camera angle.

As for the final structure of the book there was some arbitrariness and a certain amount of weariness, because my intention had been to write about six marriages. I had planned to include the Darwins, but I left them for last, and by the time I got to them, I just couldn't do any more. To some extent, the research and writing of the first five marriages had been like researching and writing five individual books. I just ran out of energy. It's a shame, in a way, because the Darwins' marriage would have been the only 'happy' or conventionally successful marriage, a marriage with children and a strong family life.

HETI: What was the reception toward the book when it first came out? Was it what you expected it to be? Did people seem to understand what you were doing?

ROSE: I expected nothing. I still don't. I am always surprised to find that some people actually read what I write, which has made for some awkward moments.

Parallel Lives received a tremendously enthusiastic review from Anatole Broyard in the daily *New York Times* ('brilliant and original'), the kind of review that makes a career, but after that the book didn't get much media attention. A Victorian literature specialist wrote a negative review for the *New York Times* Book Review (nothing new in it about the Victorians, she said), and Gertrude Himmelfarb, a conservative, wrote a negative review for the *New Republic* which I loved because it read the book as having political heft. I had little sense that the book was having any impact until twenty-five years went by and it was still in print, still being discussed in book groups, still being assigned by therapists to their patients.

In one particularly painful moment, I got a personal letter from a professor with whom I had studied nineteenth-century British

literature when I was, briefly, at Yale as a graduate student. I had sent him a copy of the book, and he wrote back asking if I really expected him to like this anti-Victorian, anti-marriage, and anti-male piece of work. I didn't think it was anti-Victorian *or* anti-marriage *or* anti-male, and the anger it had stirred in my former professor stunned me and upset me.

As I talked about *Parallel Lives* to various audiences, I found it most gratifying when people came to me afterwards and confided personal equivalences. For example: 'The president of the insurance company I work for behaved to his wife just like Dickens did' or 'My husband's cousin is just like Ruskin. He was shocked by his wife's body.' When I read the first chapter, 'The Carlyles' Courtship', at colleges and universities, male professors sometimes took the story quite personally and unkindly. None of us then knew the term 'grooming', but they seemed to feel I was pointing a finger.

My least favorite reaction was someone telling me they used to like Dickens, but now that they knew how he treated his wife they would never read him again. That was not at all what I wanted the book to do.

I wanted the book to expand sympathies and possibilities. But some people read it as making new demands. A French feminist friend turned on me for not living up to the ideals of my own book when I married for the second time. How could I marry an older man? she asked. He was preying on my youth! It was the oldest plot in the world. And my book had suggested we should live new plots.

HETI: It is so interesting to hear how books were received in the time of their publication, versus the life they continue to have. Just two weeks ago a friend of mine was over and I told him I had written an introduction to your book and he almost fell to the floor. He spoke passionately about how much he admired you and how important your book had been for him and his boyfriend. I know it has many admirers.

Have you seen any changes in society, within the relationships of the people around you, or in how women are more or less or the

same degree of free or unfree, since you wrote *Parallel Lives?* I always wonder if things get better or worse for women, or if they get neither better nor worse but just change shape?

ROSE: Are things better or worse for women? For middle-class women, definitely better. We still have not had a female president of the United States, but we have had female Supreme Court justices and secretaries of state, which was almost unimaginable when I was writing *Parallel Lives.* Women in any position of power were hard to imagine then, even in universities. As an undergraduate at Harvard, I only saw one woman give a lecture, and only once. At my own university, Wesleyan, women on the faculty were such a novelty (I was the fourth hired) that when my son was born, there was no maternity policy. Women with careers were still entering marriage with the expectation that their careers took second place to their husbands'. This may still be the case but is not the rule. I've seen much more flexibility about duties within the family – men more willing to take on childcare, for example. Gay couples being able to adopt children is a magnificent advance, also unimaginable until suddenly it was possible.

Parallel Lives came out when I was forty-two. I was more fastidious then than I am now at eighty. Having been a pampered, successful child, I was shocked by the realities of adult life, but I didn't think it appropriate to express that shock directly. I believed in Oscar Wilde's pronouncement: 'Criticism is the only civilized form of autobiography.' So *Parallel Lives* was my way of writing about my own experience of marriage and my observations of my friends' marriages.

The image that I use somewhere in *Parallel Lives* is that when you're playing tennis, you don't know that the wind is blowing until it's blowing against you. When it's blowing with you, you just think, *Oh, I'm really good at this,* and that's the way patriarchy works. What you discover as a young woman, when you encounter patriarchy in whatever form, is that there *is* a wind blowing and it's blowing against you.

At college, preparing for a thankfully unrealized life as a physician, I took Introductory Chemistry, and my section man (graduate assistant) told me after the final exam that I had done better than anyone else in the section. I said, 'Does that mean I get a straight A for the course?' He said, 'No. I can only give one A and Kent needs it more than you do.' This was a mystery to me for over ten years. Why did Kent, who happened to come from one of America's most distinguished families, need it more than me? It made no sense to me. Then I got older, then I got married, and this kind of thing happened more often, and feminism helped explain things. He needed the A because his life counted and mine did not.

My main guide to patriarchy was British literature, in which by 1964 I was getting a PhD. I wanted to write my doctoral thesis on Dorothy Wordsworth, but my then-husband, who was also getting a PhD in English literature and was much cannier than me, said that she was not an important enough subject to get me a good job. I then proposed Charles Lamb. Ditto. So I said, 'How about Dickens? Is he major enough?' and so I wrote about 'The Domestic Ideal in Dickens' Novels', which was the raw material of *Parallel Lives*, *Parallel Lives* turned inside out, or *Parallel Lives* without an idea in its head. That was 1966–8. The 'idea' part didn't come until feminism gathered force, in the 1970s. Fortunately, I did not try to publish my PhD thesis and wrote that book about Virginia Woolf instead. By then, the late seventies, I was ready to write about marriage, drawing on what I knew about Victorian literature and nineteenth-century writers' lives.

HETI: When you say you were more fastidious at forty-two than at eighty, do you mean as a writer or a thinker or in living, and what do you attribute this to? Is it bad, or neither good nor bad, to be less fastidious now than you were then?

ROSE: Perhaps I should have said that I was more 'discreet' when I was forty-two then, not more fastidious. I mean, I was unlikely when

I was younger, for various reasons, to write for the public about my personal life.

I wrote less discreetly, less transformatively, later in life. I came to believe it was a writer's duty to reveal what other people wouldn't. To tell everything. And especially to talk about the banalities which make up such a large part of life. In *The Year of Reading Proust* I was contrasting the way great art dignifies and generalizes life, as in Proust, with the randomness and insignificance of daily life as recorded in diary-style writing. That's what I thought I was doing. But it didn't work, that is, nobody else saw that in the book but me.

Is it a good or bad thing to be less discreet now than I used to be? I don't know. I may have other virtues now and I may be happier, but I couldn't write *Parallel Lives* now. I'm proud of the young woman who did.

HETI: I'm wondering if, after completing your research and writing, you felt differently about marriage, women's and men's roles, and the possibilities for our lives. Or did the writing and research result more in a confirmation of intuitions or inklings you had before you began this book?

ROSE: The latter. I had intuitions and they were confirmed by the narratives I saw in the material I worked with. I would say that with time I find myself more and more a fan of marriage, for all its pitfalls and difficulties, and I think that the popularity of same-sex marriage proves my point about new plots better than anything I could have managed in my own small life.

HETI: Why are you more and more a fan of marriage? Is it because you find yourself in a happier one now? In which case, do you see that as a matter of luck – the luck of a good match – or something about growing up and maturing?

As I mentioned, I was married for a few years in my twenties, and now I am with a different man who I have been with for more than a

decade, and though I have no desire to ever legally marry again, I feel more married in this relationship than I did in my actual marriage, in the sense of sincere commitment, and a feeling of my fate being bound up with his. When I was married, for reasons that are multiple and hard to explain (and at least partly that he was a writer and editor), I found it hard to have an independent intellectual life, to the extent that I wanted and needed to. With my current boyfriend – maybe because he's a criminal defense lawyer, maybe because of the way our personalities fit – I'm able to feel alone in my head; I can more easily maintain the richness of my inner life.

Speaking of new plots, I wonder if you've ever read the marriage therapist Esther Perel, who is brilliant. I was recently listening to a podcast of hers and it intersected so well with your book: it was about a married couple who divorced, but after their divorce they continued their relationship. Esther Perel deemed them 'still married, and just divorced enough'. They became happy as a couple only after they divorced because they both allowed each other separate freedoms. It was the word 'marriage' that had somehow prevented them from giving each other this, and from living a 'new narrative'.

ROSE: I know exactly what you mean when you say your ex-husband was a writer and editor and your current partner is not, and that this works much better, allowing you space. After my first marriage, I was never again attracted to literary or even especially intellectual men. I went for visual artists. I wanted my literary and intellectual life to be my own. I think it's important that you note the difference in occupation. Ambitious, intelligent young women tend to overvalue a mate who does the same work, but it's more likely a liability. A contemporary version of Dorothea Brooke and Mr Casaubon.

A good first marriage is luck. A good second marriage should not be. The overall tone of *Parallel Lives*, its attitude toward marriage, derives from my own experience as a young woman discovering that the person I thought was autonomous, me, once I got married, no longer was. I was part of a couple. That is a brutal transition in life. I

was too inexperienced to know at that age what kind of person would satisfy my emotional needs over the long haul. I hoped then and still hope that *Parallel Lives* might help other people make this transition, with a greater understanding of the dynamics of couples.

With time I have gotten more comfortable being part of a couple, especially now that I have lived for many years in a happy marriage. Being with someone who gives you room and lets you be yourself is the key, as you say. I was forty-two when I met Laurent. I was extremely resistant to getting married again, but it was evident from soon after he came to the US from France to live with me that it was working very well for both of us. Being old-fashioned and French, he just naturally assumed we would get married when we could. I don't think he ever even asked me! And it was just as well. I would have had to think about it. People, maybe all biological organisms, seem to work better when they have some stability and expectations for the future. That's part of what I mean by more and more a fan of marriage. Life is so difficult. It may take more than one creature to sustain one life. Even a cat helps. Certainly a dog.

Couples like the Carlyles who lived together for so many years, people who made each other, in some ways, so miserable, were nonetheless really and truly married – that is, they became something different together and the connection enabled them each to be even more themselves. I would say now that the terms 'happy marriage' and 'successful marriage' signal different expectations, and 'successful' is the more useful word.

When same-sex marriage was first legalized, I was astonished by how many gay men and women took advantage of it. I wasn't entirely enthusiastic about it at first, thinking marriage as an institution had so many problems, why spread it? But the answer is in the outcome. People seem to want to marry.

HETI: It seems to me that one of the great virtues of your book is that you do not generalize, but think about each person, each marriage, as its own creature; it makes your book a very true portrait of life. We

aren't examples of each other, or we shouldn't have to be. This gives *Parallel Lives* a very novelistic feel: you're interested in character for its own sake, not to prove some resounding thesis.

ROSE: Absolutely true and just what I hoped for. I wanted to let the story seem to tell itself, rather than beating readers over the head with points, which I think adds to the 'novelistic feel'. I went to great pains to achieve this effect, although what I saw as artfulness, *haut academia* sometimes saw as 'just narrative', 'under-theorized'.

HETI: How long did it take you to write the book?

ROSE: I'd say about six years, if you don't count the time I spent writing about Dickens for my PhD thesis. For the most part, I could only work on it in the summer and during semester breaks, as I was teaching full-time and a single parent. I could write in the summer and during holidays because my ex-husband took my son for those times.

The first chapter I wrote was the Carlyles' Courtship. The story came to me in the voice of Jane Austen. (My initial, very complicated idea, undoable, was that each chapter would be written in the style of an appropriate writer. Jane Austen was appropriate for Jane Welsh, for example.) The next was the Ruskins. I don't know if it's obvious, but I wanted each chapter to focus on a different chronological stage of marriage. The Ruskins were my newlyweds. Dickens was what used to be called seven-year itch and at that time was called a mid-life crisis. This structure broke down with George Eliot and John Stuart Mill, though it's there vestigially, and, like all structures, its importance is more for the writer than the reader.

Each chapter was like a separate book in terms of research. Although the letters I based the book on were published, and I didn't have to go to archives, it was a huge amount of research nonetheless. For the George Eliot letters, I tried to use a researcher, but it didn't work. Only I knew what phrase or detail would be useful to me. I

read all the letters myself and copied out by hand passages I wanted to quote. Pre-computer. I still think it's the best way to understand another writer.

The most fun – and the biggest challenge – was to write about Catherine Dickens, because the least was known about her. I had to create facts – by which I don't mean make things up but see in what was known that certain things deserved the status of 'fact'. The fact that Catherine was a plucky traveling companion for Dickens when he went to America. The fact that she was appreciated in America for her unassuming manners and easiness to please. Reconstructing the jolly home life of the Dickens family in the early years also was a great pleasure, like hunting for Easter eggs.

The preface was written after a few narrative chapters were written. As I told you before, I knew there had to be a more general statement and it didn't come naturally to me. So that was a lot of work and very slow going.

It was a huge benefit to me that I was writing this book while teaching at first-rate universities. I do not say this just to be pleasant: I had the benefit of minds much stronger in many ways and certainly more specialized than mine, both at Wesleyan and at UC Berkeley, and for every chapter I had my dear friend Annie Dillard, a master stylist and brilliant editor. She lived around the corner from me in Middletown. I sort of based George Eliot on her.

This is really what I meant when I said 'I couldn't do it now'. Not just that I'm old and unambitious but that I don't have those amazing intellectual communities supporting me and criticizing my work.

Coming to the ending of the book was one of the most satisfying moments of my life. I felt I was putting in the last pieces of a jigsaw puzzle. Everything fitted together perfectly. Governor Eyre and Ruskin! Carlyle's remorse!

HETI: I love what you say about the importance of other brilliant people supporting your work. That is very much the case for me,

too. It would be impossible for me to write without the feedback and support of good friends.

I was thinking, if you were both forty-two when you wrote the book and when you met Laurent, what does that mean? Did you meet your second husband in the midst of writing this book, meaning everything happened simultaneously – the disappointment of your first marriage, the writing of this book, and meeting a new man – so that writing the book was a way of unraveling all these thoughts and feelings you were undergoing? Or did you write and finish the book and feel transformed by the experience, and only then find yourself stepping into this second, new life?

ROSE: I was born in the fall of 1942. *Parallel Lives* was published in the fall of 1983. So I was actually forty-one when I wrote it. I met my husband in April of 1985, halfway to turning forty-three. I had already published *Parallel Lives* when I met Laurent. I was researching Josephine Baker for *Jazz Cleopatra*, my Paris time funded by Guggenheim and Rockefeller fellowships I won thanks to *Parallel Lives*. I definitely did not have marriage on my mind.

HETI: Part of the real power of your book is the sense we get of a writer sublimating writing and thinking about her own marriage into writing and thinking about the marriages of others. Now we are awash in women writing directly about their own lives, a mode which can become a little flat. Do you think something is lost in the contemporary resistance to sublimate – to think about our own lives through thinking about other lives? This came up for me as I was concluding the first draft of my introduction: that there is something to learn in your book about the depth we can get to when we write about our own life through the lens of other lives, as opposed to writing about our own lives directly.

ROSE: Thank you. That's very generous. But I would like to turn the question back, rhetorically, to the author of those wonderful

books, *How Should a Person Be?* and *Motherhood*. Don't you think that all literature involves sublimation of some sort or other? What you bring to a book from your own life does not make or break it. What matters is your art – sentence after sentence, paragraph after paragraph, chapter after chapter. Terms like auto-fiction may stir up interest in critics and readers, but writers will write what suits their talents and needs of the moment regardless. Proust was writing auto-fiction. Thank goodness he didn't wait for the term to be invented. I personally don't care where the material for a book comes from, so long as I enjoy the experience of reading it. I read fiction and non-fiction with equal pleasure. Even the terms 'fiction' and 'non-fiction' seem at times artificial. Norman Mailer signaled this many, many years ago when he gave the subtitle 'A Novel' to *The Executioner's Song*, his biography of Gary Gilmore, a murderer. The non-fictionalization of fiction goes back at least that far, to the era of 'the new journalism', another formulation which probably served some purpose in its time, like auto-fiction.

But I feel I am avoiding the direct thrust of your question: is something lost or gained by sticking with the personal, resisting sublimation as you put it. You do gain great power by rising above the personal. One of the most abused battle cries of my generation was 'The personal is political'. This has led to an ocean of banalities in public life – politics and journalism both – so that it seems every speech, every investigative article, must begin with a personal narrative. The personal is political only if you are a good enough writer or a good enough politician to make it so. If you want to know just how boring the personal can be, hang out with old people. It is one of the great tragedies of aging that just as every detail of every experience you've had in your life becomes precious to you, you have probably lost the ability to make it interesting to anyone else not assigned you as a school research project. You are desperate to tell *your* story, but your story, to your listeners, is 'the past', a place in which they have only polite interest or which they will mine for their own art. And that is how it should be.

HETI: I guess my final question is about the importance of legal marriage, or a wedding ceremony, in thinking about the couples you write about. In marrying a second time, you seem to be suggesting that there is something transformative or essential for you about the act of marriage. Is it categorically different for you – the long, committed relationship in which one never actually performs the marriage vows, and the couple which has formally wed? Can these two types of relationships be thought of together, as basically the same thing, or not?

ROSE: I know couples not legally married who could not be more solidly united as a couple for life. Some have children together, property together, in-laws together. It is certainly possible. When I was in France in the 1980s, it seemed quite routine for the Paris intelligentsia. French law may not privilege marriage. I don't know. But that is certainly not true of the United States now. Here, there is definitely a difference between legal marriages and unions not supported by the state. For one thing, maybe the main thing, the difficulty of divorcing makes couples more willing to ride out difficulties. To say nothing of the tax, insurance and loan benefits, medical, visiting and representation rights, and other kinds of protection for spouses, including the widowed.

Where the law is not actively on your side in marriage, legal marriage makes less difference, as is the case for undocumented people in the United States now. And it was the case, in a different way, for some of the women I write about in *Parallel Lives*. At that time, in Britain, women were legally disadvantaged by marrying. They gave up all rights to their husbands. They lost all their property upon marriage and could even lose their children. Powerful, clear-minded women like George Eliot and Harriet Taylor understood that they could work around legal marriage to their own benefit. Still, both got legally married as soon as they could, probably for reasons of social acceptance and status, rather than legal advantage.

As for me, I had a hippie boyfriend for many years. 'We don't need no piece of paper from the city hall keeping us tried and true.' Joni Mitchell's song, right? That was his anthem. But it wasn't true for Joni Mitchell and Graham Nash, and it wasn't true for me and my hippie. He always said, 'What's the point?' when I conventionally suggested we ought to be married, and so it was relatively easy to leave a relationship which, however wonderful for a time, would surely have ended in divorce if we had married and tried to stay together for the long haul.

One more thing I'd like to say on this question. Life expectancy was so much lower in the nineteenth century than it is today that, to some extent, death functioned as divorce does now, allowing more than one marriage in a lifetime. A long marriage is a work of art. Relationships get deeper the longer they last. But multiple marriages, whether legal or not, have their own art and depth. I would also suggest that even in a long marriage, especially in a long marriage, it can seem like you are married sequentially to more than one person.

HETI: That is a beautiful insight, thank you, Phyllis.

ROSE: Thank you so much, Sheila. Between us, something else was just occurring to me. Here again, the difference in our ages comes into play. At a certain point, legality is no longer the issue. Neither is love. I no longer wear my wedding ring, to signal something not to others (that I'm available) but to myself (that my husband is gone, even if I'm the only one who knows it). At ninety-eight, he is just not the man I married when he was in his sixties. He has dementia and is more a remnant than a person. Still, I am morally and practically responsible for him. We've transcended the legal *and* the emotional and reached a level of pure commitment. It's true for him, too. I am the only person who exists in his world. I am certain there are many other elderly people in similar situations, mostly with the women having to take care of the men. I don't know how the saintly people we see in movies and read about in memoirs do it!

HETI: That seems incredibly hard. I think this stage of marriage is very hidden from younger people. I'm sure most of the women (and men) who are in the same position as you also suffer in the way you do – I'm sure none of them are saints! But as you put it, it's a state of 'pure commitment', you can't really make the choice to leave. So, like women who find themselves unhappy at having chosen to be mothers, the only thing to do is to keep it to yourself. It seems too unloving, too selfish, to speak about it. And yet, it must be a hugely, widely shared experience. Thank you for telling me about your life right now. It's a continuation of the insight and honesty of your book, which has been so important to me and so many people; which has been such a teacher. I never before saw my experience as one that was so privileged. In a serious long-term relationship, you feel so psychically and morally and spiritually committed, but at my age, with my partner and I both in good health, there nevertheless remains a quality of freedom and choice that I had not quite appreciated until you described your situation to me now.

ROSE: Thank you. I said earlier in our exchange that writers have a duty to say what other people won't. And at my age, I want all the more to pass on what I've experienced, though I fear I no longer have the skill or energy to do it. ■

YOU'RE A LONDONER

Kalpesh Lathigra

Introduction by Guy Gunaratne

If you're not careful the past will follow you around like a rumour. For you, a third-generation child of an immigrant's son, it'll sound like a tired reminder: *oh, look how far we've come*. Boats from Pondicherry, Colombo Port, Kolkata, Chittagong, carried refrains from elsewhere: stories of casting outward, some expelled or fleeing, landing on homes in Harrow, Hounslow, Newham, Southall, or Brent. You'll shake your head, say to me: *I've heard this one before.*

In this city, yours is never the only story. Narratives of migration, settlement, assimilation, separation are shared across all communities. The urban mulch of South Asian, East Asian, Caribbean, African, Arab and Jewish families amass alongside one another; consequently, our myths come brimming. It's like in that play where the rabbi delivers a eulogy for a Jewish grandmother and says she was not just a person but a *whole kind of person.* The ones who crossed seas heaped with entire villages on their backs, a journey the young find difficult to imagine. I agree with the rabbi. For you, grand voyages no longer exist. For my parents, your grandparents, having left so much of themselves behind, travelling to the Mother Country must have felt like oblivion.

It'll be a while before you realise your grandparents are two of the most fascinating people you'll ever likely meet. Your grandad rode

nationalised rail when he first arrived. He stood amazed at the NHS back when it was properly funded, and the floors were still new. He used to smoke cigars, and his shoulders still shake when he laughs. Your grandmother, having arrived much later, can't tell you about the Grunwick strikes, or the Bradford 12, or the Bhuttos. She can tell you about Ravi Shankar live in London, after the Concert for Bangladesh. She can tell you about raising two boys while working shifts at a supermarket in Willesden Green. She can tell you about making do with what little she had, and how so much of her life seems a miracle.

Do you remember when the Queen died, and everyone went on about the history she witnessed simply by living? My mum's stories are like that except from the other side.

Of course, you'll never ask her. Neither did I at your age. I was all limbs and acne at seventeen, all Church of England schooling, stripey ties and busy sexuality. The point of life was to bunn parental opinion. I also had a sense that another form of inheritance could be gotten elsewhere. In books, cinema, music – Woolf, Beckett, the Wu-Tang Clan, Bresson and Scorsese. Anything my parents offered seemed overcast with conservatism. Perhaps all that tradition and religion felt worth holding on to for them. For me, it only meant everything needed to be fought over, defied, and then dramatically renounced. I kept pushing away, and my parents feared I'd forget them. *Why you have to be so different to other boys?* It forced a distance that threatened to become irreparable.

I am astonished to find that I've weathered parenthood okay so far. You haven't been easy. It's just that you haven't been as aggravating as I imagine I must have been. Much is due to the fact that we've spent our childhoods in the same city. I can recognise myself in how you navigate the place. How you code-switch the same way. *Mad how it just come out with the mandem, alie?* All those invented words inflected with heritages that are not your own. It sounds beautiful to me. It reminds me that a cacophony to some is harmony to others. Even the names of your friends are stuffed with syllables. We can both grieve the murals under Kilburn Bridge. When I mention Grenfell, you know what to say, and why it matters.

As we share our feelings of attachment, so too our estrangements. I notice the roll of the eyes whenever your aunties hand you a sequinned sari. Or when an Uber Eats driver, misplacing kinship in a recognised name, says: *okay brother, god bless, take care,* only to receive a stiff upward nod and a tight smile. I don't fault your indifference. I only worry about your incuriosity. I wonder what catastrophe you think might occur if you drop the pose. Same way my parents must have wondered about me.

I sense it's because you're so used to cameras being pointed at you. Having grown up at a time when your image is misapprehended as authentic, and your artifice mistaken as true. You always know exactly what to do with your hands, and it terrifies me. You never let yourself shrug, slouch or tremble. You never allow yourself a moment's spasm or blur. It bothers me because it was a blurring of identities that allowed for my own errantry. My generation was not as concerned with being seen or having our every posture interpreted. For you, an image makes sight sacrosanct. It wasn't always like that. We were allowed to corrupt our own images. We risked a certain blindness in exchange for reckless recreation. I remember one summer when everybody played Apache Indian in excess. We styled ourselves as rude boys and magpies, as cultural gluttons. Brown boys wore canerows. The Black girls wore bindis. We blundered. But then again, ours was a far more forgiving generation.

There was a photographer who took my picture for the *New York Times* once. I must have come off a little shy because he asked me to think of somebody that made me feel mighty. It was a prompt to get me to loosen up. My eyes must have softened after I thought of you. I was remembering a moment when I'd held you at the hospital. You were wailing away, and I was trying to soothe you, but I was exhausted. I was holding you in my arms, and perhaps out of desperation, I whispered the words: *duwa . . . duwa . . . shhhhh . . .* That word *duwa* meaning daughter. I'd never uttered the word in my life before that moment. *Duwa . . . darling go to sleep . . .* It was as if my mother had lifted my chin having known what to say, and had offered it up in a whisper. It made me feel strong.

Now it's *duwa* this, *duwa* that, *duwa, come give me a hug . . .*

When I was seven years old, my mother took me to temple in Croydon. I remember pointing at a carving of a worshipper on the wall, and I'd asked why the bodhisattvas sit like that. My mother told me it wasn't as simple as saying a bodhisattva sits like the Buddha in order to imitate him. It is because each one, in sitting cross-legged, recreating the Buddha's pose, his gestures and sayings, is bringing the Buddha back to life. That's all a person is according to our Buddhism. A collection of gestures, mannerisms, good and bad habits, repeated expressions. A person is a set of patterns embodied for a moment. It's all we remember after a person is gone. It's all a photograph sees. And sometimes, without noticing, those old patterns get folded into us.

A good photograph can reveal so much about those patterns. It can see more than *that thing you do with your hands*. More than the lines that trace your nose that is your mother's nose. It gets you laughing. Gets the way your shoulders shake when you laugh. I can see how easily you carry your contradictions. Your ambiguities. You never seem to doubt your self-worth. That assuredness, which might also be a pose, still lets you meet this city, this country.

Yours is a generation unashamed and appropriately electrified because you know instinctively what mine needed a lifetime to learn: to imagine yourselves into rooms that have never imagined you. That's why you'll embody the promise we expected for ourselves: to be a British citizen both exemplary and subversive, unrooted and unmoored, yet unburdened. How I envy your ambivalence toward belonging.

Those rooms change when you're older. Of course, I hope you get the grades and graduate into the schools we dreamed of for you. But I hope by then you will have realised the value of your complicated patterning. The strength of walking into an austere Cambridge chamber holding the knowledge in your head of both T.S. Eliot and El Saadawi. Shakespeare as well as Wannous. Having already stitched together Iqbal, Gopal, Said and Roy, Rimbaud, Jay-Z as well as Kano. All of it falling out your mouth in atypical flood.

Remember, however, that yours is not the only story. And woe unto you, descendants of first voyagers, with your English first names and surnames of many syllables if you allow your histories to follow

you around like mere rumour. There was an entire generation before you who chose to fly away and return, but we did return. We missed them. We wanted to know how to cook the dhal with buttered chillies. And now, at least we know the food. Can tell a good bhuna from the pretend in the City. But I wish I knew my mother's words for *don't forget me, my duwa.*

Don't forget to ask us. Don't forget to ask me what it was like to turn the century. Ask me what it was like to watch *Desmond's* with my father, the way we watch *Top Boy* together today. Ask me what it was like to see Arsenal win the double. Ask me and your mother what it was like to march against the invasion of Iraq. Ask why it meant everything to stand next to you two decades later, in Parliament Square on Armistice Day, with a banner you made for yourself.

You're a Londoner. Be a Londoner in every room. ■

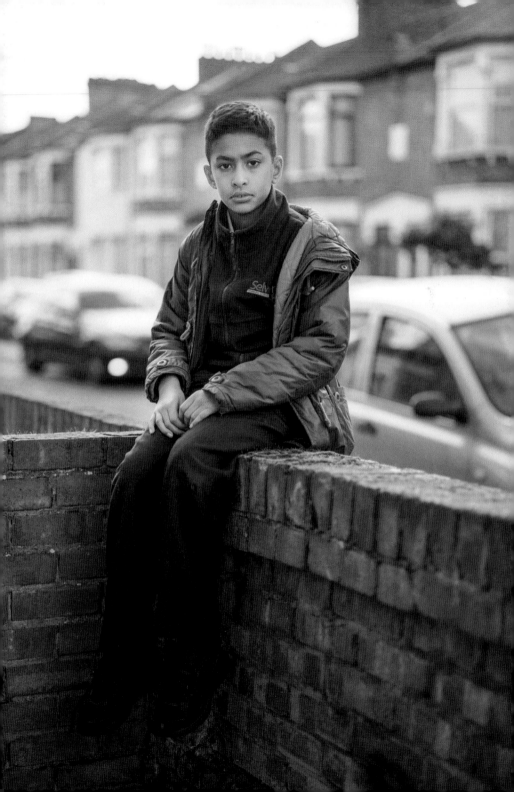

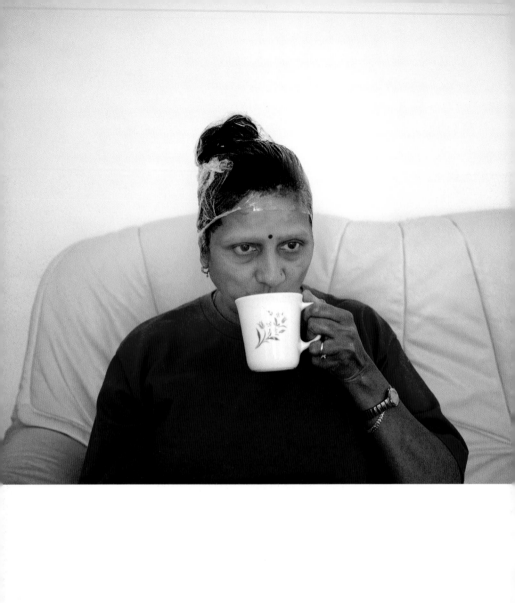

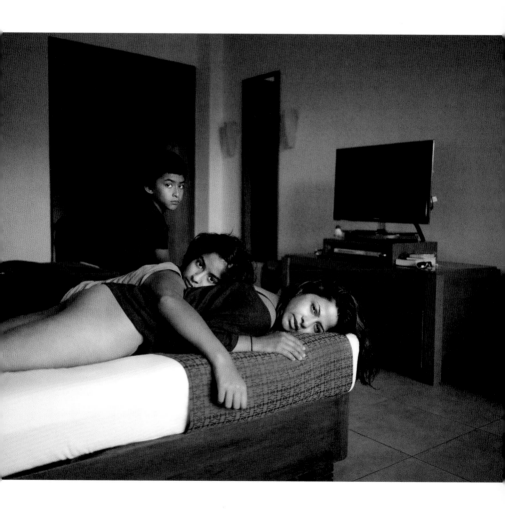

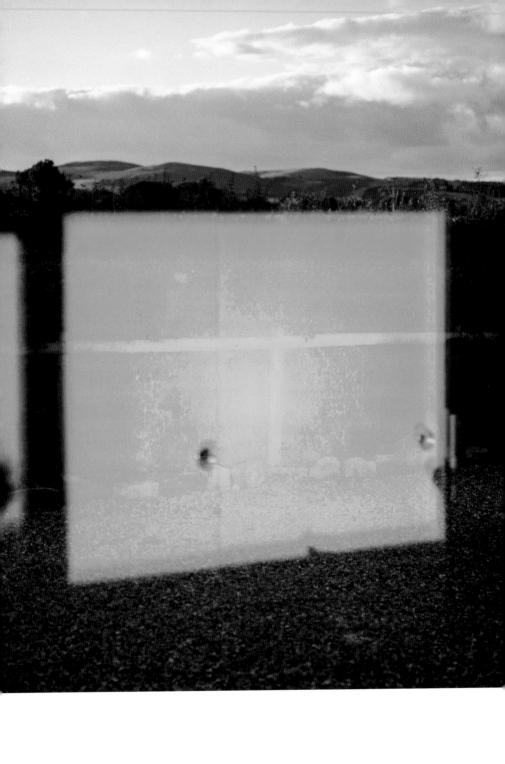

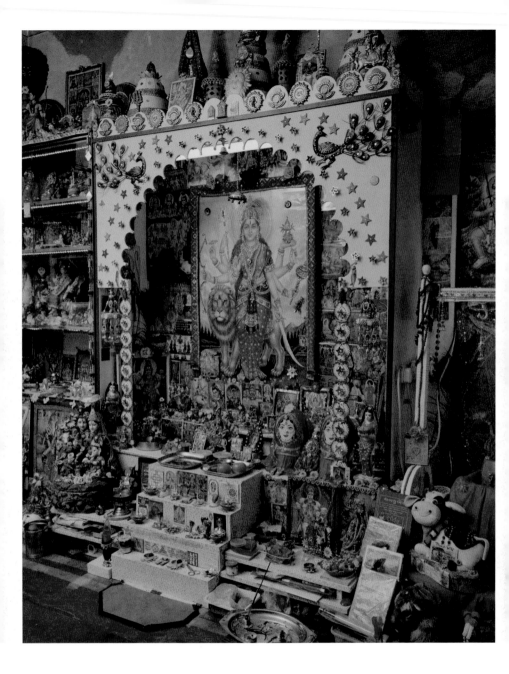

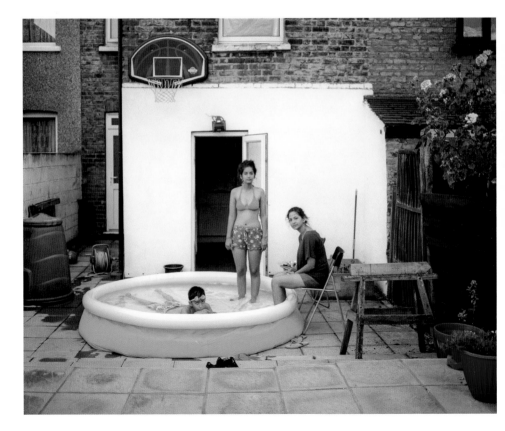

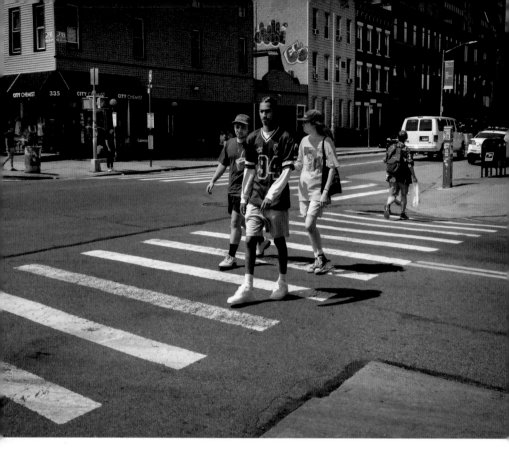

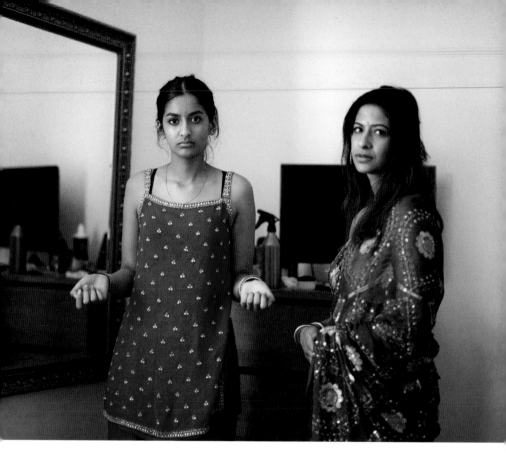

KSENIA MIKHAILOVA
Untitled, 2022

STALIN, LENIN, ROBESPIERRE

Brandon Taylor

That winter, Per was thirty-two and worked in a bookstore in
SoHo. He lived with a couple in a fifth-floor Hell's Kitchen
walk-up, where he slept on a pull-out in what they called the living
room but which was really everything that wasn't the narrow strip
of kitchen and the skinny bedroom. The toilet was in a closet and
the tub was in the kitchen. Per didn't mind sleeping on the pull-out,
and he appreciated that the lack of space kept him from bringing
books home from the store – strays, he called them. He stowed his
things in a corner behind a Japanese screen and on a clothing rack
behind the couch. He lived a tidy, monastic life amid the clutter of
the couple, who for the most part alternated between doting on
him like a helpless child and resenting his very presence with an
alienating silence.

At first, Per found this a little confusing, but a friend explained
that gay men over forty had a tendency to want to fuck you and
also make you porridge and teach you to tie your shoes, and in the
midst of this sexual confusion, they felt both rejected and parental,
resulting in a wildly swinging ambivalence. Per acclimated to this
strange weather, disappearing in the mornings and returning in the
evenings with fresh cut flowers or pastries from their favorite shop
or good coffee from the roasters downtown. They converted back to

their doting selves upon receiving these gifts like furious gods of old going silent at the burning of offerings.

There was no lease of course, and they might have turned him out at any moment, but Per did feel a real fondness for the couple. They made elaborate dinners, mostly Eastern European – Hungarian and Polish fare. Per always brought bread home for dinner because there was a very good French bakery near the bookstore, and it made him feel like he was in a French film carrying baguettes down into the subway. He liked that he had a role to play in their apartment life. Bringing bread. Clearing and washing the dishes. Unfolding the dining table. Putting away the dining table after they had eaten. Rolling their post-dinner joint and setting up the cushions by the open window so they could smoke. Watering the plants. Seasoning the cast-irons. Discarding the coffee grounds for composting. These things made him happy.

Still, seven months into the arrangement, he knew it was not a long-term situation.

For one thing, he could hear the couple fucking. Initially, they did try to go about it stealthily, but after his first couple days in the apartment, they said to him over breakfast, 'We'd like to fuck tonight. Don't come back until after two.'

Per had never heard someone be so frank about sex before. Not toward him anyway. He gulped down his coffee and practically yelled, 'Of course!' as he leapt from the table.

The couple laughed, both of them, and Per felt embarrassed at his response and his clumsiness. Ever since, the couple had simply started engaging in sex when they felt like it, even while Per slept a few feet away in the living room on his lumpy mattress. He listened to them coo and sigh and the squeak of the platform bed shifting under their weight. Sometimes he got hard listening to them go at it because they'd curse and gasp and make brutal, hitching sounds. But for the most part, their sex made Per sad because it was so soft and gentle and they seemed to know each other so well. It made him realize no one knew him that well, and probably never would. He never felt so lonely as on the nights when those two made love.

In the bookstore, Per worked from morning until evening, mostly down in the stockroom unboxing and cataloguing shipments. Breaking down the boxes and setting them out for recycling. Making sure that the deliveries of receipt paper and hand soap made it upstairs and into the staff bathroom, which he also cleaned. Then there was the dusting before hours and the sweeping after close. Checking the light bulbs and making sure that the books were mostly put back into place. He felt a little like Quasimodo, to be honest, scurrying around in the shadows, peering out at the real people who had come to buy books for themselves and for loved ones, for gifts, for leisure, for work, for clout on Instagram and social media, to signify to whatever part of the world was still sensitive to such signals that this was a person who read – what such a signal meant in today's world, Per did not really know.

One morning, pre-open in mid-November, Per's boss said that they would have a party at the bookstore. They were all gathered on the first floor for an impromptu team meeting. Per had been summoned up from his crypt.

'Like, a reading?' someone asked.

'No, a party. For the customers. To celebrate the start of the holiday season,' Imogen, the shift lead, said.

There was a murmur of unease. Per had his hands in the pockets of his apron. He was thinking about the boxes he'd left on the counter downstairs and making a list in his head of which shipments he should open first.

'I don't suppose we have a choice,' Anil, one of the senior booksellers, said.

'From on high,' Imogen said.

'I don't love, but I guess them's the breaks.'

'It'll be early December.'

'Are we . . . getting paid, at least?'

'Some will be working. But of course everyone is invited to attend.'

'So it's not a party. It's work.'

'Festive work,' Imogen said dryly. 'I know it's annoying. But please don't shoot the messenger.'

Imogen said they were free to go, and Per descended the stairs into the children's section so that he could cut into the back and resume his box duty. A party sounded nice. Working during a party did not sound so nice. But it might mean time and a half. And if he was on his regular stuff, then he'd be able to hide downstairs and avoid most of the trouble. That didn't seem so bad. Imogen called after him as he reached the middle landing.

'About the party,' she said.

'Festive work sounds better, I think.'

'I don't know about that,' she said, but then, sighing, 'It might be best if. We're going to be running a tighter ship that day. We'll be closing early to get the shop ready.'

'Oh,' Per said.

'It's not certain, but you might not. Be on. That night. But you would be totally welcome to come. And you know, be merry and bright. And. Secular in a seasonally appropriate manner.'

'Am I being laid off?'

Imogen frowned. 'No.' She descended the stairs and took his arm in hers and coaxed him further down. She glanced up behind them to make sure that no one was on the stairs and when they reached the children's section, she put her hand on his shoulder.

'I know how hard it is for you. These kinds of things. I spoke to Bette and she's said that you don't have to work that night if you don't want to.'

Per's neck was hot and his vision momentarily folded back and across itself, splitting everything in fuzzy doubles.

'I'm not an invalid,' he said.

'I know that,' Imogen said. 'I know. Look, do what you want. I just wanted you to know it's an option.'

Per's mouth was dry and he stared at Imogen's hand on his shoulder. She was older than him by about five or six years, but she had the steadfast and loose authority of a camp counselor, derived from a small yet intractable difference in age and experience. She had clear brown eyes and dark roots, but she was never cruel and she

was never brutal and she was always fair. He tried to remind himself that other people's kindness was not an indication of weakness on his part. He tried to remind himself of what his doctor had said. That it was okay for people to look out for him sometimes.

'Thank you,' he said. 'That's very thoughtful.'

She smiled at him and squeezed his arm. 'You bet.'

Imogen went back upstairs and Per went into the back room and he lifted the yellow X-Acto knife from the counter and slit the boxes in the way he had been taught, drawing its edge away from himself at a depth sufficient to cut open the box but not to harm the books. He kept his wrist loose but firm, trying to make sure there was no excess tension so that he could do this all day without injury to himself. Early on, he had held the knife so tight that his knuckles went white and his palms shook. The key was consistent pressure, not too much, just enough to let the knife stay steady and to let the sharpness of the blade do the work. Cutting was easy that way. And to move the blade away from yourself, not toward, as was his instinct. Why was that? he wondered. What made him want to draw the knife toward him? Why was it not human nature to draw it the other way? The biomechanics made no sense. God had put humans together in such a strange and funny way.

Per looked down into the box: *Frog and Toad.*

Just before lunch, one of the girls, Siva, came into the back to collect her bag and coat. She and Emmaline, another bookseller, were going to the restaurant down the street for lunch.

'Do you want something?' she asked.

'No. I'm all right,' Per said. She stood by the back exit for a moment, the denim jacket hanging off her shoulders. Per had been unboxing all morning and his hands were raw from handling the cardboard and shrink-wrap. He'd nicked the inside of his palm along the webbing between his thumb and finger. When Siva had come in, he'd been in the process of putting a Band-Aid there only for it to come off a moment later.

'It's best if you use the tape,' she said. 'High flex area.'

He looked at his hand and at the open first-aid kit. It seemed rather obvious now.

'Oh, you're right,' he said.

'Do you want some help?'

'No,' he said. 'I'm okay. I can do it.'

Siva put her jacket back on the hook and had Per sit on a stack of boxes. Then she wheeled a chair over and set about putting gauze between his fingers.

'Press,' she said. Per applied pressure and watched as she took the white medical tape from the box and did a couple quick, tight circles around and through. Then she secured it and checked her handiwork.

That close, he could see the red part of her hair, where her scalp was irritated and flaky. And he could smell something like oil and geranium on her. When she looked up, their faces were close, and he saw a ghostly white scar around the corner of her mouth.

'Thank you,' he said.

'You're welcome.'

They sat with their knees touching while overhead the early lunch foot traffic went groaning on.

'Are you excited for the party?' she asked.

'No. Yes,' he said. She laughed a little.

'I think it'll be fun. A good thing for people after the last couple shitty years.'

'And if it's not, we'll be able to say it is anyway,' he said.

'Now you're talking. Delusion is one of the best parts of the holiday season.'

Per nodded and looked down at the white bandage on his hand. It felt warm and tight. He felt looked after.

'Are you going home for the holiday?'

'No,' Per said. 'Not since I was in college. They don't. I don't. We don't handle it well.'

'The holidays?'

'Each other,' he said, laughing, snorting even, but then he saw that

Siva was not smiling and realized that he'd said something troubling instead of funny again. 'That's a joke.'

'Oh,' she said.

'Sorry. I'm. Unsettling.'

'No you're not,' she said. But then she stood and took her jacket back off the hook. She did not offer, as she sometimes did, another invitation or offer to bring him something back.

'I'm really sorry,' he said, reaching, but then taking his hand back when he saw her eyebrows raise and her eyes widen. He put his hand against his stomach.

'You're fine,' she said. 'See you later.'

The door always creaked like it was in pain when you opened it and slammed shut when you closed it. It made the small break room feel extra quiet and empty. He stood a moment in the echo of the door and tried to think about what he could have done better. Might have done better. He tried to think about what sort of person he wanted to be in this world and how he might bring that about. His doctor told him that he could only control his actions and not the feelings of others. But the kind of person that Per wanted to be was the kind of person who elicited from other people predictable, good feelings.

Per checked his watch and saw that it was almost time for Anil to take his twenty. He did not want to be around when Anil took his twenty, so he went upstairs to check the carts for re-shelves. Anil went down the stairs and Per sighed. Clem, another bookseller, spotted him watching Anil and laughed.

'He's not so bad.'

Clem and Per had come at the same time. For a little while, Anil had tried to make a joke of their names: pears and clementines, fruit of the loom, fruit bowl, stuff like that. But the puns lacked the snappy cruelty of a good inside joke and fell out of use almost immediately. Clem had gone to school with Siva and Emmaline – Bard College. They each had grown up in different parts of New York. Clem in Hudson, Emmaline in Westchester, and Siva in Brooklyn. Per, like Anil, was from Alabama, though unlike Anil, Per was from a small

town in Central Alabama whereas Anil had grown up in affluent Daphne, seven years later at that. Also, Anil went to Harvard and Per had gone to the University of Alabama in Huntsville to study aerospace engineering.

Sometimes, at night, Per liked to imagine the different trajectories they had each taken to get to this job in the bookstore at this particular moment in time. He assigned each of them a color and traced them with his fingers in the air.

'I don't think he's bad,' Per said. 'I just don't think he likes me.'

'He likes you about as much as he likes anybody.'

'That's the problem.'

Imogen waved Clem over to take the register so she could help a pregnant woman find a book. One of the older shift leads, Barbara, was doing stock on the computer. Per pushed a small cart bearing books through the art section and tried to wedge a monograph of somewhat terrible black-and-white photography back into place.

The strain made his hand sting and he glanced at the bandaging and thought of Siva. The warmth of her hand on his. The way she'd touched the tip of her tongue to the corner of her mouth. It was nice, what she'd done. He should get her a gift. Something that said thank you, we live in the world together. That fact didn't mean much to most people, but Per found it kind of miraculous. That of all the people who had ever lived, these people were alive at the same time as him. And he got to see them and be seen by them each day. How strange. It could have gone any other way. Really. There was an array of possibilities. Alternate lives. Routes. Choices.

But other people.

The cart had some poetry on it too, things picked up, read snickeringly and then set aside. Some people confused reading and literature – they supposed that these two things had a great deal to do with each other. This made for a lot of confusion because it prompted people to believe that reading was somehow the sort of behavior that was inherently good in a moral sense. When in fact the moral value assigned to reading had to do with the creation of the idea of

literature, which some people imbued with all the solemnity of the holy when in fact it was a middlebrow bourgeois anachronism created in universities and retroactively applied to some of the greatest works of human history. In that way, reading and literature were the same. Yet in today's world, reading had diverged even from these modest middlebrow origins and had sunk into some horribly populist activity.

A modern bookstore was perhaps the greatest example of this kind of fallacy. There were no true believers of this new religion, only empty-headed evangelists flogging the idea that all reading was good reading and that anything could count as reading, and anything could be literature, and that any reading was in fact reading literature and therefore morally unassailable, and in this way not merely morally good but also aesthetically good. There could never be a true faithful to such an empty string of logical transformations. Who could ever earnestly go on their knees in the quiet and the dark of their human soul and raise their face up and say to the vast and unknowable gods of that quiet inner darkness, Any reading is good reading.

Per did not read the books that were popular in the store where he worked because those books were books, not literature. They had very little to do with life and would not be read in five years. The books most popular in the store were popular precisely because of the hyper-localized nature of their idiom and the narrowness of their concerns. The books described a mode of life that would be utterly unrecognizable in a year or two. Or worse, they were about a generalized, abstracted version of the past that had been mostly cobbled out of quickly digested research articles and hazy family memories from across the diaspora. The contemporary novel as Per understood it was mostly about the self, but also about things that had happened to a family across many generations but also about Nazis but also about slavery but also about some obscure local historical atrocity that reverberated through to the present day and had shocking consequences for all involved but also about a painter on a train going to Prague and thinking about a bad man she had slept with once or thought about sleeping with anyway.

Unfortunately, Per was the kind of tiresome person who enjoyed Henry James and got emotional in the back of rideshares on his way to parties because he remembered the final words that Ralph Touchett says to Isabel Archer in *The Portrait of a Lady*:

'And remember this,' he continued, 'that if you've been hated you've also been loved. Ah but, Isabel – *adored!*'

More than once, Per had gotten drunk at a party or a bar with his co-workers and tearfully explained that this was the most beautiful moment in all of English-language literature to which someone invariably responded, 'Yes, but what about *Sula?*' Per did not have a comeback in the moment. He always felt that Morrison's poetic force was a different thing than James's. And part of what made the moment with Ralph so powerful was that it was James resorting not to his flights of fancy or interiority, but simply letting the character say what he needed to say to the person he loved most in the world.

Per checked his watch. When it had been twenty minutes, he went back downstairs. The break room was empty. Anil's jacket was gone and his apron hung in its place. He was probably smoking out in the alley even though they weren't supposed to. Anil's other preferred perch was up on the street near the restaurant where the girls were eating lunch. He could be such a pest. Per tried to take that thought back. To think of Anil in a good way. A kind way.

He put away the first-aid kit and checked the store email. There were some virtual orders he could pull. Some slips to fill. He was grateful for this small domain over which he reigned and for its hum of activity. Down here in the dark, amid the boxes and the rustling pages of books.

That night, after the shift, Per went out with some of his co-workers to the tapas bar across the street that had recently reopened after a long closure during the pandemic. Anil knew the owner because they had gone to college together at Harvard, which

Anil did not like to tell people except when he was drunk and feeling self-pitying. He was happy, actually, that he worked in a bookstore because it proved how fake the whole infrastructure of the American meritocracy was, since he, the son of immigrants, could work his ass off and go to Harvard and still end up working in a bookstore across the street from a bar owned by his classmate who had skipped most of his classes to do coke and coasted on family money. It was fine, actually, so fine, totally fine, funny actually, that he had a Harvard diploma hanging in his parents' house outside Birmingham, Alabama, and here he was in New York, selling copies of Glennon Doyle and *Braiding Sweetgrass* to stay in a studio apartment on Canal Street. There was something so beautiful in all of that.

Anil was already getting wound up, drinking mescal and recounting the days he and the owner of the bar had spent getting wasted and not going to PHIL 302 or whatever. The owner was skinny and a little short. He seemed not to know what to do with Anil's little speeches except to stand good-naturedly by and refill his friend's shot glass. He welcomed them all into the bar with a friendly, open air, and Per thought he seemed like a nice enough person, like nothing had seriously gone wrong in his life and so he had managed to reach adulthood with his capacity for kindness still intact.

Emmaline and Siva were talking among themselves at one end of the bar while Anil and Clem were at the other end talking to the owner, whose name Per now knew to be Chester. Per sat more or less in the middle with his glass of seltzer and lime. The bartender was tall and tan and he had a neck tattoo of some indecipherable creature that rose just above his starched collar. He was shaking margaritas for a table near the back wall. The tapas bar was elegant – marble and gold finishes. Everything was slender and sleek, polished. Running along the side wall was a black velvet banquette. In the summer and autumn and in good weather the windows opened out and up, creating a sense of al fresco.

They were in a decent part of SoHo, catty-corner to a church and a playground. In the springtime the trees were beautiful over the

sidewalk, and in the dead of winter the church rose high, dark and solemn over the street, imbuing everything with a certain Graham Greene-like aura. It was unseasonably warm for November, and Chester had called for the front windows to be opened, so that the bar filled with the sound of cars from the street. It was a little after seven, the primal dark of late autumn, but it was strange, with it also being so warm, and Per had the sense of being out of time. There was a quality to the darkness in autumn, so different from the darkness of summer or spring, deeper, somehow, richer in tone and temperament. It came so quickly, autumn darkness, that by the time it was seven it seemed like midnight, even though there was still so much day left.

Anil shouted, 'I just think it's mad wild, bro, mad wild, that you own this place! How sick is that!'

Chester shrugged and poured more mescal into Anil's glass. When he noticed Per watching, he winked.

'Refill?'

'No,' Per said, now feeling a little embarrassed because he hadn't even finished the seltzer he'd asked for.

'Are you doing a sober thing?'

'No,' Per said. 'I mean. I'm not sober. I mean. I don't drink. But, like, not like, systematically.'

Chester blinked slowly, then he said, 'That's cool.'

'Is it?'

This time, Chester flinched slightly, and Per wondered if he had been hostile. But then Chester smiled and nodded.

'I'm eighteen months sober. Systematically.'

'Oh wow,' Per said. 'Congratulations. Or. Not congratulations, that was probably rude.'

'No,' Chester said. He leaned on the counter and put his chin in his hands. 'It's nice. You're the first person to properly congratulate me on it.'

'Oh. Really?'

'I mean, I don't go around telling people. It's bad for business.'

'Then I won't tell.'

'I appreciate your discretion,' Chester said. 'Can I get you

something else? It's hurting my feelings the way you're hoarding that seltzer and not drinking it.'

'I'll drink it.'

'You don't have to. We have other stuff.'

Chester leaned back and looked down into the space behind the counter. The bartender had just finished shaking out more drinks and stood awkwardly by while Chester inspected their stores.

'Need something?' he asked.

'Just. Uh. Something for the, uh, chronically sober.'

'Oh, we keep the chocolate milk in the back?' the bartender said, pointing with his thumb to the swinging door. Chester stared at him coldly. Anil had stopped barking at the boys and looked their way. The girls too. Everyone was looking at the three of them, Chester and the bartender behind the bar and Per on the stool in the middle. He felt bad, like he was ruining the vibe in some way too subtle for him to really parse. So he gulped the seltzer down, and in doing this seemed to release everyone.

'See. He's fine,' the bartender said.

Chester scraped his teeth across his lower lip and flexed his hands a couple of times like he needed to shake something out. Then he turned to Anil and lifted the bottle and said, 'Don't stop on my account.'

The bartender poured whiskey sours and took them to the other side of the bar near the girls from the bookstore. Chester watched him go.

'Sorry,' he said. 'We're . . . still getting back up to speed.'

'It must have been very stressful, being closed.'

'Yeah. Something like that.'

Chester leaned on the bar again. Anil and Clem had come to stand closer to Per.

'I was telling them about how we used to skip class,' Anil was saying, starting the story again.

'They don't need to hear that one again. Change the station.'

Anil frowned childishly, and truly seemed to be casting around

in his mind for some other anecdote. It was kind of miraculous, this silence extracted from Anil. Clem laughed, which made the girls come back over too, and just like that, they had become a group again.

Chester watched over all of them, rather pleased, like a hen tucking its chicks under its wing.

'How do you like working in the store?'

'It's great,' Emmaline said. 'Well. It's a job.'

Siva laughed. 'It's more like a hobby.'

'At this pay, what's the difference?' Clem asked.

'Health insurance,' they all said mordantly.

'Technically,' Anil started, 'we probably shouldn't even be talking to you. After all, we are labor.' He drew a circle indicating himself and the other bookstore workers, then pointed at Chester. 'And you are an owner. This is bad Marxism.'

'What about the sheep lying down with the wolves?' Chester asked. 'Doesn't Daddy Marx imagine some great future where we'll all come together for the betterment of mankind?'

'That's MLK,' Anil said. 'Marx says we should put you against the wall.' He made a gun with his fingers and stuck the barrel between Chester's eyes. He smiled.

'That's Stalin,' Clem said, putting his own finger gun to the base of Anil's skull. Siva put her finger in Clem's ear and whispered loudly, 'Lenin.'

Emmaline rolled her eyes and put her finger under Siva's chin and said, 'Robespierre.'

They all groaned and extricated their fingers from each other's soft spots. But before they'd broken up, that continuous chain of human connection had made Per shiver. In the light of the tapas bar, Emmaline's blonde hair and soft eyes and Siva's sharp brow and delicate black ponytail, Clem's boyish pout and bony wrist, Anil's luscious dark hair and vibrant eyes, and Chester's good-natured blue gaze and placid expression – all of it had made him think of two paintings. The first by Goya, *The Third of May 1808*, and the second by Manet, *The Execution of Emperor Maximilian*. For the richness of

the color, the delicate humanness of the expression, the surging dark undertone of the subtext and the roaring animal scream emitting from its subjects. It was a jolt, the image of them all linked up like that, pretending to murder and butcher each other at the first moment of rhetorical weakness. Not because he thought they would do it. But because they were capable of alluding to a world in which it was possible to murder one another. Even after they had taken their hands away, Anil's finger remained between Chester's eyes, and the others had stopped laughing.

'Bang,' Anil said. Chester kicked his head back as if he had been shot. Lolled back dramatically. But Anil wasn't smiling. He turned to the rest of them and said, 'Did I tell you guys how I used to skip class with this guy?'

They were entering prime tapas time, and people were starting to come into the bar in order to ruin their appetites. New York ran on such meals. The fast, the expedient, the readily consumed while drinking.

Anil asked for a table, which Chester obliged in giving them. Per sat between Siva and Clem. Emmaline and Anil were on the banquette. The music was loud. The street was a little busier now, the bar next door and the restaurant across the street next to the bookstore had their lights on and their windows and doors open.

Chester had a rabbit paella sent to the table.

'It's a new dish,' he said. 'We're trying to expand our offerings. Be more of a small-plate situation.'

'Paella isn't small plate,' Anil said.

Siva pinched him under the arm. 'It looks so good.'

'Let me know if you like it,' Chester said. He was standing with his hands on the back of Per's chair, and Per could feel his weight pushing down. When he left, his hand grazed Per's shoulder. Clem was watching. Per focused on the paella. It was in one of those traditional pans, deep, flat on the bottom. They could hear, over the noise of the bar, the faint sizzling of the underside, the rice gone

crispy and dark. The rabbit meat looked juicy and rich. Oil glinted on the rice and the meat. Per felt such a vicious desire to taste the food that his mouth hurt.

'Check out Alabama Oliver Twist over here,' Anil said. 'You look like you've never even seen food before. What's your problem, robot man?'

'Shut up,' Clem said.

Per tried to manipulate his face into a neutral expression, but he did not know how to exactly. He hadn't realized that he'd expressed something with his face, and now he understood that he had shown his hunger. It embarrassed him. His face was hot again. And his neck hurt.

'Oh,' he said. 'I'm not really hungry anyway.'

Anil laughed.

'Seriously, man, shut up,' Clem said. Emmaline put her hand on Per's shoulder.

'It's okay, really, don't worry about him.'

'No, no, no, it's fine. It's funny. I'm fine.'

Anil reached across the table and slapped Per's chest with the back of his hand, 'Man, I'm fucking with you!'

But in doing so, he upset the dish and some of the oil in the pan lurched up its side and onto the table in front of Per. He jumped back, which made the dish lurch the other way, and lift briefly from the table. It returned with a loud clank. Per, having lost his balance, fell back in his chair and hit the floor, and the air whooshed out of his chest.

He lay there stunned, then, beneath the receding numbness, the burning arc of the chair back pressing into him, hurting. He groaned and tried to sit up, but the world grew dizzy, sloshy. And the others bent over him.

'Are you okay?' Siva asked.

Per turned his head to look at her. Tried to smile, but did not remember how exactly. The expression eluded him, and it was gone for so long that he thought he'd never smile again.

'Oh my God,' Emmaline. 'I think he has a concussion.'

Clem was crouching by him. Emmaline too. Anil had got out of the banquette and was standing over him. Per felt hot. Flushed. The air was too thick, too heavy. He really wanted to taste that rabbit. He swallowed thickly and sat up.

'I just need to catch my breath,' he said. His back still hurt. Then, throbbing, the base of his skull. He reached back to feel for blood, but found none. Still, there was a deep, splitting pain back there. He'd have a knot in the morning. He tried to stand, but felt dizzy again.

The music had stopped, and people were looking at them.

'Why did you freak out like that?' Anil asked. 'It was just some hot oil, man.'

Per stood and braced himself against the chair and tried to catch his breath.

'Come with me,' someone said. It was Chester. He had taken Per's arm gently in hand and was pulling at him. 'He'll be all right, please, eat.'

Per took his coat and his bag and allowed himself to be pulled along, his steps heavy and plodding. They went through a side door and out of the restaurant. They were in a dark passageway.

'Please,' Chester said. 'This way.'

The air in the passageway was cool and clear, and Per felt he could get his breath back. Still, he followed the pressure of Chester's hand and they went to the back of a hall and then through another narrow door and slowly up some steps. And then they were in what looked like a stairwell.

'Are you okay?'

'Yes,' Per said, nodding his head, but then the sharp pain made him stop. 'I'm all right.'

Chester looked him over, which required Per to look down since he was taller.

'My place is just up here,' he said. There was an elevator, thankfully dimmer than the stairwell, and they rode upward in silence. 'Sorry for being so presumptuous but you looked like you could use a breather.'

The apartment was spacious, there was that. It had big windows

for walls and a central sitting area with the same lush velvet and slender metal finishings as the restaurant. Below them, the city. The trees and the churchyard, the bookstore, and the buildings of the bars and shops. People in the streets. The darkness tinted blue.

'Sorry about Anil,' Chester said. 'Please, sit.'

Per did as he was instructed and sat, slowly, on the velvet chaise at the center of the room. The world had stopped spinning quite so much, but the pounding in his head was still going strong. It was in a counter-rhythm to his heartbeat, which made him woozy.

Chester gave him some aspirin and a cup of warm water.

'It's better warm, trust me.'

Chester stood anxiously over him while Per held the empty glass and stared down at the carpet.

'Should I . . . take my shoes off?' Per asked.

'No, you're fine. Actually, if it's not a hassle.'

Per laughed. Then he pulled his shoes off and set them neatly by the coffee table. Chester had already done the same, probably out of habit. And he'd been politely standing there while Per kept his shoes on, not saying anything.

'Did something happen to your hand?'

Per looked back at the bandage.

'Oh, yes. I cut myself with the box cutter earlier.'

'Rough day,' Chester said.

Per lifted his hand and examined it against the backdrop of the city. His throat was dry. For some reason, looking at his hand while his head hurt made him want to cry.

'Can I lie down for a moment?' Per asked.

'Of course.'

Per turned on his side and curled up on the chaise. It smelled like cedar wood. He pressed his face against the velvet.

'I'm sorry I made a loud noise in your bar. I wasn't trying to be disruptive.'

'You weren't. It's Anil.'

'Why do you let him act that way to you?'

'What way is that?'

Per had turned his head and could now see Chester watching him from the floor with an amused expression.

'I think you know what I mean. He is mean to you. Did you do something to him?'

'No,' Chester said. 'Well. Yes, long ago, I did something awful to him.'

'What?'

Chester sighed loudly. 'Do you want some more water?'

'No,' Per said. 'But can you tell me what you did?'

Chester leaned back on his hands and looked up. Per reached down and squeezed his foot. He was warm, this man, and firm. Chester looked at him, a little shocked, but then something softer came into his eyes.

'He wanted me to love him in a way that I couldn't. And I knew I couldn't. But I slept with him anyway. For a long time.'

'Oh, he's gay,' Per said.

'Yes,' Chester said, nodding. 'But that's not really what I did to make him this way.' His face was red, and he was again looking away from Per. This time, out the window at the building across the street, into its open, golden window where two people sat at a small table making dinner.

'What did you do?' Per squeezed his foot firmly. Chester groaned.

'Well, it made me so miserable, I went on a really bad coke bender and left him on a spring break trip to Aruba. Like. I left him there.'

'Oh,' Per said. 'Oh wow.'

Chester nodded slowly, his foot switching back and forth so that his toe grazed the inside of Per's palm.

'The funny thing is, he was totally understanding. Like, when he came back, he just said, Okay. And I went to rehab.' Chester closed his eyes tight and held still for a moment. His voice was cracked and raspy when he spoke again. 'The funny thing is. You're not going to believe this. But he wrote me letters. Not, like, sexy letters. But he wrote me these really funny letters. And at first, I really, really, really didn't want to read them. I threw them away. But this one doc at the

rehab saved them and about a week, two weeks in, he gives them to me. These letters. And I read them and they are so funny and earnest and I don't know. Sometimes you just. Need to know someone out there is thinking of you, I guess.'

Per's eyes got warm and he put his face against the velvet of the chaise again.

'Do you feel that way sometimes?'

Per did not answer. He kept his face flat to the chaise and then he felt Chester's hand against the nape of his neck and then the middle of his shoulders. He did not want Chester to see that his eyes were wet, but then he might ruin the velvet so he turned his head and Chester was looking down at him. He was on his knees, rubbing Per's back.

'Me too,' Chester said, then he sat with his back to the chaise. 'I'll just sit here a while with you. If that's okay.'

Per was not sure how long they sat there. Eventually, the pain in his head subsided. Some of the vividness returned to the world. And he was able to sit up. Then Chester joined him on the chaise and they sat there, Chester's head tilted over the back of the sofa and Per trying to sit as upright as possible. Chester told him about Harvard and about rehab and about failing to stay sober and about Anil and about second rehab, this time in California. They talked for a little while, but then Per got dizzy and Chester's phone kept buzzing. He excused himself to take the call in the bedroom and Per lay back down with his arm over his eyes, trying to quell the sense of whirring motion all around him.

He might have gone home, but the couple were eating dinner with some of their friends and would need the living room for most of the night. He might read in a cafe or go to another bar, maybe walk through the park since the weather was so warm.

'I don't think you can be left alone,' Chester said. 'I think you maybe ought to go to the hospital. You might be concussed.'

'I'm okay,' Per said. 'I can just –'

But then it was clear to him that there was no place for him to go. Other people had places. Other people had other people. That was

not a part of his fate. Per stood and walked to the window. His knees felt firmer than earlier, that was good.

'You should just stay here,' Chester said. 'You can, you know. I don't have to be downstairs. I can stay up here. Your friends have left.'

'They aren't my friends,' Per said, but then, looking at the bandage Siva had wrapped around his hand, he felt guilty. 'No, they are.'

'Stay,' Chester said. 'And if you barf, we'll go to Urgent Care.'

Per sat as he was told to sit. And he held his breath and waited to see if he felt like barfing. He didn't. He felt heavy and slow, but absent the urge to void his stomach. Chester sat next to him.

'The restaurant is busy tonight, but it's okay. I've got my mobile command center. Are you feeling okay? Need some food? More water?'

'More water, maybe?' Per asked.

Chester got him another large glass of warm water, which Per enjoyed, to his surprise. He was Southern and therefore accustomed to cold water. Chester said the warmth helped digestion.

'That makes sense,' Per said. He leaned back and closed his eyes. Again, he was struck by the thought of the Goya painting, the ghostly yellow and white, the grimy brown bleeding in out of the dark. And again that image of all of them pointing their fingers at each other, a chain of violence terminating in Chester whose crime was being rich. He was scrolling his phone now, biting the edge of his thumb. Per watched, and then when Chester noticed, he looked at him openly.

It was a disarming expression, totally receptive, without any hostility at all.

'Are all sober people like you?'

'I hope not,' Chester said.

'It's a little unnerving. Normally, I'm the one who unnerves people.'

'Why is that?'

'I'm,' Per started. 'I'm like. I mean, you notice how I am.'

'No,' Chester said. 'Not really.'

'I don't always handle people well. Or they don't handle me well. I find it hard to know what to say or do or to hide that I don't know what to say or do.'

'Oh,' Chester said. 'So you're totally normal.'

Per prickled, looked away. In the corner of the room, a slender golden lamp with a spherical shade.

'I don't think that's true. I don't need it to be true. I'm just. Myself. And sometimes I can't really. Mesh with people. They confuse me.'

'I'm sorry. I was being glib. I didn't mean it that way. I find it hard to speak to people sometimes without making a joke.'

Per's doctor said that jokes were a way to relieve the repression of difficult things and to sublimate those things into pleasure. They were an attempt at mastery.

'I'm bad at jokes,' Per said.

'Me too.'

'No you're not.'

'I am.'

'You're so funny,' Per said.

Chester's face reddened again. 'Yeah, whatever. Flattery, flattery.'

'I mean, sure, but it's true. You're funny. I like your jokes.'

'Have you even heard my jokes?'

'In the bar, you said thank you for your discretion. I thought that was funny.'

'You didn't laugh.'

'I did. Internally.'

Chester laughed. Per rested his head against the back of the settee. He wanted to close his eyes very badly, but he didn't. Chester got in close and also leaned his head back. They were looking at each other. Chester lifted a hand up and touched the soft space under Per's lower lip. The contact was warm, electric. They were not friends. They were not even really acquaintances. They were just two people in a room somewhere in the whole vast world of seemingly like temperament. They were leaning there looking at each other, now Chester touching Per's lip with his rough thumb and their faces coming nearer. Per held his breath. Chester kissed him. A little bit of animal tenderness, and then Per's lips opening and the slick warm wet of Chester's tongue and then they were kissing fully.

But then the movement jostled Per's head and the pain came back sudden and brutal, and he leaned forward and threw up between his knees.

At Urgent Care they sent him to the emergency room. Per lay in the bed on his side. His mouth was sour and his stomach was roiling. His head throbbed under the lights. The doctor had seen him and checked him over and thought he looked fine but definitely had a concussion and should schedule a follow-up with his proper doctor later in the week. In the meantime he needed observation. Chester told the doctor that he'd be on it.

Chester asked the doctor how long before Per could sleep, should he be allowed to shower, to drink, to watch TV, and more. He asked the doctor informed questions that made Per feel stupid and slow. Then, when he was discharged at three in the morning, they stood on the sidewalk. It had finally gotten cold. Chester got a car for them and Per leaned his head against the cool glass.

When they returned to Chester's apartment, they were greeted by the smell of Per's vomit. Chester wedged some windows open and stood by while Per showered. And then climbed sorely into bed. At each step, he insisted that he was fine. That he was okay. And at each step, Chester said that it was okay, he didn't mind, not to worry. In the end, Chester got frustrated and held Per down and said, 'Just let me be nice to you. Okay? You can pay me back later. Just relax.'

Per lay down. He thought about what his doctor would say. That not understanding why a person was doing something did not mean they were concealing some evil motive.

'You have to learn to trust people, Per. Not everyone wants to hurt you.'

Under Chester's blankets, Per turned to look at him. He reached out and took Chester's hand and he said, 'You aren't trying to hurt me, are you?'

Chester laughed. 'No, Per. No I'm not.' ■

NAOMI WOOD

PROPER COUNTRY

Ralf Webb

I am a moderately articulate member of my generation, state-schooled and Russell Group-educated, conversant in liberal discourse and conditioned, under the assumed threat of social exile, to hypervigilantly assess and critique my own spectatorship and relative 'privilege' in any given situation. And so, when I moved back to the West Country after almost a decade of life in London, I had my hackles up. On arrival to the village where I was to spend the next six months, I observed that it distilled something quintessential about the rural west, the landscape of my childhood and adolescence, that I'd sorely missed. It suggested a quieter, simpler existence: a life buttressed by beanpoles and wellington boots, life inside an almanac. But I understood that my interpretation of this pastoral *mise en scène* was condescending at best, and dangerous at worst. The rustic rural, I knew, is an illusion, a 'myth functioning as memory', as Raymond Williams put it, that has a vice-like hold over the national imaginary. All those rolling hills and deep green valleys – the gilded bales of hay and baaing lambs; the wisdom of farmworkers and simplicity of good country folk – these things are not entirely real. They exist in a country of the mind. The reality of rural living, I was to relearn, is far more complex.

My return wasn't a return home, precisely. The house where I grew up was sold well over a decade ago, following my dad's death. My mum and her new partner subsequently spent eight years living in neighbouring Gloucestershire, before relocating here, to a village on the Somerset–Wiltshire border, some ten miles from my home town and birthplace. This was a half-return, in a sense: I'd come back to a place that was proximate to the past without being completely saturated in it. Nor had the move occurred under happy circumstances; it was by necessity, not choice. Where some of my friends had emerged from the pandemic unscathed, where others had even thrived – securing promotions, getting married and buying houses – I found myself, at thirty-one, scarcely employed, broken-hearted, and unceremoniously shunted out of the capital. I considered this an unfair fate. I was a loser of the lockdown lottery, a rapidly ageing millennial, lousy with new-found and revivified neuroses, subject to the single tax and unable to gain any traction in my life in the midst of the cost-of-living crisis. I was in a slump, and wanted to stew in self-pity, alone.

My mum's return to the area was less equivocal. She'd found a job in a charity shop in our old home town, which meant bumping into people from a previous life on a semi-regular basis: one-time acquaintances, the mothers and fathers of my former school friends. They'd rarely recognise her. The moment you step behind a till, she said, you become invisible to most people. But this unlikely bridge to our shared past cushioned my sudden arrival in her present: it gave us plenty to talk about. After work, she'd provide post-shift dispatches – 'you'll *never* guess who I saw in town . . .' – and our conversation became rich with reminiscences, retelling local lore in order to restore our connection to it, and thereby each other. My stepdad wasn't entirely left out of these discussions. He'd take great interest in the shop's daily turnover, falling into deep thought when presented with the figure, as though the townspeople's thrifting habits expressed something profound about the regional psyche.

My stepdad – a retired engineer who sets store by shoe polish, Rothmans Silver, and his Black & Decker Workmate – seemed surprisingly easy-going about my arrival. And although he'd make quips about charging me fifty pence per shower and whatnot, I had to foist rent and bill money on him. There was no confusion in our relationship. He was wise enough – or kind enough – not to adopt an artificial role of paterfamilias, and for the most part we let each other be. I'd spend all day shut away in the back half of the converted garage, where a bar stool and knackered vanity table, elevated by stacks of books, constituted a makeshift office; he'd spend most of his time in the front half of the garage, where he'd established a workshop of sorts; the two of us separated by a thin plasterboard wall – and forty years.

But we came together at the dinner table, where our dynamic took on a different shape. He and I would occasionally find ourselves entangled in bitter disagreements over whatever happened to be in the headlines, each of us assuming the mandatory, opposing positions that culture wars, by design, encourage us to adopt. Often, I was more annoyed by the fact I couldn't convince him to alter his opinion on a given issue than I was passionate about the issue at hand. These disagreements would dog us for days, and conversation all but stopped. Neither of us acknowledged this tension, relying on the only woman of the house to re-establish equilibrium through maintaining a state of steady, reliable domesticity, despite the fact she was the only one of us also doing shift work.

M y mum and stepdad's house lies on the outskirts of the village. It's an ivy-eaten, post-war ex-council property surrounded by cropland, precariously placed on the side of a B-road, one of two such roads which, like cross hairs, bisect the wider parish. Along them, boy racers chase annihilation in souped-up hatchbacks, trailing clouds of vape smoke from souped-up vaporisers; while tractors, articulated lorries and army vehicles from the nearby MOD base tear up the tarmac. Despite its modest appearance, the house is sizeable.

It has 'good bones', according to my stepdad. The gargantuan back garden leads onto flat fields, which stretch for several miles, before an escarpment cuts across the horizon: the site of an Iron Age hill fort, stamped with a white horse. When they moved in, my stepdad was tasked with taming the interior. He repainted and re-floored the entire house, and sourced electricians to do a wholesale rewiring, slipping bundles of cash into their palms ('the old-fashioned way') so they could pocket the VAT.

My mum focused her energy on the garden, pick-axing away bamboo and reseeding the lawn, which was covered in dead patches from where the previous owner's dogs had pissed and bleached the grass. There was also the matter of the hot tub, installed atop a cement slab in the far corner, which absolutely had to be removed. The very existence of the hot tub was perplexing. She – and I, by extension – are from modest, Protestant stock, former members of the aspirant lower-middle classes, and allergic to ostentation of any kind. What kind of people, we wondered, would spend money on such a luxury, let alone have the temerity to install it out in the open air?

Finally, there were vermin. Rats had taken up occupancy under the rotten timber decking, and needed to be eradicated. Every conceivable tactic short of witchcraft was deployed: traps, poisons, ultrasonic rat repellents, culminating in my stepdad standing watch with his air rifle. He would sit outside, puffing away, sight trained on the rat runs – of which my mum, with the cunning of a military tactician, had sketched detailed blueprints – ready to squeeze the trigger. It took some time, but eventually the rats were exterminated.

The village proper is hidden down a hairpin lane half a mile from the house. There are Bath-stone weavers' cottages, a large farm and its attendant outbuildings, an impressive manor house, and a small church that dates to the 1400s. Its serene graveyard is full of crumbling tombstones, spattered with fallen yew berries, like so many little drops of blood. In an overgrown meadow lives a nag nicknamed 'Boots', his face permanently concealed by a fly mask. The place could be described as a chocolate-box village, if

not for the dozen or so modern homes of truly epic proportions that also line its single street, whose driveways are stacked full of SUVs and Teslas, and puncture any illusion that the village never escaped the nineteenth century. There's also a pub, set back from the B-road and ensconced by towering poplar trees. In gentle wind, the leaves flash like shoals of fish. GOOD FOOD, GARDEN, REAL ALES reads the sign, five words that spell paradise to the old boys who occupy the locals' half of the bar. The beer garden is usually quiet, criss-crossed by apple-fat fairy lights, with a flag of England strung limply on a flagpole. If an inquisitive drinker were to wander round the back, they would find, stowed away beneath a lean-to, three wooden statues carved from tree trunks: racist caricatures of Black jazz musicians, replete with exaggerated facial features.

At the last census, the population of the wider parish was three hundred. Ninety-eight per cent are white, the majority over fifty, and most identify as Christian (the Islamic faith is represented by a single self-identified Muslim). As though to allay any doubt as to the parish's denomination, a man-size timber crucifix stands at the crossroads. It used to be a source of great local pride, until its century-old, metre-tall, solid bronze statue of Jesus – complete with bronze 'holy nails' for rivets – was stolen several years ago. The Jesus heist was no hack job, I learned, but had been carefully planned, and the culprits are rumoured to be local. Not *local* local – it's inconceivable that anyone's immediate neighbour would have committed such heresy – but from one of the less affluent towns nearby.

The closest bank, supermarket, post office, and doctor's surgery are located in a much larger riverside town five miles away, which is almost completely inaccessible except by car. There is a bus, but it makes just one journey to the town per day, departing at an ungodly hour in the morning and returning at noon. Despite this economical schedule, it is so unreliable that no one bothers to use it. In short, this is proper country – or 'the sticks', as my stepdad would say – isolated and relatively cut off.

When I arrived in autumn, the village was undergoing two seismic changes. First, the landlord of the pub and his family were leaving the area for good. This barrel-chested, blue-eyed, ruddy-faced innkeeper – the kind of man for whom several pints would constitute an aperitif – had helmed the pub for many years, and his departure was lamented. The pub lay empty for a month before the new landlords moved in, a younger, married couple from Bulgaria. The gravity of the second change to village life can hardly be overstated: a family of Travellers had bought a plot of land from the farmer up Love Lane, behind the pub, and established residence, precipitating an immediate, parish-wide panic.

Anyone who has spent any time lingering in 'proper country' will understand this point. The Gypsy, Roma and Traveller communities are the target of a seething, unconcealed racial hatred, and pejoratives and slurs directed towards them flow freely from the lips of even the most progressive ruralite. With the Travellers' arrival came discussion and debate. How many were there? Had the landlord left because of them? Were the Bulgarians somehow wrapped up in it all? In this mire of confusion and suspicion, the hand-wringing wetwork of local government got going, and the council sought legal advice to evict the Travellers. The Bulgarian landlords, meanwhile, were met with a frosty reception. In a Scrooge-like, cringing retreat, the villagers withdrew their patronage in those dreary winter months, leaving the future of the pub uncertain. It was a potentially disastrous act of community self-harm. A pub, after all, is one of the few 'British' institutions whose reality often lives up to its promise: a place of refuge, warmth and sociability – literally a public house – that lends soul and substance to a given neighbourhood. That the locals, so unnerved by our friends from the East, were content to let the beating heart of the community bleed out was astonishing. Even the five old boys decamped from their stools. Business, however, began to pick up again after two men from the family of Travellers started making regular visits: a reluctant realignment of villagers to public house that seemed more about reclamation than anything else.

One regular kept showing up, even throughout the pub's fallow period. A man in his sixties, whose milk-white pallor suggested a dire need for sun exposure, yet whose insistence on wearing a polo shirt and shorts, regardless of inclemency, implied that he lived, in his imagination, in the Mediterranean; an impression underscored by the ancient-looking coupé he drove. This pale patron would appear almost nightly, accompanied by an older woman, presumably his mother, who seemed unable to actually go into the pub due to restricted mobility. Thus, the man would skip into the bar, emerge with two gin and tonics, return to the coupé, set them on the dash, mix the drinks, hand one to his mother, whereupon they'd clink glasses and drink, staying in the car the entire time.

My mum, stepdad and I would visit the pub perhaps three times a week throughout my tenancy, and my mum and I were quick to pick up on the pale man's routine, deeming it 'strange behaviour'. Perhaps we felt it necessary to put a distance between us and them. After all, our own routine was not all that different, was, in fact, a direct echo: she and I were merely a couple of decades behind. In making this judgement, we hoped to suppress the feeling that my return 'home' had set us both sleepwalking towards a future that resembled their present, which, we presumed, with no evidence but our own projected fear, was an unhappy one. Never mind that our routine was already more eccentric than theirs. We'd always opt to sit outside, for instance, even in the pouring rain, our collective desire to light up outweighing the minor discomforts of sodden clothes, cold hands and wind-blown hair. 'This is nice,' my mum would say, sincerely, as the rain lashed us. My stepdad would justifiably grumble, draped in an outsize raincoat, sage as a monk, the enormous hood shielding half his face, forming a dark crater out of which billowed smoke and cigarette ash.

The pale man and his mother sat in the coupé watching us, dry as a bone.

Our pub visits provided us with an opportunity for small talk. This usually amounted to regurgitated bits of news skimmed from a variety of sources: Sky News (stepdad), Channel 4 (my mum), Twitter (me). Each of us, for our own reasons, were casually boycotting the BBC. Later, at the dinner table, galvanised by cold cuts and excesses of mashed potato, this small talk would grow into something approaching dialogue in its truest sense, by which I mean an exchange of ideas. But the conversation was not exactly eloquent. With the generational gap, the unspoken and rarely tabled political leanings of each interlocutor, and my stepdad's partial deafness and oft-malfunctioning hearing aids, misunderstandings and misdirection were rife.

Talk on the climate crisis, for example, might start well enough. It went like this: 'The human race doesn't need any help,' my stepdad said, 'in killing ourselves. We're perfectly capable of doing so alone.' This was more or less a catchphrase of his, and although I'd heard it three dozen times in as many days, I nodded my head solemnly in agreement. But this didn't sit well with my mum, who, while acknowledging the dire straits we're all in, preferred to emphasise optimism over pessimism. Bored, impatient, leg jittering up and down, I saw this disagreement as the perfect opportunity to soapbox. Our obsession with extinction, I said, is really a desire *for* it; the truth is that, like the Žižek screencap I saw on IG, we're all 'perverts secretly horny for the apocalypse'. This stunned them into silence, enabling me to dig in my discursive heels. It's your generation's fault, I went on, luxuriating in a pose of bratty, latter-day teenage angst. What they're really mourning in their talk of climate apocalypse is their lost innocence, the innocence with which they sauntered through their lives blasting aerosols and burning diesel and manufacturing crap, an innocence that my generation never fully possessed. This is why the most vociferous XR members, I argued, are the retired, middle-class ones: they can't come to terms with their loss of innocence, and through protest hope to occupy the morally pure position of the white knight, and thereby reclaim it.

By this point my stepdad had, understandably, checked out, and was instead focusing on migrating a heaped spoonful of mashed potato from the serving bowl to his plate without spilling any. My mum and I continued the debate. Though she questioned whether my last point about older XR members was even true – it sounds like something you just made up, she said – I was convinced my diatribe, like the expanding-brain meme, was reaching its apotheosis. It's mourning all the way down, I went on, the 'olds' only care about progeny and bloodlines and the fate of their inheritances; they try to convince you you're a heartless monster if you can't empathise with the future lives of George Monibot's speculative grandchildren, or whatever.

'*Monbiot*,' my mum corrected me.

'Robots?' asked my stepdad. 'Are you talking about that article on AI?'

'What?' I asked.

'*Monbiot*,' said my mum, 'we're talking about Extinction Rebellion.'

'Lot of radicals!' he said.

When we talked like this, it felt as though we were speaking in a different language entirely, a private language, a wonderful kind of gobbledygook, and I thought that if anyone overheard us – if the neighbour was eavesdropping on the other side of the wall – they'd think we were literally mad.

I'd expected a certain amount of friction between me and my stepdad before I moved back. Apart from being an interloper, only emerging from a state of near-catatonic depression to crack wise at the dinner table, I was also an anomaly. My very existence complicated his understanding of the workings of the world. It was difficult for this man, who had retired after a fulsome career unmarred by redundancies or demotions, to fully comprehend what my 'job' as a freelance arts admin journeyman entailed. Still more difficult to explain that this was merely a meal ticket, that my actual, burgeoning career – I hoped – was as a quote-unquote writer; and that, despite not making much money doing either, I seemed intent on doing

both. Nor could I explain to him that my entire professional world existed inside a screen, or that, when I appeared comatose, staring goggle-eyed at my phone, I was really trying to nurture the only social life available to me out there in 'the sticks'. I'd help him navigate the digital-by-default facts of modern bureaucracy – obligatory online banking, QR codes in lieu of parking tickets, medical data locked within impenetrable NHS apps, and so on – but my obvious tech-fluency only accentuated his tech-illiteracy. Though I shared his opposition to digitisation, I had the luxury of doing so in the abstract, freaked out by the demonic data harvesting and surveillance of all these devices, yet insulated from the exasperation and alienation that comes from being unable to interface seamlessly with them. Exasperation because the vernacular of daily life had outpaced him; alienation because no one, nothing, cared or made allowances.

Though I'd long assumed this former pheasant shooter and *Antiques Roadshow* enthusiast was a cut-and-dried Conservative, the truth was more elaborate. I came to learn that although he is a monarchist, he is also secular, and actively detests the institution of the Church. Despite flip-flopping between Labour and the Conservatives for most of his voting life, he would choose to identify as a Communist, 'if only Communism actually worked'. In his view, rail, water and electricity should be nationalised, but any politician who suggests as much is likely a far-left extremist and can't be trusted. He voted for Brexit but wishes he hadn't, considers the Tories 'crooks' and 'racketeers', and will, more likely than not, spoil his ballot at the next general election. His not-unjustified, free-floating disgruntlement at the state of the world would, occasionally, require a host off which to feed, something concrete to latch on to. At times, it latched on to the Travellers, what the villagers – aiming for diplomacy, but achieving dehumanisation – had come to term 'the situation'. Though he didn't display the same fervour about their presence that I knew others in the village had, he expressed support for their eviction, and we argued about it intensely.

As spring came around and I prepared to move out of the village – a room had come up in a friend's flat in Bristol – the parish councillors and their solicitor, a coffee-stained pen-pusher from two towns over, mounted a legal challenge against the Travellers. The argument went that they were attempting to establish permanent residence, but hadn't gone through the requisite channels to do so – planning applications and so forth – and therefore should be evicted. After a site visit and public hearing, for which the Travellers had their own legal representation, the council's challenge failed, and it was found that no laws were being broken. This didn't end the issue. While the councillors sought to regather strength, new arguments and rumours about the Travellers circulated through the village.

A particularly fierce one emerged that they were involved in hare-coursing – an illegal blood sport where greyhounds are sent to hunt hares – though, of course, there was no evidence to support this. But the rumour found traction with my mum, who has a deep and profound appreciation of wildlife. We rarely discussed the so-called 'situation' in blunt terms – it was a volatile subject – but I'd sensed, over the winter months, that she was as discomfited by the presence of the Travellers as she was by the fact of feeling discomfited. In this uneasy position, her instinct towards empathy – 'Everyone,' she said, 'needs somewhere to live' – was at risk of being overcome by the social contagion of hatred that had infected the village. This hare-coursing rumour threatened to be the tipping point, even though I knew she understood that the difference between hunting hares in the field and shooting rats in the rat runs is only one of scale and reward. Sensitivity to such hypocrisy wasn't shared by members of an infamous, ostensibly 'trail only' local hunt, which counts among its ranks policemen, a former MP, and a prominent parish farmer. At the very same time that the hare-coursing rumour emerged, huntsmen had been secretly filmed in their tweed finery and velvet-covered Hamptons flushing a live fox from a den and throwing it to their hounds to be killed.

What is it about the Travellers that so perturbs the villagers? Why do they accuse them of invented crimes; not least ones they

are guilty of committing themselves? Why do they want them gone? Whatever the cause of this hatred, it is surely not rooted in reality. For the Travellers living along Love Lane in a patch of field completely hidden from view are peripheral to the village; the villagers have no direct contact with them. None of us know anything about their lives; we do not offer them chickens' eggs in gestures of neighbourly goodwill; we do not even know their names. The hatred towards them arises from the imagination, diffuse as vapour, to hang in little clouds of fear above our heads.

The villagers consider themselves prosperous and clean; the Travellers, they must imagine, are neither. The villagers are sure of their own skin colour, but they are uncertain of the Travellers'. And we live in a society in which the operative power of one's rights – one's right to make a home, to go about one's life with dignity – corresponds to wealth and race. The villagers understand this, even if only intuitively, and so they cannot allow the Travellers to establish a home, however temporary. It would seem to pervert this principle of belonging, and it is this principle that gives the village its meaning and coherence. The arrival of the Travellers forced an unwanted introspection, forced the villagers to consider – if only for a moment – that their green and pleasant land, this 98 per cent white, Protestant pastoral, simply is not absolute; it is only a single strand in the communal mesh, intertwined with and inseparable from other ways of life.

Any departure from my mum and stepdad's house is attended by their neighbour, a live-alone widow approaching ninety, popping her head out of the bedroom window like a cuckoo in a clock to ask where we're going. This doesn't feel as intrusive as it might seem, in part because she will, without fail, offer valedictions and well-wishes, no matter how small or trivial the journey. The day I moved out, she shouted down to me that she had prayed, together with her cat, that my move would go well, and that I'd be happy in my new living situation. Like most of the villagers, once you get to

know her, she is kind and warm-hearted. That their generosity should be delimited by prejudice is a reality I struggle to accept. With the panic of a man clinging to the tail end of his youth, I worry that such diminishment of spirit correlates to getting older: that as the years pass by, a chronic lack of inquisitiveness sets in, an ossification of attitude, a hardening rather than a softening of one's edges.

This isn't a fear about becoming aged, exactly, but a premonition that the longer I live the more complacent and fatigued I'll become, the more willing I'll be to see threats where there are none, to interpret the world superficially, to withhold generosity and aggressively defend that which I think of as mine. The rural West Country, after all, is where I'm from. It is a part of me, and so too is this village, in all its Christendom and homogeneity. The old nag in the meadow kicks up dust, and the light glints off the poplar trees as though some celestial mason were taking a chisel to the atmosphere. In the pub the old boys, over pints of golden ale, talk about yields and storms. And around back, all our secrets and shameful fears are covered in cobwebs under the lean-to, out of sight but not entirely out of mind. ■

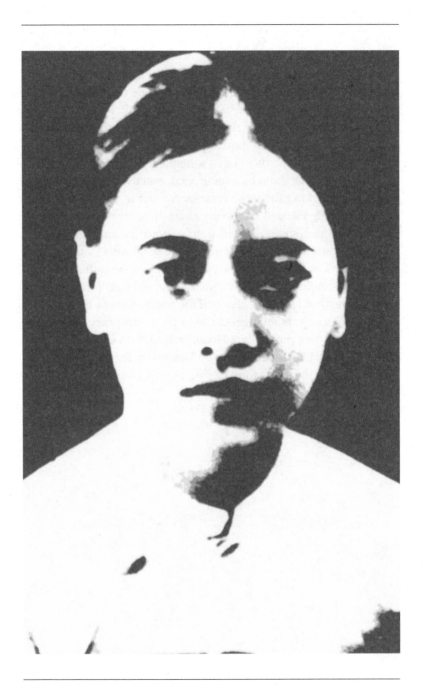

Nam Le

[3. Ekphrastic]
(Self-portrait)

Photo.
 Right of blood: *ba ngoai.*
 She in *me* in me.

Monochrome.
 Tinge of colour decay.

Note: spots and blotches
 À la calligraphic ink.

 Spilled logogram.
 Smeared morphemes.

 Character cannot cohere.

Note: overexposure
 Giving effect of flatness.

Note: low contrast
 Giving effect of flatness.

Note: lack of contour
 Giving effect of flatness.

As if repeatedly photocopied
 From photocopies.

 ★

Note clothing:
 French *ao dai* (silk if you like)
 with off-centered mandarin collar.

 (It writes itself.)

Note face: full moon circle
 rising from slim circle collar.

Hair flat, conforming.
 Acceptant of (path of) totality.

What the photo cannot say:
 Are her eyebrows painted T'ang green?
 Is that smudge on her brow actually gold foil
 in the Southern Dynasties style?
 Her unseen teeth black-lacquered?

All in the look.

Note expression: inscrutable, impassive,
 passive as craters,
 scuffs on jade terrace.

 Now write about it what you like.

Photo courtesy of the author. This poem is from a longer series called *36 Ways of Writing a Vietnamese Poem*.

Your experiences shape you

Enjoy great savings at 100s of cultural destinations for £79 a year with a National Art Pass. Visit artfund.org

National
Art Pass_

Art Fund_

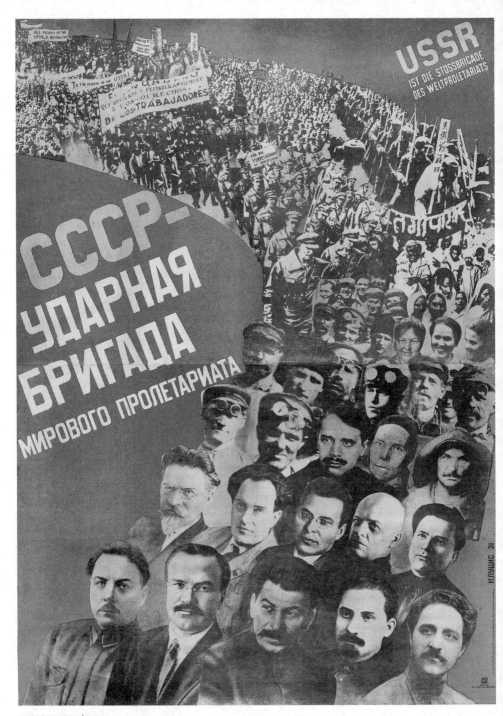

GUSTAV KLUTSIS / TATE
The USSR is the Shockworkers' Brigade of the World Proletariat
1931 photomontage poster depicting the Politburo heading a column of workers

LIFETIMES OF
THE SOVIET UNION

Yuri Slezkine

The Soviet Union lasted one human lifetime. It was born in 1917 and died in 1991, at the age of seventy-four. The difficult Civil-War childhood was followed by precocious 'construction-of-socialism' adolescence, Great-Patriotic-War youth, 'postwar-reconstruction' maturity, Khrushchev-Thaw midlife crisis, and 'period-of-stagnation' dotage culminating in a series of colds, frenzied CPR attempts, and death 'after a protracted illness'.

Such an obituary works as a metaphor and a draft of a biography. It seems to make sense because the Bolshevik 'party of a new type' was not an organization seeking power within a particular state but a faith-based group radically opposed to a corrupt world, devoted to 'the abandoned and the persecuted', composed of voluntary members who had undergone a personal conversion, and dedicated to the total and immediate destruction of the 'old world' of suffering and injustice. It was, by most definitions, an apocalyptic sect awaiting an all-consuming revolutionary Armageddon followed by the millennial reign of Communist brotherhood as the overcoming of the futility and contingency of human existence.

Most apocalyptic sects do not survive the failure of the doomsday prophecy. Most sects of any description do not survive the transformation of an exclusive community of fraternal converts into

a complex society of hereditary members. Most sects, in other words, never become churches. The Bolsheviks built an enormous Potemkin temple but failed to transcend their sectarian origins and expired along with the last true believer.

This story has a nice shape to it but it doesn't work as an outline of Soviet history. The 'Old Bolsheviks' who built the Soviet state did not live long enough to grow old. The last Bolshevik who died in the top job was not a true believer. The founders' successors came in two mutually hostile cohorts. The tale of the Soviet state consists of three generations.

The original Bolsheviks were born in the 1880s and 90s and converted to socialist millenarianism as schoolchildren, seminarians, and college students. Their cause was the working class as universal redeemer; their parents were provincial clerks, clergymen, teachers, and doctors. The movement's center lay at the empire's periphery: between 1907 and 1917 the share of ethnic Russians among exiled revolutionaries (43.4 percent) was about equal to their share in the population; the proportion of Georgians and Armenians was twice as high; Poles, three times; Jews, four times; and Latvians, eight times (8.2 percent of exiles compared to 1.2 percent of population). The only condition for joining underground revolutionary circles was unconditional faith in the coming Armageddon and a readiness for self-discipline and self-sacrifice. The main activities were reading (socialist texts as well as 'treasures of world literature') and, as one gained in revolutionary consciousness, 'propaganda and agitation'. As in most apocalyptic sects, the core members were young men who abandoned their families in order to form a band of brothers around a charismatic leader (Lenin's nickname was the Old Man). Women made up a small proportion of the membership and played auxiliary roles as debate audiences, prison liaisons, model martyrs, 'technical workers', and writers' muses. At the turn of the twentieth century, 'student' was a synonym for 'revolutionary', but, according to most revolutionaries, the real university was the prison. Unfree spaces were filled with free time, and most inmates spent days and months reading books and taking notes. The education of a revolutionary was

completed in Siberian exile, which combined banishment to hell with a chance to create a sacred community of true believers. Present-day suffering was a guarantee of future happiness.

One such student revolutionary was Aleksandr Arosev, a prominent Kazan Bolshevik and the son of a merchant, who associated the victory of Bolshevism with the transformation of the world into a fraternal sect. Communism was the kingdom of universal friendship. His closest friend was his high-school classmate, a fellow sectarian and amateur violinist by the name of Scriabin.

The prophecy came true on Easter Monday, 1917, when Lenin rode into Petrograd on a train and declared that the time had come, the prophecy had been fulfilled, and the present generation would not pass away until all these things had happened.

Sects and revolutions are staffed by young people. When Babylon fell, Arosev and his friend Scriabin, who had recently changed his name to 'Molotov' ('hammer') were twenty-seven. The Old Man was forty-seven. Arosev became one of the leaders of the Bolshevik military insurrection in Moscow and a prominent proletarian writer. Molotov emerged as one of the leading Bolsheviks in the capital. They were almost as young as the world they were ushering in. 'The great uprising of the human mass in the name of humanity,' wrote Arosev, 'began simply and without hesitation – exactly the way the old books describe the creation of the world.'

For the next three years, the top Bolsheviks moved around continuously from one front of Armageddon to another and one assignment to the next. Some were accompanied by their permanent female comrades, most had short-term liaisons with nurses, secretaries, cryptographers, and propaganda department typists. Time flew so fast it was always about to end. According to the era's most popular song, 'Our locomotive is rushing full speed ahead, next stop Communism.'

The 'last and decisive battle' was won but the new world failed to materialize. War Communism was followed by the New Economic Policy, introduced by Lenin as a temporary retreat, opposed by many

Bolsheviks as a betrayal of the revolution, and followed by a period of melancholy analogous to 'the Great Disappointment' suffered by American millenarians when the world failed to come to an end on 22 October 1844. Thousands of believers, as one of them put it, 'wept and wept, until the day dawned'.

The postponement of the Millennium coincided with the death of the Prophet. Trotsky could not attend Lenin's funeral because of a mysterious nervous illness. A public prosecutor who could not stop weeping for several months was treated for 'traumatic neurosis'. In 1927, 1,300 Bolshevik functionaries stayed at the Lenin Rest Home No. 1 outside Moscow. Six were found to be healthy; 65 percent of the rest were diagnosed with various forms of emotional distress (described as 'neurasthenia', 'psycho-neurasthenia', 'psychosis', and 'nervous exhaustion'). The surviving Old Bolsheviks, now top government officials in their thirties and forties, moved into the Kremlin and several downtown-Moscow hotels that had been converted into dormitories known as Houses of Soviets and settled into a self-doubting communal domesticity – visiting each other's rooms, smoking cheap tobacco, drinking strong tea, arguing about the timing of the second coming, and weeping. And weeping.

There were two ways of reviving the revolution. One was rejuvenation through love, which seemed to require intergenerational romance. The great Party theoretician, Nikolai Bukharin, married the daughter of one of his oldest friends (after taking her away from the son of another old friend). The head of the Party's Jewish Section, Semen Dimanshtein, married his adopted daughter. The chairman of the Military Board of the Soviet Supreme Court, Valentin Trifonov, married the daughter of his own wife. One day, he moved out of the mother's room and into the daughter's. They all continued to share the same apartment. One of the offspring of the new union was the writer Yuri Trifonov, who would devote his work to the question of how the revolution had devoured its parents. He was born in 1925, the lowest point in the history of the Soviet Great Disappointment and the highest in number of births among Bolshevik officials.

Arosev married and had three daughters, but his wife soon left him for another Party official, who had left his wife and three children in order to be with her. Arosev was sent to Prague as Soviet ambassador to Czechoslovakia and soon married his eldest daughter's dance teacher, a young German Jewish woman named Gertrude, whom he called Gera and whom his daughters loved to hate.

The other way to rescue the revolution was to fulfill its promise by having the workers inherit the world. The intellectuals who had instituted the 'dictatorship of the proletariat' were committed to the cause of their own obsolescence through class-based affirmative action. The key to overcoming the rot of the New Economic Policy was streamlined mass education and the preferential promotion of the 'socially close'. There were, roughly speaking, two main groups of beneficiaries (known as *vydvizhentsy*, or 'promotees'): the children of workers and peasants, who became prominent in industrial management and regional Party apparatus, and Jews from the old Pale of Settlement (the only members of the literate classes not compromised by service to the tsarist state), who came to dominate the cultural, intellectual, and professional elites. In the 1920s the Old Bolsheviks produced two sets of heirs: the ones they selected as young men with 'healthy social roots' and promoted to positions of ever greater responsibility with the goal of eventual supreme leadership, and the ones they conceived in guilty midlife passion in the Houses of Soviets. Both were products of the Great Disappointment.

And then the day dawned. In 1927, Stalin launched his 'Revolution from Above', also known as the 'Era of the First Five-Year Plans'. Its purpose was to bring about the fulfillment of the original prophecy by adding an industrial 'base' to the already solid political 'superstructure'. Industrialization was to be accompanied by its presumed consequences: the abolition of private property, the destruction of class enemies, and the definitive self-realization of the proletariat. The weeping ended. The Left Oppositionists repented, the Right Oppositionists surrendered, and the rejuvenated Old Bolsheviks set about building, purging, and collectivizing. Valentin

Trifonov returned from diplomatic postings in China and Finland to become chairman of the Main Committee on Foreign Concessions; and Aleksandr Arosev began to draft a revolutionary epic, the last volume of which was devoted to 'the economic building of socialism under [Stalin's] direction and the falling off of the de facto alien elements'.

The Old Bolsheviks' official successors, born in the first decade of the twentieth century and promoted through Soviet colleges' 'workers' departments', got married, joined the Party, and stopped being workers. Nikolai Podgornyi, born in 1904 to a metalworker of peasant origin in Karlivka, Ukraine, graduated from the Kiev Institute of Food Industry; Leonid Brezhnev, born in 1906 to a metalworker of peasant origin in Kamianske, Ukraine, graduated from the Kamianske Institute of Metallurgy; and Aleksei Kosygin, born in 1906 to a metalworker of peasant origin in St Petersburg, then the empire's capital, graduated from the Leningrad Textile Institute. All became engineers, 'Red Directors', and, for the rest of their lives, 'people of the First Five-Year Plan'.

By 1934, the Stalin Revolution had been largely completed. Life, according to Comrade Stalin, had become 'merrier'; the age, according to thousands of posters, was one of 'happy childhood'; the country, according to Isaac Babel, had been 'gripped by a powerful feeling of pure, physical joy'.

The Old Bolsheviks settled down and moved into their new permanent homes (in old imperial buildings or in new houses built for the purpose). Most of the men were in their forties and early fifties (Trifonov turned forty-six, Arosev forty-four), most of their wives were in their thirties, most of their children were between five and twelve, and most of their maids (each family had one) were young girls from the famine-gripped farms their masters had recently collectivized.

Family life in Old Bolshevik homes tended toward the nineteenth-century Russian model as represented in 'Golden Age' Russian literature (which, unlike most of its West European counterparts,

was aristocratic, not bourgeois): the remote, admired, feared, and usually absent father; the less remote, less admired, less feared, and frequently absent mother; the more or less pitied German governess; the more or less dreaded piano teacher; and the beloved peasant nanny, who did most of the child-rearing until it was time to start reading the books their fathers would select for them. Most of those books came from the same nineteenth-century canon – as did their children's own lives, complete with Christmas midnight magic, now called New Year's; swimming and berry-picking at country estates, now called dachas; regular trips to Black Sea palaces, now called rest homes; and an intense cult of love, friendship, book-reading, letter-writing, and diary-keeping. Every girl was Natasha Rostova from *War and Peace*, and every boy was Prince Andrei.

The children of the revolutionaries were happy dwellers in the land of happy childhood. They respected their seniors, loved their country, and looked forward to improving themselves for the sake of socialism and to building socialism as a means of self-improvement. They were children of the revolution because they were their fathers' children, because they were born after the revolution, and because they were proud of their paternity and determined to carry on what was at once their father's 'profession', their country's mission, and History's secret purpose. Born in the 1920s, they came of age along with socialist realism, and the heart of socialist realism, according to Bukharin's speech at the First Writers' Congress in 1934, was romanticism. 'The soul' of 'most of the young people of that time', wrote one of them many years later, was 'romantic' – romantic in the sense of being exalted, vibrant, hopeful, and vulnerable, and Romantic in the sense of seeking transcendence in the here and now. The fathers' generation had been shaped by the expectation of the apocalypse; the children's generation was 'religious' about the heavenly city they inhabited. The fathers' friends and lovers were fellow sectarians who shared their faith; the children's friends and lovers were unique individuals whom they loved for reasons they never tired of discussing but were never supposed to exhaust.

The fathers' 'classical' reading was tempered by Symbolism and disciplined by the study of Marx, Lenin, and economics. The children were bored by modernism, entirely innocent of economics, and only indirectly acquainted with Marxism-Leninism through speeches, quotations, and history-book summaries. No one ever read *Das Kapital*, everyone was in love with Pushkin.

After toasting the New Year of 1937, sixteen-year-old Lydia Libedinskaia and her friends from the elite Moscow Exemplary School went to the Pushkin Monument on Tverskoi Boulevard, in the center of Moscow. That night is one of the central episodes in her memoirs.

> The snow kept falling, melting on our flushed faces and silvering our hair. Our hearts were overflowing with love for Pushkin, poetry, Moscow, and our country. We yearned for great deeds and vowed silently to accomplish them. My generation! The children of the 1920s, the men and women of a happy and tragic age! You grew up as equal participants in the building of the Soviet Union, you were proud of your fathers, who had carried out an unheard-of revolution, you dreamed of becoming their worthy successors ...

The fathers, meanwhile, were torn between the powerful feeling of pure, physical joy and the equally powerful feelings of guilt and confusion. How was life in elite apartments, with maids in the kitchen, carpets on the floor, and children in Moscow Exemplary going to turn into socialism? What did socialism inside the home even mean? What might possibly follow happy childhood?

And then they heard a knock on the door. Sects are, by definition, besieged fortresses; the Bolsheviks had always thought of their state as a besieged fortress; in the mid-1930s the Soviet Union was, indeed, besieged from the East and the West; and individual Old Bolsheviks were under siege in their own apartments, cluttered with orange

lampshades and poor relations. When the knock on the door came, they were all guilty of having abandoned their youthful vision of socialism.

Arosev, Gera and the children were on vacation when the knock came. To everyone's surprise, they came for Gera. Arosev kept trying to reach Molotov, but whoever answered the phone would either hang up or breathe into the receiver without speaking. Arosev kept saying: 'Viacha, I know it's you, please say something, tell me what to do!' Finally, after one of these calls, Molotov said: 'See that the children are taken care of,' and hung up. Arosev was shot in February 1938, two months after Gera.

Valentin Trifonov was arrested on 22 June 1937. His eleven-year-old son Yuri, who was reading *The Count of Monte Cristo* earlier that day, wrote in his diary: 'I have no doubt that Dad will be released soon. Dad is the most honest person in the world. Today has been the worst day of my life.'

Most of the men were executed within weeks or months, although their children would not be informed for over two decades. Most of the women were sent to special camps for 'family members of traitors to the motherland', where they spent eight years (plus another ten or so in exile) before returning to their children's new homes – old, sick, broken, unwanted, unloved, and utterly lost. Their youthful faith was gone – along with their husbands. They and their children had nothing to say to each other. Bolshevism, like most millenarian movements, proved a one-generation phenomenon.

But the Party and the state still had time left to live. The top offices left vacant by the Great Terror were taken over by those who were meant to lead the dictatorship of the proletariat but hadn't until the mass arrests started – those former workers who were too young to have taken part in the revolution or Civil War but old enough to be promoted in the 1920s, admitted to colleges under class quotas during the Stalin Revolution, and hired as industrial managers in the mid-1930s. They identified with the Party that identified itself with them but were utterly uninterested in Marxist theory or 'treasures

of world literature'. They prided themselves on being modest, pragmatic, and uncharismatic. They inherited the jobs of their martyred Old Bolshevik sponsors without ever wishing or needing to acknowledge the fact. They kept talking about building socialism but seemed content to keep building factories. They were the children of the revolution in the sense of being its ultimate (in the sense of both 'best' and 'last') beneficiaries.

Within two years of the end of the Great Terror, Podgornyi advanced from deputy chief engineer to chief engineer to Deputy People's Commissar (minister) of Food Industry of Ukraine to, by the time he turned thirty-six, Deputy People's Commissar of Food Industry of the Soviet Union. At the same time Brezhnev moved – also through a series of quick steps over dead bodies – from college director to the Dnipropetrovsk Oblast propaganda secretary, and Kosygin, from factory director to People's Commissar of Textile Industry of the Soviet Union. Most members of that cohort served as political officers or industrial managers during World War II, came into their own as leaders of postwar reconstruction, survived Khrushchev's attempts to restore the spirit of their First Five-Year Plan youth (which they acknowledged as foundational but feared as a threat to their hard-earned respectability), and came to power in a coup d'état in 1964, Kosygin as Prime Minister (Chairman of the Council of Ministers) and Brezhnev as First (later 'General') Secretary. Both were fifty-eight years old. Podgornyi joined them a year later as President (Chairman of the Presidium of the Council of Ministers). For the next twenty years they presided over 'really existing socialism', or a revolutionary regime devoted to permanence.

The children of the actual revolutionaries were twenty years younger and worlds apart socially, culturally, and emotionally. Unlike the Brezhnev generation, which had taken after its Old Bolshevik sponsors in being publicly all-male, they consisted of boys and girls who would grow up to be distinct men and women. The Great Terror put an end to their happy childhood but not to their passionate identification with the country their fathers had built. Yuri Trifonov

and his sister were raised by their Old Bolshevik grandmother; Arosev's three daughters were raised by their mother. When the Great Patriotic War began, most boys chose to clear their fathers' names by volunteering for the army. Many were killed – thus fulfilling their oath to Pushkin and following him into the temple of eternal youth. The rest graduated from prestigious colleges and rejoined the Soviet cultural and professional elite (known to both members and non-members as the 'intelligentsia'). Yuri Trifonov became a celebrated writer and Stalin Prize winner; two of Arosev's daughters became actresses (one of them, Olga, a movie and TV star), and one, a writer and translator from Czech. They followed the ascent of their proletarian older comrades in the newspapers and marveled at the miraculous rise of the new socialist factories; celebrated their happy childhood as part of a common proletarian victory, before and after their fathers' inexplicable demise; and joined their fellow countrymen – workers, peasants, Party bosses, and urban intellectuals – during the war, in pursuit of 'one victory, one for all, whatever the price'. The song with that refrain was written by the celebrated 1960s bard, Bulat Okudzhava, the son of Georgian and Armenian Old Bolsheviks born in 1924 in downtown Moscow. The generation of the 1930s 'happy childhood' had become the 'war generation'.

But then the paths of the revolution's two sets of heirs began to diverge. What came as a springtime of hope for the young war veterans from Old Bolshevik backgrounds appeared as 'Khrushchev's hare-brained schemes' to the mature Party leaders. What was 'loyalty to the ideals of Marxism–Leninism' to the Brezhnev generation looked like a 'Big Lie' to the urban intelligentsia (the 'war generation' had become 'the sixties generation'). What was known officially as 'Party leadership' seemed like usurpation to the more educated among the led. For Andrei Sakharov, the father of the Soviet hydrogen bomb born in 1921, the moment of truth came in 1955, after a successful test of his 'device'. According to Sakharov's memoirs, the test was followed by a banquet at the residence of Marshal Nedelin, the commander of Soviet Strategic Missile Forces.

When we were all in place, the brandy was poured. The bodyguards stood along the wall. Nedelin nodded to me, inviting me to propose the first toast. Glass in hand, I rose, and said something like: 'May all our devices explode as successfully as today's, but always over test sites and never over cities.' The table fell silent, as if I had said something indecent. Nedelin grinned a bit crookedly. Then he rose, glass in hand, and said: 'Let me tell a parable. An old man wearing only a shirt was praying before an icon. "Guide me, harden me. Guide me, harden me." His wife, who was lying on the stove, said: "Just pray to be hard, old man, I can guide it in myself." Let's drink to getting hard.'

My whole body tensed, and I think I turned pale – normally I blush . . . The point of the story (half lewd, half blasphemous, which added to its unpleasant effect) was clear enough. We, the inventors, scientists, engineers, and craftsmen, had created a terrible weapon, the most terrible weapon in human history; but its use would lie entirely outside our control . . . The ideas and emotions kindled at that moment . . . completely altered my thinking.

In the 1960s and 70s, Sakharov's thinking came to be shared by a growing number of inventors, scientists, engineers, and craftsmen working on much less explosive devices. Like its imperial predecessor, the Soviet intelligentsia had been created to serve the state but ended up serving its own 'consciousness' (split, in various proportions, between 'progress' and the 'people'). The more desperately the aging state clung to its founding prophecy and the more intransigent it became in its instrumental approach to the educated elite, the more passionate that elite became in its opposition to the state and its attachment to (true) progress and (with ever growing reservations) the people. The children of the Old Bolsheviks began to think of their

fathers as tragic heroes and of their fathers' proletarian disciples as impostors. In theory – and often enough in practice to produce a sense of acute annoyance – the Party claimed the right to make all decisions about everything – from the Bomb to the Beatles. What added injury to insult was the growing sense that the ruling generation was not only politically illegitimate but socially inferior. The Soviet Union had started out as a dictatorship of the proletariat run by intellectuals; what it had become, in the eyes of the children of those intellectuals, was the dictatorship of the former proletarians who remained culturally proletarian (inarticulate, anti-intellectual, Russo-Ukrainian, domino-playing) in a country that had long since moved on. The Party bosses quietly admitted defeat by raising their own children to be professionals, not party bosses. By the 1980s, the rapidly growing anti-regime 'intelligentsia' led by the children of the Old Bolsheviks and their high-status contemporaries were watching with amused contempt as their former older comrades were dying slow deaths on national television, one after another, day after day. Kosygin died in December 1980, Brezhnev in November 1982, Podgornyi in January 1983. After a few more deaths in high office, there was no one left.

In 1963, Stalin's daughter, Svetlana Alliluyeva, born in 1926, had written about her generation: 'They are the best of the best . . . They are our future Decembrists, they are going to teach us all how to live. They are going to say their word yet – I am sure of that.' They did. When Gorbachev walked onto the stage and proclaimed a new policy of *glasnost* ('speaking up'), they were assembled in a chorus line, poised to give voice to a new millennium.

'Decembrists' were early-nineteenth-century aristocratic rebels who, according to Lenin, gave birth to the Russian revolutionary movement. The title of Lenin's newspaper, *Iskra* ('The Spark'), referred to a line from a poem by the Decembrist Alexander Odoevsky: 'From a spark, a fire will flare up.' The Old Bolsheviks started a fire in the expectation that capitalism would produce its

own gravediggers, the proletariat. But history did not cooperate, and they had to do most of the gravedigging themselves. Having buried capitalism and anointed their proletarian successors, they moved into family apartments and, in due order and not entirely unselfconsciously, produced their own gravediggers by raising their children not as Bolshevik true believers but as members of the intelligentsia and would-be aristocrats ('the best' by virtue of both moral superiority and inherited privilege).

The Brezhnev generation inherited the state but not the flame. The state withered, and so did they; no one in the post-Communist world remembers their youth, celebrates their rise or claims them as ancestors. The modest rulers proved the greatest losers. A formerly proletarian state run by a few former proletarians turned out to be a dead end.

The Alliluyeva generation was kicked out of the Houses of Soviets but kept the flame burning – until the time came to torch their fathers' inheritance. They never outgrew their youthful enthusiasms and never stopped discovering new books, people, and causes. Most eventually became liberal Westernizers and/or Jewish nationalists (most Russian nationalists came from non-elite quarters and were not liberal Westernizers; most Jewish and other nationalists did not distinguish between tribalism and liberalism). Those who did not emigrate (to the US, Israel, or Germany) lived to see their children take over the ruins.

Their children – the grandchildren of the revolution – were conceived during the Khrushchev Thaw and raised amid 'the Brezhnev stagnation'. They inherited their parents' social status and latter-day anti-Sovietism but not their romantic exuberance. They drank heavily, smiled knowingly, flaunted their elitism, and turned their parents' fitful liberalism into a dogged devotion to a free world of their imagination, from uncompromising libertarianism to a cargo cult centered on blue jeans and rock and roll (the true colors of late Communism, according to the anthropologist Alexei Yurchak, were King Crimson, Deep Purple, and Pink Floyd). They were shaped and

deformed by irony. Every word was a hint, every look a wink, every act a parody. Their foundational text was Venedikt Erofeev's *Moscow to the End of the Line*, about the end of the line also being Moscow. The artistic style they generated was 'Moscow conceptualism', which made late socialism postmodern. (In 1975 one of my high-school friends – the son of a KGB agent – and two fellow performers built a nest and spent several hours sitting in it at an Achievements of the National Economy exhibit, hatching an egg, or perhaps the Spirit, they weren't sure.) The economists among them made the point of learning the opposite of what they were taught and, when Boris Yeltsin appealed for help, took charge of building capitalism. The shock-therapist-in-chief, Yegor Gaidar, was born 19 March 1956, less than a month after Khrushchev's 'secret speech'. His father was a Navy officer and head of Pravda's military desk; his grandfather, a Civil War hero and a classic of Bolshevik children's literature. His friends and followers from among the revolutionaries' grandchildren formed the core of new Russia's cultural elite. They admired the West, deplored 'the people', thought of their grandparents as victims of Stalinism, and raised their children as citizens of the world. Many – perhaps most – have now left Russia. My conceptualist friend lives in a psychiatric hospital and, according to a classmate of ours who visited him there several years ago, cannot stop laughing. ∎

DEVASHISH GAUR
Kolkata, 2019

THE ATTACHÉ'S WIFE

Karan Mahajan

Everywhere J traveled in the country with the government press attaché, people would turn to the attaché and say, 'But you should explain the background to him, after all he's not from here.'

One day, exasperated, J said to the attaché, 'Will you tell me why people keep acting this way with me? Do they sense something about how I walk? My clothes? My accent hasn't changed at all since I left.'

The attaché smiled. 'But they know you live abroad.'

J, an internationally syndicated columnist, had been invited by the government to write a report about the country's progress.

'But does that mean,' J said, 'does that mean I've lost my connection to the country, that I'm not capable of understanding it? After all, I'm *from* here. I grew up here. In fact, that's why the government invited me back for this work.'

The attaché said, 'That's a good point,' though he clearly didn't believe that.

J couldn't let it go. 'Millions of our people live abroad. Is this how you want them to feel?'

'But there are certain things, sir, only a local –' The attaché held his tongue.

'But that's what I'm saying. What is this *magical thing* I don't understand? OK, fine: I'm not aware of the name of the latest

cricketer or whatever sidey politician is in charge of this district. But why is that even important? This obsession with proper nouns – that's not wisdom. As far as I can tell, the basics of the place – the corruption, the pettiness – have not changed.'

'It seems like you have decided on the content of your report, sir,' the attaché mused.

'This habit of putting people in categories. Inside, outside; upstairs, downstairs. And as far as you're concerned, I'm outside. How could I – some foreigner with *zero* connection to this place – possibly understand anything about this great country? Why even invite me to make a report?'

'No, sir, it's so you *can* understand,' the attaché said.

J was beginning to comprehend the attaché's humor. 'You think this, all this that I'm saying, it's proof of being a foreigner,' J said, 'getting bent out of shape like this –'

'Not in the slightest, sir,' the attaché said, but J could swear he saw his eyes twinkling.

'OK, let's continue on our tour,' J said.

But as they drove around the city, J got angrier. He remembered now why he'd left in the first place: the people of this poor hot country were smug when they had nothing to be smug about. They were petty and possessive.

I'll write the damn report, he thought. *And it'll be damn negative.*

In the middle of the night, when the attaché was asleep, he received a call.

'I knew it!' the voice on the other end was shouting. 'I knew it! They don't say this to foreign journalists, only to people like me who left!'

After getting his bearings, the attaché said sleepily, 'Perhaps they feel you've outgrown our little country, sir.'

'No, no, no, not at all! They're angry. Angry that I got away from this place. They want to pull me down!'

'The visit is arousing feelings for you, sir,' the attaché said.

'All you bloody people are!'
Then the phone was slammed down.

'Who was that?' the attaché's wife asked.
'Some foreign journalist.'
'Oh,' she said.
'But he grew up here,' the attaché said.
'Ooof,' she said.
'And he's angry people don't treat him like he's from here.'
'He might be the first person I've heard of who *wants* to be from here,' she said.
They both snickered.
'Goodnight,' he said.
'Goodnight,' she said.
Then, suddenly, the attaché got up. 'Is that really what you think of our country?' ∎

POPPY THORPE
Lucy, 2022

ISABEL

Lillian Fishman

From the threshold of the living room Diana observed the blonde who was presiding over the party. The room was held in a hush, and the woman on the couch twisted her hands as she spoke, until a laugh broke out and she touched her fingers to her hair.

Diana shouldered her way into the living room as the laughter quieted. The blonde was seated in the center of a large sofa, cradling a half-empty tumbler and touching thighs with a bearded man who had begun speaking to her about something apparently urgent.

'Who is that?' Diana said to the woman beside her.

She gestured toward the blonde with her beer bottle. 'That's Lucy,' she said.

Lucy wore a white tank top in which her breasts stood at attention, like loyal little pets, and she had the cheekbones and eyelashes that Diana associated with rarified, glossy womanhood.

The woman standing beside Diana introduced herself while on the sofa the blonde, Lucy, toyed absently with her necklace. Diana moved toward Lucy and softly touched the edge of the sofa.

'Excuse me,' Diana said to Lucy. She and the bearded man beside her both turned expectantly. 'Could I get you another drink?'

A mild, appropriate blush washed across Lucy's face. She was clearly used to being sought. 'Sure. You know,' she said to Diana,

'I could use another drink, I'll come with you. Okay?' she said to the man, and rested her hand on his forearm for a moment, like a teacher reassuring a young boy that he will be just fine on his own.

Diana smiled, as much at this gesture as at Lucy's acquiescence. As she led Lucy to the kitchen, her silver ring and the links of her watch gleaming against Lucy's white top, she turned to see a crestfallen look in the eyes of the man on the sofa – a look that made her laugh out loud.

'What?' Lucy said.

'Your friend,' Diana said. 'I think he's jealous. What are you having?'

'A gin and tonic, please.'

Diana arranged the bottles and located a knife in a kitchen drawer. She began to slice a lime. 'I haven't seen you here before,' she said, indicating the apartment. 'How do you know Minta?'

'We went to high school together,' Lucy said. 'I only moved here recently, we haven't seen each other in years. It was sweet of her to invite me.'

'I think it was more a favor to us than to you,' Diana said.

Lucy turned around on her heels, smiled, splayed her hands on the kitchen counter and leaned forward as though she were about to announce a dare. Diana saw that Lucy's appeal was in the nostalgia of her looks: Hers was a teen beauty, at home nowhere more than in a miniskirt. Even in her bland slacks and loafers she had the flirtatious, dismissive charm of a girl at the height of her popularity, the challenge and invincibility of a team captain.

Diana poured the tonic into Lucy's glass. When Diana was a teenager, no girl had ever given her the look Lucy gave her now. After an adolescence in which the very fact of her lesbianism had seemed to disqualify her from the contest of desire, she had, in her brief adulthood in the city, finally become attractive. She had natural qualities that hadn't initially looked like advantages – height, broad shoulders and a face given to brooding – and she had learned to appropriate the mannerisms that made powerful men suspicious

and irresistible, chief among them a degree of directness to which the world capitulated almost unconsciously. The spin, the smile, the crush of Lucy's tits in the tank top: Diana recognized all this now with the wistfulness of a former adolescent boy who had once jacked off, in frustration, to a teen flick. In an hour she would make this bitch come around her fingers, and that's how she would say goodbye to it once and for all – those excruciating sexless years – the slurs, the nights spent crying, the year she had starved herself and, perhaps worst of all, the relentless, disgusting, unconsummated wetness she had carried around between her legs, which marked her as an animal.

'You know,' Lucy said, taking a sip of her fresh drink, 'I'm glad I came. I'm making friends already.'

Diana came around to Lucy's side of the counter and placed her hand on the back of Lucy's neck, where a light sweat had begun to collect. She could feel the thrum of intention beating in her own chest and along the muscles of her arms. There in the warm kitchen she let her ring rest against the first vertebra of Lucy's spine and later, after the long charged walk to Diana's apartment, when Lucy was supine on her bed, she felt with satisfaction the moment when the hard alien contour of the ring surprised Lucy, made her hitch her hips up before she could catch herself. Lucy smiled, to show she was game. From there Diana did what she had learned to do: make a girl feel absolutely surrounded, alternately by forcefulness and by utter softness, as though she were smothered in Diana's desire. Diana could tell which kinds of girls would like this and which would find it overwhelming, and she intuited that Lucy's capacity to receive passion had been so distorted by her excessive beauty that only a real showing would satisfy her. At the very end she crouched between Lucy's legs and began to pet her softly, almost as though at any minute she would give it up. She kept at this for so long that Lucy began to shake, to say raggedly, *no more, no more* until, just a few moments later, she came with a humiliating trembling in her legs, her body splayed and limp like an empty bag.

'Christ,' Lucy said a while afterward, wiping her brow. A dank, sweet smell of success permeated the room.

'You've never been fucked by a woman, have you?' Diana said.

Lucy laughed – a lovely ripple, her breasts shaking – and then she turned, propped herself up on an elbow. 'Did you really think that?' she said. 'Why do you think I came home with you?'

Diana made a neutral face. So who was that man Lucy had been sitting thigh-to-thigh beside, whose forearm she had touched so awfully – someone she teased for sport? The idea made Diana like Lucy better, maybe even grudgingly respect her. When Lucy left it was with shameless grace, the air of having won something flattering and inconsequential.

In the morning Diana made her way out for a coffee. She felt light and free. She was at home in the blare of traffic, roaming across blocks that smelled of bacon fat and sewage. The sun moved over her, confirming her strength. When she checked her phone, she saw that Minta had texted her. *I heard you went home with Lucy!* she wrote. *Isn't she special??*

As Diana ascended the stairs back up to her apartment the word *special* echoed in her mind and conjured the disheveled hallway, the hush, the sight of Lucy glimpsed across the bay of heads, the spin of Lucy's body as if she were suspended over a football pitch.

Lucy had been in the city three months. Sure, she said on the phone, she would let Diana show her around. Where did Diana like to go?

'Well, now that the pools have opened, I like to go to the pools.'

'You just want to see me in a swimsuit.'

Diana waited for her on Houston Street outside the entrance to Hamilton Fish. The early summer was yellow and jubilant. Lucy arrived wearing a competition one-piece under a denim skirt, carrying nothing but a water bottle and a small makeup kit tied around her wrist. Diana felt a keen satisfaction surveying Lucy's proportions, the rightness of her shoulders, her waist, even the smart length of her hair.

'You'll have to share my towel, is that it?' Diana said from behind her sunglasses.

The pool was filled with children celebrating their release from school, rowdy and irrepressible. Diana spread her single towel down at the far end and they sat together at the edge, their calves dangling in the water. The pool, protected and bejeweled, spread out before them in its vastness. The sound of traffic on Houston was distant yet comforting.

'How do you know this place?' Lucy said.

'I know all the pools,' Diana said.

'Why don't you go to the beach?'

Diana didn't explain that she only felt safe in Manhattan, hugged between the rivers, aware at all times of what was up and what was down. She leaned into the reticence which had by now become natural to her, and which took on an air of glamour when paired with bravado. Lucy had no trouble keeping them both entertained. She had a keen memory for what were apparently years' worth of stolen anecdotes, bar stories, family secrets. Her brother was a frequent protagonist: his troubles, his cruelty, the things he had stolen, the people her father had called to keep him out of prison.

In the second hour, while Lucy's voice sped along over the contours of past summers, Diana noticed a pair of adolescent girls staring at them across a stretch of shallow water. The girls were long-haired, silky and full of themselves in pink bikinis which presumed more adulthood than belonged to them, and they alternated between whispers and shrieks. 'But he just did it again the next month,' Lucy was saying. 'Can you believe that?' Across the pool the bolder girl pointed at her, Diana, and gave a high laugh. Diana felt heavy. Her shoulders were too hulking even to remain upright. She hated the girls, their dark eyes and spoiled smiles, and simultaneously she felt grateful to them for their ruthless obedience to the truth. She made the smoothest possible entrance into the safety of the water, so that only her head was visible, and circled around in front of Lucy, shielding her eyes with her hand. Lucy talked charmingly. She hadn't noticed anything.

As June meandered into July, Diana introduced Lucy to the Manhattan pools. On Saturdays they tried to visit two or three in a single afternoon. As they trekked on the subway from one set of locker rooms to the next, damp-haired and giddy with chlorine, Lucy outshone whatever else was on offer in the growing summer heat. The freckled tan on her chest had no rival. And the fifteen seconds of the weekend Diana cherished most were those in which she spread a triangle of sunscreen onto Lucy's upper back: She felt the pressure of Lucy's muscles straining toward her and the brute inside her shivered.

Lucy enjoyed those miserable cold showers at the pool, she laughed at the ads on the subway, she smiled at the idiot kids who raced around her street on scooters and nearly pushed her into traffic while she coolly produced her building key and shouted, like an overworked sister, 'Don't forget to drink some water!' When Diana, ravenous by the time she got Lucy into bed at seven or eight in the evening, bruised Lucy's hips without meaning to, Lucy liked this too.

Falling in love was the just reward for Diana's years of stoicism, for all that grief that had not, in fact, been wasted, because it had yielded her this golden future. But doubts arose after Lucy fell asleep. Diana began to have thoughts that hadn't troubled her in recent years, during which she had been so callous toward women that she had no need to be afraid of them. If it was the case that when she was a teenager she had been greedy, tactless, wounded, ugly – for she must have been all those, to have been so hated – it was inevitable that those qualities were still lying in wait beneath all her established charms, her boldness and her polished style, her significant silences, the shoulders which she had learned to hold just so. Since she had come to the city she had never disclosed to anyone this ghost that clung to her: the person she had been before. While Lucy slept in the cave of her arm, smelling of Coppertone and the lemon juice she combed into her hair, Diana looked around at the possessions which attested to the extremity of her solitude. The clock above her closet was not accurate, since no one consulted it; the costumes which were her city clothes hung flaccid and emptied of their authority. All these

allures she pretended to, the allures that had ensnared Lucy, would soon be discarded as false tricks.

This doubt was a slender cup into which Lucy's desire fell. Didn't Lucy call Diana first thing on Saturday mornings and sometimes on weekday afternoons, too? Didn't Lucy ask Diana about her favorite candies and which breeds of dog she admired when they passed gaggles on the sidewalk? Didn't Lucy let her fingers linger on Diana's waistband at the poolside? Diana's mother, a timid woman who was unequal to what life demanded of her, had said only one meaningful thing about what Diana had endured: that adulthood would be more forgiving. Diana had not believed her, but she had prayed that her own skepticism would be contradicted. And perhaps Lucy was proof that her mother had a little wisdom.

While Lucy was on her arm, among her friends, Diana's doubt struck her as insubstantial, like a memory left over from another world. Nothing fortified Diana so much as attending a party with Lucy. While lounging beside Lucy on that same sofa in Minta's apartment, at a party later that summer, Diana felt the warm, lazy safety of a lizard in the sun. She was listening to Lucy and Minta talk about their hometown in Ohio. They had known each other in school, but they hadn't been friends. 'I always liked you,' Minta said, 'but you were just so popular. No one could get near you,' and Lucy said, teasingly, 'But you *did* get near me!' and the two of them laughed.

'The whole thing was just awful,' Minta said. She looked tired and edging past her prime. Smoking had loosened her skin. In her voice high school seemed especially distant, a place far beyond the rivers. 'Wasn't it?'

'Oh, it was high school,' Lucy said. 'It's so bizarre. Nothing about it made sense. Right?' And she began to describe the hierarchies and misplaced priorities and the intense, impossible passion she had felt inside herself then, all the time, the sense that she was filled with a manic energy which could only be temporarily relieved through athletics or teary conflict-resolutions. She described this with laughter and a little bashfulness, as though it were embarrassing, in retrospect,

how important everything had seemed. Then Lucy said to Minta: 'Do you remember Isabel?'

'Isabel Walker?'

'Isabel Garcia. Who came when we were sophomores?'

'Barely.'

'The thing I really remember about high school, to be honest, is how in love with her I was,' Lucy said. 'The first girl I was really in love with.'

'Isabel Garcia?' Minta said. 'Really?'

By the time Isabel had moved to town, Lucy said, she had been worrying over her attraction to girls. But when she met Isabel it was undeniable. They got to talking during a biology class and met regularly in the evenings, at each other's houses, for months. At school they didn't acknowledge each other. God, it was harrowing to think of now, Lucy explained, since she had been so in love with Isabel, and yet at the time she felt she had no choice but to deny it.

Lucy and Isabel had agreed that their relationship would be an absolute secret: Neither of them was interested in being branded among their classmates. In order to facilitate their cover, they agreed that they were allowed to have boyfriends. Isabel was too busy to have a boyfriend; she spent her afternoons playing soccer on the JV team. But Lucy had a boyfriend already, the first in a series, and she really did feel warmly toward him. Their first explorations had been sweet – his inherent gentleness, her obliging fascination with his penis. But her interest in him was not comparable to her feelings for Isabel. Nights after she had spent a few hours with her boyfriend, she would sneak into Isabel's house, just two blocks from her own, and spend hours writhing on a basement sofa with Isabel. Isabel was madly in love with Lucy, too. Once, Lucy recounted, she and Isabel had stolen some time together in the back of Isabel's mother's car in the afternoon, while her mother was inside speaking to an administrator, and Lucy had pulled on Isabel's jersey in her hurry to dress before Isabel's mother returned. Afterward when Lucy went to her boyfriend's house her boyfriend said, What's that you've got on?

Lucy was beside herself with fear that he would realize it was Isabel's jersey and find her out. But he quickly forgot.

By this point people on the couches around Lucy were listening. Her ability to captivate a room could not be attributed to her beauty alone; perhaps it was that fierce energy she recounted from her teenage years channeled into a new adult expression, animating her face and hands.

'And what happened in the end?' someone asked. 'Between you and Isabel?'

It went on like this for a year, Lucy explained, and by then she had a different boyfriend. Isabel never got a boyfriend of her own. She was heartsick. She was starting to suspect that maybe it wasn't all bullshit between Lucy and her boyfriend – that maybe there was something real in it. While Lucy was with her boyfriend Isabel would text her constantly, and when she failed to respond Isabel would grow by turns teary and livid. She would approach Lucy's friends in the halls or the cafeteria and ask: Was Lucy all right? Had they heard from her? But her friends hadn't known that Isabel and Lucy even knew each other, and this made Lucy terrifically anxious. What am I supposed to do? she said to Isabel. Even though we know it's fake, *he* doesn't! What else can I do?

One evening the boyfriend slept over at Lucy's house. The two of them were woken in the darkness by Isabel standing over the bed. Lucy and Isabel knew all the back routes into each other's houses, they knew how to find the hide-a-keys and the loose window sashes even in the dark. You sleep with him? Isabel shouted. With *him*? Isabel had watched them go to bed from the street, through the window. Lucy forced Isabel out of the house before her parents realized, but the boyfriend knew something strange had happened. In the dark he hadn't recognized Isabel. But he had heard her. Who was that? he asked when Lucy returned to bed. Lucy, in her panic, could only say: My brother, it was just my brother, go back to sleep.

She and Isabel never spoke after that. Lucy's boyfriend was confused and alarmed, however much she tried to placate him, and

could not decipher the truth of what had happened. They broke up. Later, at a party, Lucy's friends drunkenly accused her of sleeping with Isabel: What are you doing with that girl? they said. Don't you know it's obvious? It was the performance of her life, acting as though that rumor was so absurd it could only embarrass those who repeated it. When inwardly, of course, she was terrified of anyone discovering the truth.

Lucy paused and looked at Minta. 'Did you know, did you hear about me and Isabel back then?'

Minta had heard rumors about Lucy, but there were rumors about girls all the time, she hadn't believed it, she remembered merely being afraid of the day when the rumor would concern her, Minta. It was clear why Minta and Lucy had been afraid. After that week when she had asked around after Lucy, Isabel was teased and mocked relentlessly where before she had been ignored. Once she was surrounded by a group of boys and dragged down to the pool, where they threw her in the water along with the contents of her backpack.

But – it was strange, Lucy admitted, she had never understood it – if Isabel was targeted for her relationship with Lucy, Lucy herself, after that terrifying moment at the party, was never accused of having anything to do with Isabel again. And in fact, in the years afterward, she slept with other girls at school, very quietly, with none of the obsession or emotion she had felt for Isabel, and no one was the wiser.

'How many?' Minta said, with a look of admiration. 'I mean, that time that we kissed, I thought that was a crazy thing, for both of us.'

'Oh, I don't know,' Lucy said. 'Ten? Fifteen? But I didn't get over Isabel. It was all just kind of sad. But I felt like I had to do it. I was trying to feel free, or to like myself, or something. Even secretly.'

Lucy laughed and made a rueful face to show everyone listening that there was no reason to feel sorry for her. It was all so far in the past that it seemed silly to even think of it now.

The room grew loud again with the sounds of other people's conversations. 'I could use another drink, baby,' Lucy said, her hand landing lightly on Diana's thigh. Diana trembled. She rose and turned toward the kitchen, but Lucy pulled her back.

'Wait,' she said. Lucy's lashes were long and delicate and evenly spaced, and she looked up at Diana from beneath them. 'You don't think I'm terrible for all that stuff, do you? What happened in high school? Because, you know, I've never treated anyone like that since – I would never treat anyone that way now, the way I treated Isabel. You know that, right?'

'Of course,' Diana said. She went to Minta's kitchen, found the lime, cleaned the knife.

When she had made her excuses to Lucy she hurried home and by some instinct double-locked the door behind her. She was up all night considering it. Lucy was a type she had never imagined before: a girl who, by virtue of charm and a willingness to give blowjobs, managed not only to remain popular and beloved in her adolescence but, throughout that time, to conduct secret liaisons with the other closeted ice cream scoopers and lifeguards of her hometown, sneaking around in cars and public bathrooms and finished basements in an ecstasy from which she emerged only to repeat, at the next house party, the slurs to which she herself was never subjected. And not only this, but Lucy had graduated from this small-town regime of covert and ecstatic hedonism into life in the city, where she was praised for her lesbianism and instantly forgiven the mistakes of her youth. How many girls like this had existed in Diana's own hometown? How many had there been in any town Diana had driven through, in the towns where she had gone to play soccer? Had they only been the most beautiful girls, the most popular girls? But they couldn't have been, because there had been the kinds of girls Lucy had fooled around with, too, the girls like Isabel and Minta who she wouldn't acknowledge at school. And for Diana there had been nothing – only the apparent senselessness of coming out at fifteen, which she had thought noble, and the loneliness she had believed would never leave her. She felt, at the time, that there was no choice about coming out. Everything had seemed so incontrovertible; it had not occurred to her to conceal her impulses, nor did she think she could have. She was too self-righteous to entertain conflicted feelings. And even though

she hadn't intended to come out, hadn't Isabel been just like Diana – principled, unflinching in her sexuality, unable to stomach even the charade of a boyfriend, tortured by her classmates for these very qualities?

It wasn't Lucy who had called Isabel names and thrown her into the pool. But wasn't she responsible? Wasn't it true that both Isabel and Diana had suffered at the hands of girls like Lucy, perhaps even more so than at the hands of their straight classmates, because it was girls like Lucy who might have helped them, if they had had the strength or the selflessness? No one could have hated Lucy, even if she had come out. The lives of girls like Diana would have been infinitely easier, if only one girl that everyone envied had stood up and said, *It's me you're talking about.*

Early in the morning Diana let herself out onto her stoop, lit a cigarette, and called Minta. On the third try Minta answered. 'It's six o'clock, Di,' she said. 'Is there an emergency?'

'Listen,' Diana said. 'Aren't you even a little mad at Lucy? I mean, don't you think she could've – I don't know – don't you think it was fucked up, what she put Isabel through? And you too! You kissed, and she acted like it never happened.'

'So did I,' Minta said. 'We were basically children. Did Lucy put you up to this? Is she freaked out or something?'

'No –'

'Diana, we can't talk about Isabel Garcia at six a.m. I'm sorry. Go back to sleep.'

Diana smoked until she was sick and then she ran a couple of miles to remind herself that her experiment with weakness was over. It was Saturday. In a few hours Lucy would call her with that coy, thrilling edge to her voice to ask, 'Where should we go today?' – which almost persuaded Diana that she finally belonged in this elevated social realm which she had feared she'd never enter: the realm in which men were rich and women were beautiful, and the frail ugly underbelly of human life was only pavement over which she rode in a powerful car.

They went to the Dry Dock Pool. Lucy wore a white swimsuit which was too bright to look at directly, and which Diana could only take in by holding up her camera: Lucy belonged in that little screen. Diana felt the absurdity of having believed she might belong on a little screen, too, at full brightness.

'God, when Minta said you were special, I had no idea,' Diana told her when they were in the water.

Lucy smiled without surprise. 'What do you mean?'

'You know what I mean,' Diana said. She swam up to where Lucy sat with her legs dangling at the edge of the pool and pulled herself up between Lucy's knees. 'Haven't you noticed I'm falling for you?'

This was the way to say it to a girl like Lucy: like it was a challenge, like the girl was at risk of being made a fool. You couldn't be mistaken as a beggar or a suitor. You couldn't offer it up like a free gift.

'Are you asking to be my girlfriend?' Lucy said.

'I'm not asking,' Diana said, grinning, so that it was like a joke between them. 'What else do you think I am?'

Oh, she had been right, right about every single thing. Lucy bit her lip, squeezed her knees around Diana's waist. Around them were the shouts of 'No diving!', the blare of a horn on an adjacent block. Lucy laughed, and then said, with a plump, impish kiss – 'Well, I guess it's official.'

In the weeks that followed, when Diana made those love confessions she had never made before and heard Lucy return them, she was thinking of Isabel Garcia. These were the slick lashes Isabel had seen when she admitted her devotion. This was the trembling mouth from which Isabel had heard those impossible words – *I love you, I love you* – this was the frenzied energy with which Isabel's face and neck had been covered with kisses. This was the obscene, perfect body which Isabel had lain beneath on the couch in the basement, this was the spot at the small of the waist where Isabel had pressed her hands. Lucy was so intoxicating that in moments Diana almost believed in the love she was imitating, she felt suffused by Isabel's passion. Then she remembered to ask herself: What had

Lucy's face looked like in the hallway, in the cafeteria, with her boyfriend's arm slung over her shoulders? Had Isabel been picturing that passing face when Lucy nuzzled her in the basement? When Lucy sighed, had Isabel envisioned her knees on a sticky carpet, blonde strands caught against her cheeks, her mouth stretched around a purple cock?

'I should've known you'd go for a girl like her,' Minta said to Diana at their neighborhood diner. By then the summer had meandered into its dog days.

'A girl like what?'

'A men's-fantasy girl. The kind of girl you have to fight over at the bar. Who likes it when men fight over her.'

'Was that what that whole Isabel story was about?'

'The thing about Isabel Garcia?' Minta said. 'I don't think so. I appreciated her honesty about all that. What could any of us do back then except try to get through it? Kimmy's the only person I've met who's all smiles about it,' she said. Kimmy was her girlfriend. 'She talks about high school like it was so cozy, just being with her family. And you've never complained about those years either. You have no idea what it was like for me and Lucy, the town we grew up in.' She shook her head, as though to shake herself awake. 'Has something happened between the two of you?'

'Not really. I just thought that story was kind of an attention-whore thing.'

Minta rolled her eyes. 'Come on. You were obsessed with her about ten minutes ago.'

Diana wondered: Did Lucy confide in Minta about the canceled dates – the way Diana sometimes left before midnight, as though she had somewhere else to be – the times Diana screened her calls – the way Diana hid the face of her phone when they lay next to each other? Had Lucy begun to notice?

In the bottom of her mind, where her slender doubt lived, Diana felt again the imperviousness that had sheltered her in the past few

years. When she looked at her phone she saw that Lucy had texted her, but she put off responding. Probably Lucy had never waited half a day, let alone a full one, on delivered. But Diana knew how it felt: the rereading, the ambivalence, the follow-up text, the sickening daydreams. What was especially painful was the moment in which that breezy response finally came and immediately it was all rescinded – everything you had felt – the dark and lonely futures you deserved which had opened up before you like tunnels – and within minutes you believed wholeheartedly that you had never worried at all, that you had always been busy, happy, disinterested.

On the eve of Lucy's birthday, in August, Diana arrived on her stoop bearing flowers and a wrapped jewelry box. Lucy answered with surprise. They had been seeing a little less of each other, owing to Diana's new, contrived avoidance; they had exhausted the local pools. Their relationship had become almost casual again, and because this is not the natural order of intimacy there was an awkwardness to it.

Lucy took the flowers from Diana. They sat at a little table by her kitchen window, the air hot and fragrant, the sounds of the subway serving as gentle reminders to Diana that she belonged to the streets and the underground, as a stray animal belongs. Lucy unwrapped the chain bracelet Diana had brought, and Diana clasped it for her. The sight of Lucy's fine hand, which Diana had so craved when she had seen it touch the forearm of the bearded man, was overwhelming. She lifted Lucy up onto the windowsill and softly lifted her dress. She breathed to Lucy that she loved her.

Lucy kissed Diana on her cheeks, on her neck.

Diana could feel the presence of doubt glimmering between them, a wariness in the compact, gracious way Lucy held her body. It terrified her that Lucy's gestures claimed to emanate a warmth which Diana could not feel. Yet this wariness was the effect Diana had hoped for over the previous weeks. She reminded herself that power and terror went hand in hand, that any extreme sense of supremacy

or impotence was a place from which other people looked distant and unlikely, and could not be understood.

The next day a picnic was being held in the park to celebrate Lucy's birthday. Diana went out for beer and arrived late. In the meadow she lingered among her friends, said hello to Minta. Lucy, radiant in a sleeveless red dress, was surrounded by well-wishers and little coolers of ice cream and drinks.

'She really can be a bit over the top,' Minta said as she watched Lucy gesticulate, with a frown that made Diana's heart punch up. It was she who had done this – changed Minta's mind.

When Lucy finally spotted her Diana steeled herself. She touched her silver ring and dug her heels into the ground. Lucy made her way through two groups of girls, smiling, touching forearms gently, until she reached Diana's side and leaned forward to kiss her. At that moment Diana put her hands in her pockets and leaned away.

Lucy's face shifted. Diana could see confusion rise and alongside it something worse – what she thought was resignation – as though, while a part of Lucy could not believe it, another part of her had been expecting this. Once again Lucy moved to embrace Diana and once again Diana leaned away, as if Lucy were contagious.

'What are you doing?' Diana said.

Minta was watching them silently. Lucy raised her hand again. It hovered there for a moment.

'Aren't you going to wish me a happy birthday?' she said finally.

Diana laughed and said to Minta, 'What's going on with her? She's obsessed with me.'

Lucy's waist as she walked away was haunting in its sweetness, so too her shoulders which had grown freckled on their poolside afternoons. Diana closed her eyes against the sight. She heard the faint hiss of a can opening, and Minta's voice saying, 'Diana, what the fuck?'

She had wanted urgently for Lucy to comprehend some shadow, at least, of what she herself had inflicted on a girl she claimed to love – some semblance of that anxiety, that despair, finally that violent public rejection, not just rejection but in fact the denial of any involvement

at all. Diana was certain that now some essential balance would be restored. It was not for some people to suffer everything, and others nothing. Not while she had her wits and her resources.

She opened her eyes to glimpse Lucy just disappearing over a small hill at the edge of the meadow and felt instead, with gravity, her own regret. The sight of Lucy's back seemed to radiate pain. This was what she had intended. But for what had she punished Lucy? If not to offer her the chance to step down from her rarified place, deepen her empathy, show she was human?

She found Lucy on a bench beyond the meadow, where the picnickers would not see her. Facing the bench was an artificial lake crossed by a little stone bridge. Diana sat beside Lucy, took her hand between her two palms and kneaded it. Lucy allowed her hand to be taken. The sun moved over Lucy's cheekbones and lashes, over the red folds of her dress and the skin of the lake. Diana was beginning to comprehend Lucy's experience: So this was what it felt like to inflict pain and to participate in it. This was what it was to relish power and – she watched pain and shame battling in the jaggedness and trembling of Lucy's lips – to simultaneously regret it. She felt a profound sense of understanding settle over her, her body anchored itself against the bench, and she held Lucy's hand more tightly. How could she have been so stupid, how could she have hoped she and Lucy would love each other, when they couldn't yet understand each other? She had known nothing of Lucy's effortless power, and Lucy had known nothing of the obscure, miserable frustration of being excluded from the contest of love. She could feel in the tangle of her fingers that Lucy was experiencing this breadth of empathy too. The past seemed to retreat to a small and pivotal place in the distance. Diana would forgive Lucy for the story of Isabel, and Lucy would forgive her for this ruined birthday.

Tears crept down Lucy's face. She held Diana's hand more tightly. The bracelet Diana had given her was hot against their entwined wrists. 'God,' she said. Diana held her.

'I have to go back,' Lucy said then, freeing Diana's hand.

Diana couldn't go back over the hill yet. 'I'll come tonight,' she said. Lucy walked with square shoulders, her back held straight.

That evening Diana walked to Lucy's apartment with a fierce, rare feeling of joy. Tonight Lucy would repent for what she had done to Isabel, and Diana could made amends and show her sincere self to Lucy: the self which had not always been rakish but had once been outcast, the same self which loved Lucy and forgave her. But she found, when she arrived, that there was no answer. Perhaps Lucy had drunk too much at the picnic and passed out already, or lost track of time at some party?

Diana waited half an hour in the warm darkness, aware that she was in the grip of a hopeful, piteous devotion to which she had hoped to be invulnerable. Then she walked home and slept with the windows open.

In the morning she went back to Lucy's. The sun moved over her, and she felt hopeful and lightly sick. She rang Lucy's bell four times. Finally Lucy appeared on the stoop. She was still wearing the red dress, though it had suffered some grass stains since the previous afternoon. Diana remembered the immaculate desire she had felt when she first encountered Lucy, fervent and doubtless, and the greedy pleasure of watching her bewitch a whole room. She reached out to embrace her.

'Don't touch me!' Lucy said, pushing the hand away. Her face was tight. 'Why are you here? Why the *fuck* are you here right now?'

'Won't you just have a cigarette with me?' Diana said, after a moment. 'Please, come outside?'

They walked a block in silence. At the corner Diana bought a pack and a lighter and they stood under the bodega sign together in a raw breeze. Lucy's lashes were clumped together a little, but Diana loved her no less.

'Why are you here?' Lucy said, waving the lighter around. 'You've been shitty to me for a month! And what the fuck was that in the park yesterday? Okay, I get it, you don't want to be with me anymore, but did you have to shit on me in front of my friends, on my fucking birthday? Couldn't you just tell me like a human being?'

'But that's not what's going on, not at all,' Diana said. 'I do want

to be with you, I just – I thought –' and she stopped. She looked at Lucy. 'You don't understand,' she said, 'do you? This is about Isabel.'

'Isabel?' said Lucy. 'Isabel who?'

'Isabel Garcia!'

Lucy squinted at Diana. 'Do you know her?' she said. 'Do you know Isabel from somewhere?'

'No, I was trying to show you – I wanted you to understand. About high school. What it was like for Isabel. What it felt like if you were gay then, and if you –'

'High school?' Lucy flicked ashes onto Diana's shirt. '*High* school?'

D iana could make it over the bridge, out of Manhattan, all the way down to Sunset Pool. She knew where the river was; it had only switched sides.

If she lay on her back at the poolside and braced the concrete, with a shirt draped over her face to shield the sun, she became a part of the wide, generous summer. She could hear the size of the pool, the moods of the children shouting, the little dives that splashed the water up and the obligatory shouts of the lifeguards. Early September: The air had a bright, soft sound to it. The cry of the whistle was silver.

When the sun had exhausted her, she gathered her things and went to the bank of showers. She rinsed her face in the stream. She heard the slap of flip-flops, the dull sound of metal keys. Then she heard the voice she knew was Minta's saying, 'No, put that under the towel, over there.'

She turned and saw Minta and her girlfriend, still dry, with their arms full of towels and magazines.

She shook the water from her hair and moved toward Minta. She didn't feel afraid. She had crossed the bridge and drunk up all that light. Adulthood was more forgiving. 'Hey,' she said, and touched Minta's arm. Minta turned toward her. Her cheeks grew taut with surprise, the aging looseness of her face disappeared, and as her mouth curled with disgust she looked as fresh and livid as she must have at sixteen. ■

SOPHIE GLADSTONE
Kathleen, 2022

THE FULL PACKAGE

Zoe Dubno

I had decided to allow my grandmother to take me shopping. Her campaign to go shopping with me had been unrelenting since I was two, around the time I announced I was finished going in my pants and wanted to learn about what happened in the toilet. Her desire to march me around department stores was so strong that she ended most phone calls with a reminder that I was a teenager with a *body like a clothes hanger* and that it was *cruel and unusual* not to let her, a short busty woman with a love of fashion and a waistline like a soda can, dress me.

I rarely let her take me shopping for two reasons. One: if I did, I had to take the train from New York to the suburbs of Philadelphia so I could spend the weekend browsing at a department store called Boscov's, which sounded more like a type of chocolate-milk syrup than a store, and sold things made out of synthetic materials that looked like clothes for a suicidal-depression-themed Barbie. The other, much more important reason, was that she always managed to turn these shopping sessions into weekend-long summits on my hair, my relationships, my grammar and my future life prospects. Even if I did go, it was never just the shopping. Entreaties would be made: I needed to stay longer so she could take me to see the sculpture garden, the symphony orchestra. It would be expensive, but it would be worth it to

teach her nail-biting heathen of a granddaughter something about life.

Planning my life was one of her life's great joys. For a period she thought I should be a lawyer, like her husband, my Pop-Pop, but then sometimes she would get annoyed with him, and by extension the entire legal profession, and so she would decide I was *too good* to be a lawyer. Whenever that happened she remembered that everyone in her mother's family had been a doctor, except her mother who was forced to be a nurse because of sexism, so I should be a doctor to right the wrongs against my great-grandma. The evidence was incontrovertible. I was in AP Biology. I was becoming a doctor. Then one day when I was in tenth grade she saw a science ethicist with fantastic hair on one of the cable morning TV shows. Of course, science ethics was my calling because it married the two passions she'd decided I had, law and biology.

Oh! Sweetheart! You've got to see this woman. She was so ELEGANT! she said after I finally picked up the landline at my parents' house.

My brother and I usually screened her with caller ID because we knew that if we answered and it was Grandmom we'd never be able to do even a third of our homework before dinner. She mandated at least forty-five minutes on the phone, not as an official rule, just in practice. If you had to hang up she would say *just hold on a minute* in a way that was something between a command and a plea and so completely disarming that it never failed to get you across the forty-five-minute mark.

Once I actually answered, it was easy for me to spend hours talking to her on the phone, and clearly other people felt this way; her conversation was in high demand. Every once in a while she'd say *hold on, don't go away* and put you on hold to tell Lorna or Edith or whoever had called her for some entertainment or advice that she was *on the phone with her granddaughter* and absolutely *not to be disturbed.* I'd hear the click of the phone line switching back to me and she'd say something like, *anyway, her mother wasn't as dumb as everyone thought she was. And boy was she built. But she had a horrible death. She was decapitated in a car accident. I can't believe I can't remember her name.*

This was always much better than my homework.

Even though I saw my grandma nine or ten times a year for the Jewish, American, and made-up holidays that we celebrated, apparently I never saw her. *All my friends' granddaughters come over every day after school*, she would tell me as I was trying to write my lab report about the Krebs cycle. *They bake cookies together and listen to classical music.* I told her this was such an obviously fake thing for grandmothers to do with their grandchildren that I knew it was a lie. *And even if it weren't*, I'd say, *would you really want to have a granddaughter in high school who goes and bakes cookies with her grandmother every weekend?* Appeals to normalcy always worked. She was all for anything we could do to be on the high end of normal. Her main aspiration was fitting in, but with a little extra.

Her own mother had bought her the nicest clothes they could afford in the hope she would stand out in the right way at *the very best public girls' school in Philadelphia.* She was always remembered at reunions, she said, as the girl with incredible, tailor-made outfits, even though she grew up in a ramshackly multifamily in South Philadelphia, not *on the Main Line* like the rest of her cohort. Which was why, as an adult, she tormented my mother in the 1970s by making her wear pink cat-eye glasses and mustard-yellow, coordinated bell-bottom sets straight out of *Mademoiselle* magazine. My mother's outfits didn't have a similar effect on her classmates.

One afternoon in January, when I was sixteen, I was on the phone with my grandma and we were discussing the differences between Martha Stewart and the Barefoot Contessa's recipe styles – *the Contessa has a heavier hand with the oil, which explains the obvious difference in their appearances.* My defenses were weak because it was winter break and I was bored and everyone from school had gone on various vacations while I was stuck at home watching my brother play video games, and so, without thinking too much about it, I agreed to take the train down and go shopping with her.

When I got to her house I remembered why this was something I didn't do. I was presented with a three-ring binder full of photographs

of female celebrities torn from magazines that I was forced to peruse as a sort of vision board of doom. The binder had separate tabs for me, my mother and my aunt. In my tab were J. Crew ads, pictures of Gwyneth Paltrow, and women with Republicanly thick blonde blowouts wearing cable-knit Ralph Lauren sweaters. *Your hair looks like it's been caught in a Mixmaster,* she said the moment I arrived, grabbing my tangles and assaulting me with a brush.

I had agreed to come on the condition that we skipped Boscov's. I had a suspicion dating back to early childhood that the gray-brown carpet was a sort of primordial soup from which the hideous gray-brown clothing on offer emerged. It used to give me visions of mottled wool rising up from the floor and racks and ensconcing me in a scratchy full-body tube sock. Instead we were going to a consignment store where the rich ladies like her friend Marlene Silverberg – who had *great taste* – sold their *designer-brand* clothing.

We were whipping around in my grandma's massive silver Toyota, traversing her neighborhood made of near-identical houses, all constructed in the late sixties from a set of four plans that differed only in window, door and garage placement. We passed a few that looked exactly like hers, which she said was Plan B, *the most elegant plan.* Even I had to concede hers looked the best, with her elaborate landscaping of the standard suburban front yard, which she referred to unironically as *the grounds.* We were sipping our chocolate-flavored water ice, when she rolled her sleeve up and showed me a Band-Aid on her right forearm.

Remember how I had a disgusting brown spot here?
I didn't.
Well I went to the dermatologist and he said it was nothing.
I was glad.
No, wait.
She swerved slightly into the shoulder of the road whenever she spoke because of her need to make eye contact with me.
So then I went to another dermatologist and she said I shouldn't worry about it.

I was glad.

And then I still had a funny feeling about it because it was a raised brown spot, so I told her she should biopsy it, and she said she wouldn't. So I went back to the normal dermatologist and said he should biopsy it and he did it.

So you won?

Hold on hold on – guess what?

She looked at me with her enormous, almost bulging blue eyes.

Thank God it was cancer!

She turned to me and smiled her big, winning smile. People always say that old people begin to look like children, but there was something so girlish about my grandma that I'd never noticed before. Her strawberry-blonde bob framed her full cheeks and her front two teeth were slightly longer than the rest, which gave her the appearance of a cartoon bunny. She wasn't really looking at the road, and people were honking at us because she was drifting into the right lane whenever she turned to look at me. I estimated a 30 percent chance we were going to die in the car, but I didn't mind because I was laughing uncontrollably. I repeated *thank God it was cancer* back to her as a question.

Yes, thank God I was right it was cancer and I made them check so that they got it off.

So you're happy you have cancer?

Well I don't have it anymore, they burned it off. And now I have an unsightly wound.

We got out at a strip mall with a kosher deli and a nail salon and a dollar store with a piece of printer paper that said OR MORE in Comic Sans taped up next to the dollar. Next door was the consignment store with a jaunty sign written in loopy cursive and a mannequin with a fusty pink tweed skirt-suit in the window. I followed my grandma in and resigned myself to the suffering to come, which I knew was a part of life on Earth.

Shopping was generally a not fun thing for me. The girls at my school wore a uniform of riding boots, down puffer vests and a specific

brand of black yoga leggings. At one point I considered adopting this uniform, but my mom said she would not pay the 100-dollar price of the yoga leggings. She said I clearly lived in a different tax bracket than she did and that I could get normal yoga leggings at one-tenth the cost. Obviously the point of those specific yoga leggings was that they were 100 dollars, so that left me nowhere. I didn't even like how they looked, or much else about the girls in my school, but I still desired their approval for obvious reasons documented in all films and media about teenagers.

I wasn't *against fashion*; I wasn't one of those people who need to make it into a whole statement about their *intellect*. On Thursdays I swiped the Styles section from the newspaper on my way to school. But of course I didn't really have the occasion to wear runway fashion in the tenth grade. Also those clothes cost much more than the yoga leggings.

Instead, shopping meant meandering with my mom around big stores in SoHo full of millions of random things, both of us feeling lost and frightened. I hadn't even learned about hating my body yet and I still felt that way. We watched other mother–daughter duos in the store move about as if they had a purpose, fawning over tunics and *accessories* and selecting items decisively for one another as if this were an arena guided by logic and order rather than weariness and confusion. It could sometimes get very bad, like when my mom held up some item as a suggestion for me to try on and I said, *Do you expect me to take advice from someone wearing a dress that ugly?* Her dress wasn't even that ugly. It would take a good half-hour of not speaking to each other from across the store to recover. We usually left with tops with *big personalities* and skirts I was convinced could be the *secret to my new life*, and then I continued wearing jeans and my dad's overlarge sweaters to school.

My grandmother held up a navy pinstripe suit with big shoulder pads and said, *Oh that is beauuuutiful* in the grave and rapturous tone she used indiscriminately to refer to an oil painting or a particularly good tuna sandwich.

Where am I wearing that?

To school.

I'm not wearing a suit to school.

Why not?

I'll look insane.

No you'll look beauuuutiful. Like Katharine Hepburn. You should wear these things now before your breasts get too big.

I looked down at my chest and couldn't understand what she was talking about. I had been waiting to grow this thing for years.

We could give it to Mommy, I said. She'd have more use for it than me.

Than I –

Than you what?

She was now using her fancy-diction transatlantic voice. *No. The proper grammar is – she has more use for it than I. Don't they teach you anything at that school?*

You want me to speak like I'm in some kind of Shakespeare thing?

Her thin, strawberry-blonde eyebrows scurried up her face.

Shakespeare thing? What's wrong with you pussycat? You should always speak the correct way even if other people don't. You're better than other people.

She thrust the suit at me and I stumbled through the synthetic satin curtain into the fitting room.

Most girls, I felt, had some guidance about shopping from their mothers, but mine had no interest in it. She had a lot of black clothing that made her look like a Left Bank intellectual who works on an organic farm. I mean this in a nice way – she looked like she didn't care too much about her appearance, but was still attractive and strong. Aside from the Theory suit she bought with much fanfare to testify at a congressional hearing for work, every garment simply *entered her life.* They just appeared in her drawers and then on her body for all time. She wore sweaters her sister left at our house, a few tops her friend didn't want anymore, and because I was taller than her by the time I left elementary school, most of the jeans I'd worn since the age of ten.

The girls at my school had mothers that gave them hand-me-down designer clothing – my friend's mom took pity on me once and gave me an Agnès B bateau-neck top. With my mother I was always doing hand-me-ups. I understood why she hated shopping so much. It wasn't that she thought it was frivolous, or judged women who spent lots of money and time on their clothes. She was scared of shopping. Even in a downtown boutique full of asymmetrical tunics or whatever, the kind of place my grandma would never go, my mom still felt her mother's shadow following her around and saying *on you, that blouse would have nothing to recommend it.*

But grandparents don't loom quite as large in the psyche as parents. Parents are your jailers, your tormenters and your superegos; they control your access to food and shelter and a curfew after 11 p.m. Grandparents are kindly benefactors who ply you with candy and presents in exchange for attention and kisses. They've already exhausted their energy trying to perfect your parents, it's not your problem.

There was no mirror in the dressing room so I had to emerge for inspection. When I pushed through the silky curtains there were four women huddled around my grandma expectantly, one who had accidentally dyed her hair purple with the shampoo that removes yellow from white hair. My great-grandmom used to do that when I was little and I thought it was natural, like it was a hair color people were born with in *the olden times* that didn't exist anymore.

UGH! You look GORGEOUS! Didn't I tell you she was the full package? Come here just a sec let me fix you. THAT BODY!

My grandma, who was more or less a foot shorter than me, straightened the waist on the trousers, which were just above her eye level. She spent a long time preening around the lapels and smoothing my hair down. She was always petting me and my brother as if we were her pets but I never realized the extent to which she herself was like a tabby cat – her reddish hair, her mercurial temper, and of course her desire to clean her offspring. I looked at myself in the mirror. I resembled a 1980s talk-show host, but I didn't mind. I felt like two little boys inside a suit to make an adult, though not exactly

the kind of adult I imagined myself becoming. I guess I made some kind of negative face.

You don't like it?

I like it but I don't want it.

Oh you're a fool.

No really, I don't want it.

When you're my age you'll wish you could go back and never take that off! You look like Grace Kelly but even TALLER!

The chorus of old ladies came to fawn over me, and while I managed to escape back into the dressing room, my grandma basked in the compliments about her tall blonde granddaughter. *Yes she gets her height from her father!* We drove home empty-handed, my grandma lamenting our suitlessness the whole way home.

When we arrived at her house, the only Plan B on the street, my Pop-Pop was outside using a leaf blower to clear out *the grounds.* He was standing under the oak tree next to a koi pond that my grandma had begged my Pop-Pop to dig into the grass, but which only ever held fish for one spring in the early 2000s. I turned to approach him, expecting to be grilled about my performance in history class or about his two great loves, Winston Churchill and the US Civil War, but my grandma dragged me away as usual because as we all knew I *belonged to her.*

We went through the kitchen to *the den,* which she had transformed, over the course of her fifty years in the house, into a Louis Quinze-style salon, and down into the basement. The dankness of the basement made me uneasy – there are certain smells one doesn't experience growing up in the city – and my eyes began to itch. I had already spent six hours as my grandmother's captive, and I knew that after whatever she needed me to do in the basement there would be a mandatory screening of the film *Gigi* in what was once my mother's room and was now an all-white mausoleum for cherub statuettes.

I paused at the bottom of the staircase. For some reason I had thought coming to my grandmother's would afford me *more* personal

space, but now I longed to be locked in my tiny bedroom as my brother and his friends consumed an entire ice-cream cake while playing video games about murdering people and my mom talked on the phone so loudly one wondered if she wouldn't be better served just yelling out to whoever she was trying to contact. I could say I was too tired to watch the film, go upstairs after my tuna hoagie, and savor sleep's respite until it was time to go home – but I knew that would mean my entire visit *didn't count*, and my grandma would call demanding the completion of our date for the next few months. She seemed to sense I was thinking of ways to escape because she suddenly gripped my wrist, digging into me with her long painted fingernails.

Just hold on a minute, I just want to see something –

She fished around on a rolling rack full of clothes with dividers marked with my mom's name, my aunt's, my uncle's, until she reached the marker that said MINE, pulled out a gray garment bag and unzipped it. Inside was a black dress, made from a sort of swishy suiting material. It was short, sleeveless and simple.

Here, you little brat – in reality she used her special name for people she loves, but I won't tell it.

I changed out of my clothes, careful to remain standing on top of my sneakers so I didn't touch the cold basement floor. My grandma carefully put the dress over my head and zipped me into it slowly. It closed exactly over my waist, then the zipper snaked up my back until the dress fastened perfectly over my bust. The rigid material fit every contour of my body, as if it were spandex that had stretched to cover me, but it was inflexible and secure. I looked in the mirror and saw her small form behind me. The dress would have been knee-length on her but it ended in the middle of my thigh. I followed her directive to spin around. I let my feet touch the cold basement floor and the hem of the dress fluttered. I suppressed a smile. She grinned.

Just as I suspected. ∎

SHOOTING STARS IN YOUR BLACK HAIR

Jack Latham

Introduction by Joanna Biggs

'No one has to have their photo taken,' Jack Latham would say to the women having their hair done at Mo & Co in Cardiff's Daisy Street, 'but if you feel beautiful, we can take a photograph.' The invitation was so simple, so easy to say yes to. 'Am I not having my photo taken too?' Mary, the woman on page 223, asked Latham. 'I feel beautiful.' In her portrait, Mary tips herself towards the camera, smiling with the left side of her mouth, just about. One eye is ringed red and the other is bruised – yesterday was not a good day, yesterday she fell – and yet now her hair is softly curled, artfully swept to her right, newly blonder at the tips. She is ready to face the world again. In fact – she looks like she'll launch at it, head first.

Returned to his home town in winter 2019, Latham spotted the salon from his flat across the street, and promised himself he would go once lockdown had lifted. His grandmother died at the start of the pandemic, and he had not been allowed to see her. When the salon reopened, from 11 a.m. to 3 p.m. on Thursdays and Fridays, Latham would make himself useful: sweeping up hair, chatting to the ladies, driving them home, carrying their shopping. Over the years that Latham made these portraits, he had to bear a break-up, a death, a parent's illness. 'I knew nothing bad could happen in a hair salon,' the recent divorcee in Sheila Heti's *How Should a Person Be?* says,

'and nothing out of the ordinary ever did.' To be in a hair salon is to be bubble-wrapped against the world – or at least that's the fantasy.

The photographs began with Debbie, the stylist who inherited the salon from her aunt Mo. She was worried her clientele was dying out, and asked Jack to take some photos to put in the window – wasn't he a professional photographer or something? Latham brought in an old wooden camera with bellows, which he mounted on a tripod. Sometimes, he hung one of the robes, flecked with gold, as a backdrop. Other times, he pointed his camera at the bonnet dryers, revealing a forgotten training head and an empty vase. These women aren't used to being looked at. Even the youngest of them, surely someone's daughter, folds her fingers into each other, tucks an instep behind an ankle, and stares off dreamily, almost absently. Only her blow-dried hair, flicking obediently under at the collarbone, draws the eye.

My hairdresser, Lotte, is younger than me by about fifteen years, but it often feels like she's older. She has come by her wisdom fairly; she has had hundreds, even thousands, of women come and sit in her chair with nothing better to do than talk about their lives. I like it that she asks whether I'm getting too hot under the dryer. I like it that she understands when I arrive with dirty hair. I like it when she says: why don't you go to therapy, why don't you just go there, why don't you try balayage?

'The shooting stars in your black hair,' Elizabeth Bishop wrote in 'The Shampoo' from 1952. 'Come, let me wash it in this big tin basin, / battered and shiny like the moon.' Bishop is washing her lover's hair – are the stars she sees light as it moves, or grey strands? – but think of the people who have washed your hair in your life and first it will be people who love you, like your mother, and then people who are paid to, like your hairdresser. (If you are lucky, you might be shampooed by a lover in between.) A trace carries over from those first washings whenever you are in a salon. Your hair might drop when you step outside, but mercifully the feeling lasts a while longer. ∎

CRAFTS

Join the *Crafts* community

Become a member of *Crafts* and you'll receive:

- Our beautiful magazine published twice a year, delivered to your doorstep
- Access to a digitised archive of almost 300 back issues
- Invitations to exclusive talks, tours and other events
- Discounts and offers with galleries, museums and retailers

Membership starts from £4 per month
Join today to find inspiration.

Head to: **craftsmagazine.org**
or scan the QR code to learn more.

Supported using public funding by
ARTS COUNCIL ENGLAND

ZORA J MURFF
Implement, 2019
From the series *At No Point In Between*

RICKS & HERN

Nico Walker

Naturally, no partnership is perfect. Certain pieces will be at odds – you'll have that. With these two, the oddities were a lot to do with generational frictions. Hern disliked hearing people younger than him cuss and he would dog curse Ricks on the infrequent occasions when Ricks ever did cuss, whereas, on the other hand, Hern was in the habit of using the N-word and Ricks had been taught to internalize his racism. But they made it work because they were the police and they had a job to do.

They'd been partners three weeks, the morning Hern told Ricks to pull onto the side street. There was a space in front of a fire hydrant next to an old church. Ricks parked the Charger and Hern got out and raided the clothes donation bin, returning with an outfit: an old, raw-wool pullover; a turquoise pair of lined parachute pants; and a black, oversized, trench coat.

'If you're ever going to be a proper narc, you're gonna need some undercover experience, and I think you're ready. I've got the go-ahead for you to infiltrate Lomax High. Put these on.'

'Is this a prank, Sergeant? – a high school?'

'This is no prank, Ricks. A lot of guys started their undercover careers this way. You know who Donnie Brasco is?'

'It's one of the DVDs in the Stress Room.'

'Brasco was a real guy. He got his start undercover at a high school.'

'Don't kid me, Hern.'

'Search Donnie Brasco if you don't believe me.'

'How do you spell his name?'

'Like it sounds, Donnie with an i-e, not a y . . . Then space, *B-r-a*,' Hern had anticipated Ricks might buck at the assignment, so he had edited the Wikipedia page for Donnie Brasco, '. . . s-c . . . o, that's right . . . What does it say, Ricks?'

'Uh . . . says, Donnie Brasco . . . a lot of stuff . . . hold on . . . conducted his first undercover sting operation assignment at . . . Lomax High School in the 1960s. Wow, I guess you were right.'

'Apology accepted. Pop the trunk.'

They exited the vehicle. Hern lifted the trunk lid. Ricks said, 'We've been driving around with drugs in the trunk of the G-car this whole time?'

Hern said, 'We're the laws, Ricks. What could possibly go wrong?'

'Yeah, wow . . . it's just that . . . this is a lot of dope though, right?'

'There are over a thousand students enrolled at Lomax High School. Try using common sense.'

'This is like . . . three, four, six, eight, nine – *nine* big things of drugs.'

'It should be ten. Wait. No. Right, it's supposed to be nine because of another thing I have to do.'

'What kind of drugs is it, Sergeant?'

'Its essence is carfentanil.'

'You're not serious – fentanyl?'

'*Car*fentanil, Ricks. Much stronger, made for elephants, like for when you're doing surgery on an elephant but you don't want the elephant to feel any pain. Don't worry, you're going to get to step on it some more before you go and intent-to-distribute it to these kids. There's a video for how to do it.' Hern tapped into his phone. 'You've got the link . . . now.'

Ricks's smartphone went *ding*.

'Give them free tastes in the morning if they don't want to buy and check back with them in the afternoon. By the afternoon, you'll be able to do whatever you want to them. Have fun with it. It's supposed to be fun.'

'We really have the go-ahead for this?'

'It's called budgets are up for renewal and we're not the only ones who are out here doing shit like this right now today, I bet.'

R icks went to close the trunk.

Hern said, 'Don't. Here, put the drugs in this duffle bag. We want to be sure it all fits.'

'Sergeant, isn't this stuff supposed to be dangerous even to touch?'

'You fucking moron.'

'What?'

'I put the dope in the trunk, Ricks. I fucking did, and I'm fine. Do you really want to ask me about this fake bullshit or do you want to ask me about something real? What are we really talking about right now?'

'I'm cool. It's just that there's a lot of drugs here for a high school. Like, how many kids are we trying to kill do you think?'

'Relax, this is mostly cocaine. This is what cocaine smells like, or what it smells like when Crime Lab give it back to you with too much ether in it.' Hern slammed the trunk closed. 'Why do you think they call it Vice Squad, Ricks?'

'Because we focus on vice?'

'Shit. Fine. Do you know Willy? – big, tall guy on Homicide Squad's softball team, bats lefty.'

'The first baseman.'

'Finally, he knows something.'

'He plays first base.'

'Jesus, fuck, we heard you. Way to fucking ruin it.'

'My bad.'

'Shut up.'

'I'm sorry.'

Hern drew his gun, casual-like, like something fatalistic were in the works.

'Now, you remember what I said about the budgets are up for renewal.'

'I do.'

'Amazing. But you don't know what it means.'

'It means how much money we get.'

Hern racked a round. There was already a round in the chamber. It popped out and landed on the street and rolled toward the gutter. Hern jabbed his gun toward it. 'Do me a favor and pick that up for me.'

Ricks turned to fetch the bullet. He thought: how'm I supposed to know what this SOB wants me to act like? – I'm here to do a job, get a paycheck, go home, buy a barbecue, find my Mrs Right, host Super Bowl parties, and now I've got this old man, this grouch, who's supposed to be my partner, my mentor, my guide, he thinks he can talk to me like any old way and I guess I'm just supposed to take it off him, when I'm pretty sure I could beat his ass in a fight . . .

Ricks was steamed. He was so steamed he didn't clock how Hern was following a step behind him on his way to the gutter, until Hern brought the butt of his pistol down on Ricks's dominant shoulder, where it met with the neck, just as Ricks was coming back up with the bullet. The butt of the gun came down hard enough to drop Ricks to his knees.

Ricks yowled. Both in pain and in real fear of his life. His partner stepped around to the front of him, smiling a grim way that Ricks hadn't seen him smile before.

'What are you doing to me, Sergeant?'

'Open your mouth.'

'Nope –'

Hern grabbed Ricks by the forelock and shoved the pistol into Rick's mouth and said:

'Look into my eyes. This is not a game. This is not a test. This is initiation. If you look away from my eyes even for a second, I'm going

to shoot you in your brain, knock that brain right out of your retarded head. Blink twice if you understand me.'

Ricks blinked twice and then looked away.

Hern yanked the pistol and whipped him on the eye: 'Last chance. My eyes, you pussy-ass gump. Don't think about looking away! Don't think about it because I'll know and I'm a son of a bitch. That's what you wanted to call me, wasn't it? Blink twice if you wanted to call me a son of a bitch just now.'

Ricks blinked twice. Hern said, 'I can read your mind, Ricks. I can read you like a book, like a gay little book. I know you better than you know yourself. Blink twice if you believe me.'

Ricks blinked twice.

'Now put my gun back in your mouth . . . Don't touch it with your hands. Bring your mouth to my gun. Remember, you're looking in my eyes.'

Ricks scuttled forward on his knees. He had to duck his head funny because Hern was holding the gun too low for what they were supposed to be doing. Ricks didn't break eye contact. Hern was staring back at Ricks, with dead eyes and a grim smile. The split above the corner of Ricks's eye was stinging something fierce. Blood was running down warm to cool against his red-hot cheek.

Why do bad things always happen to me?

Is it really me doing them to myself?

Hern said to him, 'You minced-up little beta cuck. Your father would be ashamed of you if he ever gave a rat's ass and he wasn't chopped up in a goddamn hole full of lime someplace overseas. Don't get me started on that shitbird. At least he knew how to act like a man. For all his faults, he was a chad. I can say that because I'm a chad. I doubt I'll ever say it about you. Blink twice because I said so . . . Good job, Ricks. You're doing such a good job. We were talking about budgets, weren't we?'

'Yeah,' Ricks said. Except it didn't sound like *yeah* on account of the gun back in his mouth. It sounded like *baa.*

'I'm going to be honest with you, Ricks. We're only this far into our partnership, and I despise you. I think you're a worm. I actually have more respect for worms than I do for you. Worms don't embarrass me. Yet as much as I'd like to put you out of your misery, you're my partner and I'm not in the mood to be explaining shit to anybody today. Besides, if anything, I like to think of myself as an educator.'

Hern took his piece out of Rick's mouth, being careful this time to not fuck up Ricks's teeth. He holstered the piece under his arm, and waited for Ricks to get up so he could see into his eyes better.

Ricks wasn't up to his feet straight away. His knees hurt him and his back was stiff from leaning forward. His bell was rung from the hits he had taken.

Whatever you do, don't cry, don't let him see you cry, you'll make him mad again and he'll lose respect for you.

'You know, that was unfortunate,' Hern said. 'But I had to scare the shit out of you, because I'm about to tell you something not a lot of people realize, and I need you to understand that if you fuck up and breathe a word about it to anybody I will kill you like a dog.'

Ricks spit and wiped his chin: 'So what's up?'

'The first baseman.'

'Willy.'

'Yes, Willy the first baseman. You know him.'

'I know who he is.'

'Back when I was on Homicide Squad, whenever budgets were up for renewal, Willy would mask up and push white women in front of trains. Has anybody ever told you that about Willy?'

Ricks swallowed: 'This is the first I've heard of it.'

'Well that's what Willy does, Ricks, and it's a lot of what he does. It's what he did the whole time I was on Homicide Squad and he was already doing it when I got there. Willy's a professional. He knows the job. If a budget's up for renewal, Willy's destroying all the office furniture, killing the plants in the office, then he orders *more* new shit to replace the shit he stole, until not one penny's gone unspent.

Then he's out there pushing white women in front of trains, in front of busses, taxicabs, tripping them down flights of stairs, knocking them out in elevators from time to time randomly – and not because he *wants* to. He's a regular guy, a decent guy. I think he has kids, but above all Willy is a professional, so he's going to be out in the streets right now, trying to secure every last red cent of the pie he can get allocated to Homicide Squad. He's out there doing it as we speak, I bet, while we're wasting precious time standing here talking about him.' ∎

PHILIPPE KOUDJINA
Maria Callas and Pier Paolo Pasolini at the airport of Niamey, after scouting for the film *Medea*, 1969
Courtesy of the Estate of Depara / Revue Noire Paris

NIAMEY NIGHTS

Rahmane Idrissa

A night in 1968. Maria Callas, clad in a dark leather jacket – it
must have been December – walks briskly across the tarmac
at Niamey airport; next to her, Pier Paolo Pasolini, in attendance as
a luggage porter, peers into the Sahelian night through dark glasses.
The moment is captured in a shot by Philippe Koudjina, the Daho-
Togolese photographer who chronicled the 'Niamey by Night' of the
sixties with his camera. Callas and Pasolini, who were on an African
location scouting tour for a film (*Medea*, ultimately shot in Syria and
Turkey), were not the only European stars to show up in his photos.
Johnny Hallyday had given two concerts at the Rex cinema, not far
from Niamey's Marché de Huit Heures, in early May. Koudjina
catches him cavorting with a local *yéyé* in a nightclub – presumably
Harry's Club – and posing with a posse of young policemen on a
hotel veranda. Salvatore Adamo also performed in the city, perhaps
that same year. Koudjina, a regular at the partying of celebrities,
photographed him as he boarded the plane. Koudjina's camera also
takes us to a 'maquis' bar where a plump woman plays the accordion
surrounded by young people in front of a table cluttered with beer
bottles; to nightclubs where there's plenty of dancing the twist and
flirting the night away; to night-time gardens where young revellers
pose on motorcycles and bicycles, the girls in short dresses, the boys

in tight pants. It was the era of the *Double* headscarf (in the shape
of a tower), *Chéri regarde mon dos* dresses, *Mon mari est capable*
motorcycles, *Tête de nègre* high heels. It was, above all, the age of *yéyé*
music, which, until the turn of the century, left urban Nigeriens (and
Malians and Voltaics) with a casual addiction to the cutesy-ironic,
candy-sweet, innocent-while-being-naughty or naughty-while-being-
innocent hits of the French charts of those days. They were the tune
of the first modern generation in the Sahel. In their native land, these
ditties were second fiddle to the real thing, Anglo-Saxon rock and pop
music. *Yéyé* came from the 'yeah, yeah' that punctuated rock lyrics, its
biggest star was 'Johnny Hallyday' (actual name: Jean-Philippe Smet)
– but here, they represented a drastic shock to what was, in essence,
an ancient-regime culture . . .

Yéyé culture, like hip-hop today, was mostly young people
having fun, within the narrow limits of a society full of taboos and
an economy of small means. They made use of a sparse material
infrastructure: a handful of venues equipped with sound systems and
suitably lavish electricity, a two-wheeler import company, a brewery,
a few fashionable fabric and clothing shops (not stores), a couple of
movie theatres that also served as concert halls (in Niamey, there were
two of those, the Rex and the Vox). Nearly everyone was the scion of
a farming or (more rarely) herding family that lived 'back home', a
phrase that almost always referred to some far-off village or hamlet
where people led what looked like imperturbably ancient lives. The
sight of a gilded youth was something for the future. But if we go by
relative proportion rather than quantity, the infrastructure was not
as modest as it seems. In mid-sixties Niamey, it catered for a town
of only about thirty or forty thousand people, many of whom would
not dream of using any of it. For the few who did, it was more than
enough. The youth sets involved connected in that way to the modern,
zamani in local speech. They became actors and players in a historical
escapade whose beginnings trailed back to a past that was still alive in
their parents' memories. Some had perhaps heard an old relative speak
of the day when *zamani* first drifted into Niamey, then a cluster of large

riverbank villages, in the shape of three metallic boats, one of which harboured, on the rear-deck, a bicycle called Suzanne, the first two-wheeler ever to show up in these parts, standing next to a phonograph. The convoy was helmed by Lt Émile Auguste Léon Hourst, the advance scout of French colonialism who was reconnoitring the Niger River. The boats glided past the villages, gleaming unnaturally under a fierce sun, on 5 April 1896, Easter Sunday. Reading about this moment in my studies, I imagined a wise person looking on from the shore and seeing a threat carried by a promise.

More than half a century later, in the sixties, the large villages had merged into a small town, filled with people who could be trade unionists and schoolchildren, cinephiles and even a few film-makers, Dahomean and Togolese immigrants (like Koudjina) and juveniles who had a blast to *yéyé* music or the sound of Orchestre Poly-Rythmo, brought in by the immigrants, and where the funk of James Brown met Congo's Soukous, Afrobeat inspirations and the ritual percussion of Voodoo. On certain evenings, the future Prince Consort of the Netherlands, then a German diplomat posted to Niger, could be seen dining with a future eminent Romanian intellectual (Neagu Djuvara, who died at 101, six years ago, in Bucharest) in a *gargote* in the old town. It was possible to develop a taste for things Indian, or the Mississippi blues (being a 'bluesman' was a thing). And there was a whole week in 1966 when one could spot Zalika Souley, maybe the first career actress in Black Africa (though her day job at the time was that of saleswoman at the town's main store) gallivanting on set on horseback, in jeans and Stetson hat, playing the role of the cowgirl 'Reine Christine' in a Western spoof called *Le Retour d'un aventurier*.

The first time I heard of generations, they were likened to the loops of a ribbon. It was my very first history lesson. The teacher told us that history was 'a ribbon that uncoils', and that each coil was a generation. This idea of a ribbon that keeps uncoiling disturbed me. At that time, we were living in Tillabéri, a small riverside town in northwestern Niger, in a modern-style house – cement-built,

Formica-furnished rooms and white-painted walls – in Bagdada, a neighbourhood that was the new part of town. Its exotic name – 'Baghdad' – revealed as much about its past as its location on a slope between two fields, the Camp des Gardes and the Camp des Fonctionnaires. All this topography was, in fact, history: tangled history. The lower part of the town on the riverbank, was, and still is, the old town, Tillabéri proper, whose core settlement is Gandatié ('Low Foot'), home to the patriarchal residence of my paternal grandfather, a descendant of one of the town's founders. Behind Gandatié, at just the point where the slope begins to make itself felt, one enters Zongo, the place reserved for the foreigners who were allowed to live in the town. A *zongo* was equivalent to the French *faubourg*, 'the outer-borough', and as in the towns of medieval Europe, it was separated from the *bourg*, 'the borough', by the fairground, the meeting place of natives and peregrines. My mother's family lived there. They were people from the distant Mossi country – from the Volta River basin – who married into a Fulani family, Zongo dwellers themselves. Farther up the slope, you cross a dry creek bed and pass a church. When I was a child, it was in ruins, a house of bats, but the cross still stood above its doorless entrance, making our half-Islamic souls shiver. Then came Bagdada, which didn't exist at the time this church was built, so that in its good days it had behind it only a vast wasteland that culminated in the plateau where the colonial power camped out, with its guards and functionaries, dominating the scene from these heights. The school was built just behind these demesnes, at the foot of a hill topped by a water tower which must have given the town its name (Tillabéri means 'the great mound').

My Tillabéri childhood presents the following facts:

There were mornings spent in a sunny, many-windowed classroom filled with the soft-dry fragrance of chalk, a globe on the teacher's desk, a map of Africa on the wall. The reading lessons were about the daily life of a family somewhere in Africa, Mr and Mrs Boda, their three children René, Mina and Rémi, their dog Miro and their cat Miki. The history lessons were the stuff of romance and poetry,

depicting the chance encounter in the woods of a stallion-riding princess and an elephant hunter that spawned the Mossi people, or the blaze of a thousand bundles of sticks – *une flambée de mille fagots*, in the evocative euphony of the French phrase – with which the king of Ghana illumined his capital every night. The songs we learned at the end of the day incited us to love school or hygiene. 'Little Djibo' was given candy, chewing gum and a bouquet of flowers when he knew his lessons, water was praised (*Vive l'eau!*) for making little kids 'clean, wise and handsome'. (There were also French songs, which I always dreaded a bit because they thought nothing of conjuring for our brittle kiddy hearts – mine anyway – the abrupt demise of a heedless damsel or the unhappy life of a poor sailor.)

And then there were after-midday trips to Gandatié or Zongo, where it was the duty of us kids to carry the lunchtime meal to our grandfathers. This was a symbolic obligation, an offering that signalled that, although we lived in another part of town, we were still part of their homes. Depending on the day of the week, I went either to Zongo or to Gandatié, and laid the still-warm dish at the resident patriarch's feet (they were unlikely to eat it, as other dishes, sent by other satellites, surrounded them; they were, in fact, food redistribution centres). My paternal grandfather was then sick from the illness that was to take his life within a year and, locked away in a twilight of suffering, he rarely knew who I was or why I was there. The visits to my maternal grandfather, on the other hand, were true events. They took place in the large shadows of the cob-built room, covered in thatch, that served as a vestibule or living room attached to his apartments. He often sent me inside the even gloomier apartments to fetch an object from among the odd and scary things he stored in the front chamber: skins from unknown animals, leather bags that hung on the wall and from which he would sometimes remove knots of cloth filled with powdery substances that he would ask me to lick off his finger; a whole heap of natural products: roots, horns, hooves, dried viscera and leaves, juices splashing around in calabash gourds, citrus fruits, kola nuts wrapped in the cool moisture of a wet jute sack.

Sometimes he would take me in his arms and whisper in an unknown language – Mossi, I surmised – and addressing spirits, I was sure.

After the first history lesson, the teacher asked us to find out who our ancestors were up to the seventh generation. In the Songhay tradition, your ancestors are your father's line, so I went to Gandatié, and one of my grandmothers briefed me expansively. I found the details incomprehensible, not because they weren't clear enough, but because they were extremely clear. My grandmother told her stories with Balzacian precision, but they were about individuals and their relationships, and characters, and strange names (Songhay, not Arab-Muslim names), and the places, many new to me, where they had been, and events that, sometimes, involved spirits. These enchanted incidents were mentioned the way one would talk of a trip down the river or cows grazing in the fields. Banalities. I wrote down the names of my forefathers in a straight line back to Bagham, the colonist from Anzuru (a region some distance to the east) who took part in the founding of Tillabéri, and forgot the rest.

The Sahel has a dual history. The first is that of the old empires and kingdoms, and of the colonial encounter, a history full of sound and fury and firmly linear in its telling. Once the ribbon is in place, you can hang strings of dates and events, and say how this led to that, or, in what looks like a twist, how this killed that, a formula that works well for the colonial encounter. The second history is the subterranean one of generations, which accepts, with Proust, that our lives are 'careless of chronology'. It's not amenable to the science of history, but I imagine a specially crafted genre of novel-writing might do the trick of telling its stories.

I don't know what philosophy of history guides teaching in Sahelian schools these days. In the eighties, it was still the philosophy of progress, hatched by those from the first modern generation who were in charge of the state. The idea, like in all modern nation-building projects, was to instil pride in the past and trust in the future. The Boda family in the reading textbook set an example for a future where

we'd live the Western-style middle-class life, with pets in the living room and a pipe-smoking daddy who read the papers at breakfast; and the history textbook showed an African past full of great kings and glorious emperors. The contrasted glamours of feudalism and the bourgeoisie were offered for Janus-faced students. But did we really come from that past – and were we really heading to that future? As the eighties wore on, that question became more pressing, and along with it, the sense that my generation were orphans of progress.

The ebullience of Niamey, Ouagadougou or Bamako in the sixties was the result of states trying to harness their societies to the idea of progress. It was a Promethean moment, the time of the founding fathers who found the fire of modern knowledge in the schools of the colonizer and wanted to give it to those who lived at an orbicular distance from the capitals of modernity. They wanted them to have the strength to stand up and become equal to all modern souls. The idea behind the Boda family was not a servile imitation of the West, but parity with it, in a world unified by progressiveness, and in which to be different meant to be backward, a powerful slur of those days. In a book published in 1972, *Le Retard de l'Afrique*, Boubou Hama, one of the heralds of this evolutionary epic, assured his African contemporaries that their tardiness, the fact that they had lagged behind, was a sign that their modern epiphany would be all the more precious. Having started earlier and gone too far, Europe burnt its humanity in the Vulcanian fire of material progress; Africa the laggard would bring to the resulting anguish the adjuvant of a humanity preserved by the very *retard* for which it was pitied. The last would be first.

In the eighties, we entered an Epimethean age. Prometheus was the one with the philosophy of history. Epimetheus, his brother, was a pure pragmatist. In the Sahel, after the killer drought of the early seventies had crashed the vision of the first modern generation, it was time to go for broke. In Mali and Niger, juntas toppled a socialist (Mali) and a progressist (Niger) party and pledged to *do* rather than *dream*. Even Thomas Sankara, the dreamer who seized power in the

Upper Volta a decade later and turned it into Burkina Faso, was a super-doer, someone who thought the patient evolutionary massaging of the previous generation (the key, for them, was *mentality* change, a slow-going affair) needed to be superseded by revolutionary rush and bustle (there was a bringing into line of recalcitrant mentalities, and a purge of the obdurate). But alacrity was soon dampened by austerity – the economic one, the one that means being ruled by debt. In serious times, one learns complicated words on television. I sensed that 'conjuncture', often uttered in televised presidential speeches in Niger in the mid-eighties, was something dismal – though I didn't know what it meant. A decade later, it was one of the least complicated, cheeriest words in the maquis of Niamey, as a slang name for the local beer, La Girafe. Stranded on the shoals of the Washington Consensus, the Epimetheans had downsized the state and discharged and retired the public workforce in droves. Such circumstances beget gallows humor. The soothing tipsiness promised by La Girafe earned it the nickname of the dreaded 'Conjuncture' – fondly shorthanded as *Conjonka*.

The first political slogan I learned was probably the alliterative, *Le PAS ne passera pas* ('SAP [Structural Adjustment Program] shall not pass') – supplemented by *Pas moins d'État, mieux d'État* ('Not less state, a better state'). In a world where globalization would have been political, protesters in those demonstrations would have marched on Washington's 19th Street NW, not on a thoroughfare in Niamey where all they did was to disturb the street hawkers. But they did not march in Washington, and the SAP passed. What then followed was a kind of psychological dry spell, which all the Conjunctures in the world could not quench. The fall of 'progress' scrambled the map we had relied on since independence, and many felt lost. But even that did not last.

M y generation was part of the last global text generation, the one that looked for its provender in printed books and magazines, not on a screen. In the early nineties, I noticed that the mats and stands of second-hand booksellers near Niamey's High Market

or at Dakar's Colobane Market overflowed with Marxist-Leninist literature, not because they were in demand, but because obsolete stocks were being liquidated. The books were offloaded in bulk to *beignet* sellers, and if it was your thing, you could read a paragraph on *Gattungswesen* on the oil-stained bottom of the paper wrapping of your spiced up *akara*.

Many 'comrades' were now reading the productions of New Horizons, the US State Department's response to Moscow's Progress Publishers – the source of the Marxist-Leninist texts that were ubiquitous in the eighties. (I did read some of the offerings of the Progress Publishers, because they included novels and short stories and lots of Soviet sci-fi – a taste that confirmed to some of the comrades their suspicions about my 'bourgeois tendencies'.) Now the Soviets were gone, the Americans suggested democracy and capitalism as a replacement for progress and socialism, and there was a 'why not?' reaction. Other books in Arabic script – something until then very uncommon in 'normal' life – began to appear on student bookshelves. In Dakar, where I spent most of the nineties, I once opened my door to another student who had knocked to inquire about something. I was dancing a little; there was music in my room. Days later a friend told me that my 'behavior' – the dancing and other things I didn't suspect were of interest – was the subject of an hour-long meeting on the rooftop of the building that the state of Niger rented for Nigerien students in the city. While in the old days the *comrades* had accused me of being a bourgeois comprador – I was sixteen and mortified – it appeared I was now an unbeliever in the eyes of the *brothers*.

From the sixties to the eighties, the meta-historic map promised a modern future that might be bourgeois or Communist but would in any case be materially munificent – and humanised by a dose of Africa. In the nineties, the liberal-democratic billboards of the triumphant West briefly captured some imaginations, and an Islamist fast-track to the Caliphate ('Islam is the Solution' was a slogan of those days) pulled others, at least in Niger and Mali, much less in

Burkina Faso. The spirit of my generation became a middle ground in which a fusion, or rather a confusion, of these conflicting maps was attempted, as if people were going to live in a place that would be at the same time France and Saudi Arabia, without the affluence of either. The lack of affluence favoured Islam: being poor did not prevent you from being a good Muslim; but to be like a Westerner, you needed material backup for the 'pursuit of happiness'. Already in 1972, a Nigerien movie had satirised that as a pipe dream for most people in the Sahel. The main character of *FVVA* (an acronym for *Femmes Voitures Villas Argent*, i.e., 'Women Cars Villas Money') came to grief when he tried living the lavish life of the modern consumer on the means of what then passed for the middle class in his country. In the early nineties, a high-school philosophy teacher wrote a column for *Haské*, Niger's first independent newspaper, where he explained his attraction to the Islamist project – a dereliction of duty, since philosophy teachers were supposed to be for liberalism what clerics were for Islam. 'The Islamic revolution' showed, he wrote, that 'it is now possible to be a man without necessarily looking like a Westerner.' And, he piled on, 'many they are, the frustrated, the rejected candidates for Westernisation like you and me, who harbour a latent sympathy for the Islamist movement.'

The screen generation is not as easy to read. The fact that they do not read – at least not the way we read – means that they are inscrutable in a way that cannot be chalked up only to a proverbial generational divide. They are in some sense inscrutable to each other. Our text culture created a generational space that made debates possible, clashes inevitable and even sought after. The youth seem to fold themselves into their virtual and networked worlds. They lack a generational public space, or perhaps have no need for it, because the maps have become a maze and the absence of fixed references come with a kind of freedom from expectation which previous generations could not imagine. Much of this must be true for the screen generation the world over. The difference, in the Sahel, is the

conditions in which they operate. In Niger, there was in the early sixties a radical progressist movement, Sawaba, that was crushed by its more moderately progressivist rivals of the Nigerien Progressive Party (everyone was progressive back then!) and became decades later the subject of a 900-page book by the Dutch historian Klaas van Walraven, *The Yearning for Relief*. Relief, not progress, was really what it was all about – relief from drudgery and power, relief to be oneself, and, to quote a Songhay text from Boubou Hama – a nemesis of Sawaba – relief to be able to be *bere nda ni wono*, 'great with one's own'. The younger generation of Sahelians still yearn for that relief, and they perhaps have a better chance to find it in the open maze, outside the doctrinaire maps of their elders. ■

PHILIPPE KOUDJINA
Les voyageuses, 1960–1970
Courtesy of the Estate of Philippe Koudjina / Thomarts Gallery

PHILIPPE KOUDJINA
Le grand bolide, 1960–1970
Courtesy of the Estate of Philippe Koudjina / Thomarts Gallery

PHILIPPE KOUDJINA
Woman playing an accordion in a courtyard
Courtesy of Estate of Depara / Revue Noire Paris

PHILIPPE KOUDJINA
Couple, 1960–1970
Courtesy of the Estate of Philippe Koudjina / Fonds Loic Quentin

GUY LE QUERREC / MAGNUM PHOTOS
Inside a school, Brittany, Saint-Brieuc, March 1973

THE LIFE, OLD AGE
AND DEATH OF A
WOMAN OF THE PEOPLE

Didier Eribon

TRANSLATED FROM THE FRENCH BY MICHAEL LUCEY

M y link with my mother placed me within a collective history and a mental geography that a single word can describe: family. In her book *Old Age*, Simone de Beauvoir calls attention to societies studied by ethnologists where older people are the keepers of the knowledge of family genealogies. Is it not the same in our own society? It is certainly so when it comes to genealogies, and, more widely, to that social memory that is most at risk of disappearing alongside genealogies. The task of remembering in this way usually falls to women, partly because they live longer, on average, than men, but also because, in a general way, women are the ones assigned the task of maintaining family relationships and friendships throughout their lives, and so they keep the register up to date, and understand the complexity of these relationships and the changes that take place within them. So it is that in *Patrimony*, Philip Roth can insist about his mother: 'it was she around whose quietly efficient presence the family had continued to cohere,' and that she was 'the repository of our family past, the historian of our childhood and growing up'. The point here extends beyond 'family' understood in the narrowest sense of the term. I am acutely aware of this now: my mother's death has cut me off from an entire part of myself which, by way of her, remained connected with even quite distant family connections. When I came

across the name 'Eribon' somewhere on the internet beside a name I didn't recognise, I could always ask her: 'Do you know who this is?' and she would reply: 'Yes, that's one of your father's brother X's sons,' or 'Yes, that's the wife of X, one of the sons of your father's cousin,' and so on. Her genealogical knowledge extended across several generations.

But now I will no longer have access to this kind of information. And so I lose a connection, however distant and vague it may have seemed, to an entire universe of 'kinship'. My mother's clarifications inevitably reintegrated me into that universe, where I would find my bearings without too much difficulty thanks to the map those few names she mentioned laid out for me, reconnecting me to the mental landscape of my childhood and adolescence as she recreated it for me.

M y mother's death cut me off from my family 'genealogy'; but did it not also break the final threads that attached me to the social milieu I came from? This was a milieu that I had wanted to flee, and only later did I try to rediscover it, something I have managed only partially, and with a hesitating kind of rhythm. 'I shall never hear the sound of her voice again,' writes Annie Ernaux at the end of *A Woman's Story*, having just described her mother's death. 'It was her voice, together with her words, her hands, and her way of moving and laughing, which linked the woman I am to the child I once was. The last bond between me and the world I come from has been severed.' The same is true for me. It was mainly by way of my mother that my present was linked to my past, to my childhood, to the years of my adolescence. She was of course present in my memories of these periods, just as I was in hers, memories that she enjoyed sharing, sometimes with irony, sometimes with acrimony, though most frequently in a simple, factual tone, defending her stories and her versions of the facts when I challenged or contradicted her. I didn't always like it when she described the young boy or the teenager I

had been – a version of myself I had wanted to put behind me – or when she recalled things I had said that now struck me as naïve or embarrassing, or when she described clothes I would wear that, in retrospect, seemed ridiculous, so typical of a working-class boy whose only way of distinguishing himself from the other boys in his milieu was to look 'eccentric', as my mother used to say, even though I still looked working-class to the other students at the lycée, who, for the most part, came from more privileged backgrounds, both economically and culturally. (These weren't the children of the 'grande bourgeoisie' of Reims, of course. They sent their children to the private Catholic schools in the city, where they wouldn't run any danger of being exposed to the 'propaganda' of 'Communist' teachers who were thought to 'populate' public schools. They went where they would be given a traditional and conservative education, safeguarded from the turpitudes of the surrounding world, with its leftist ideas and principles of social justice and secularism.)

There was a day when I went to school wearing an orange shirt and a purple tie and was summoned to the principal's office, who then sent me home because I was inappropriately dressed. (What times those were, when you think back on it!) My father grumbled about the way I dressed, which he found ridiculous (there was no equivalent in his world, certainly not at the factory where he worked). My mother, who shared his view, calmed him down by saying, 'It's what's in fashion in the schools,' which, of course, made no sense. I must have been thirteen or fourteen. This was shortly before I turned into a Trotskyite activist and an aspiring intellectual, which involved a radical change in the way I dressed and acted: long hair, corduroys, turtlenecks, a duffle coat, Clarks sun boots . . . My parents found this just as difficult to understand, but at least it was less colourful. And it did correspond better with 'lycée fashion' – much more so with what was fashionable in universities; the students I was spending time with in my political activities all wore the same thing.

The litany of memories was doubtless, for my mother, the best
– and perhaps the only way – for her to maintain an emotional
connection with me: 'When you were little . . .'; 'When you were
fourteen . . .' and so on. How these memories must have been going
round in her head in silence during the long years I was absent! She
was first and foremost trying to re-establish the moments in which
we had lived together. We had twenty years of life in common before
I left home, but even that history we hadn't experienced, or at least
perceived, in the same way. What she had been able to see of my life,
from the time I was fourteen or fifteen, remained for the most part
exterior to what it was becoming, at least for me; her version of my life
was one I moved further away from day by day. She knew about my
political activism, which took up large amounts of my time from the
age of sixteen. The least one could say is that she wasn't particularly
happy about it: in her eyes it was a distraction from the attention my
studies required, and it could only lead to trouble. But she did not
know what I was doing in any detail. My father was called in by the
principal at the lycée, who filled him in and warned him about the
consequences that could result – suspension or expulsion from the
school, for example, and, almost certainly, a negative evaluation in
my file, which would be an issue if I wished to enrol in preparatory
classes for the *grandes écoles* after the *baccalaureate*, so I could take the
entrance exam for the *École normale supérieure*. This was a meaningless
threat, since neither my father nor I knew what he was talking about.
Still, it provoked quite a crisis. Due to some sort of gender divide, my
father only said a sentence or two about it to me. My mother took on
the task of expressing their shared anger. 'We don't pay for you to
go to school so you can sing the *International* in the lycée courtyard,'
she shouted at me that evening, adding numerous curses and threats:
'You're going to quit school and get a job.' They couldn't understand
it: here I was with the good fortune to pursue a secondary education,
a chance they had never had, and instead of being serious about my
studies I was spending my time on all these other things. It left them
altogether indignant.

As for the evenings and nights I spent in gay cruising areas starting at the age of seventeen, my mother knew nothing about them . . . My nightlife was a secret life, one I hid from everyone to avoid the opprobrium that fell on anyone who was discovered – or unmasked, you could say – with all the insults and cruel jokes that necessarily followed. Everyone struggled to protect themselves from this. Once, during a lively shouting match between a group of Trotskyites and Communists in the halls of the university, one of the latter hurled 'You faggot!' at me – it was a typical way of tarnishing someone, particularly a political adversary. A series of violent replies came back from the group I was with: 'Stalinist cop!' 'Uptight priest!' 'Reactionary pig!' 'Fascist!' and so on. A few days later, I noticed that same person out cruising: insulting others was a way of making his friends believe he wasn't gay, even if they would never have suspected that he was. As for me, I stopped hiding my sexuality at the age of nineteen, or at least I was open about it with those close to me (which meant at that moment my Trotskyite comrades in the *Ligue communiste*). It never crossed my mind to come out to my family. I no longer hid who I was, and made no attempt to conceal anything from them, but given that I was seeing them less and less, and soon not at all, I didn't bother going out of my way to tell them about the life I led, and would go on leading. I refused to think of homosexuality as an anomaly that needed to be disclosed to the family; I'd let them figure it out for themselves, and told myself that if they hadn't worked it out already, too bad for them.

But then from my side of things, what did I really know of my mother's life? Of the work she did, which she seldom mentioned, or of her feelings and desires, about which she said even less? When I was seventeen or eighteen I spent a month of summer vacation working in the same factory where she had been for a while, a place that would remain the exhausting setting of her days for nearly two decades more. I was able then to witness what working life was like for women in the factories. At the time, I didn't speak to her about my own life and didn't ask her any questions about hers. She showed

no inclination to discuss it herself. When she left work, she preferred
to leave the world of the factory behind, forgetting it until she had
to go back the next day. How little one knows, really, about one's
parents. I didn't know much about her life in the present, except for
the time she spent at home, and I knew even less about her earlier life,
by which I mean the life she led before getting married and having
children. (I could say the same thing about my father.)

Given that she knew almost nothing about me and my activities
once I had left home and was living far from her, far from them, she
always seemed to focus on the period when we still lived together, my
childhood and my adolescence. When we chatted over coffee in her
house in Muizon – once I started spending time with her again after
my long absence – she insisted on recalling, even though it annoyed
me, things I used to say and attitudes I'd had, mostly from when I was
twelve or thirteen or fourteen, sometimes younger, back during the
time when we still communicated. Her insistence prevented me from
forgetting all those aspects of that distant past; she brought them back
to me with the stories she told about me, or rather, about me and her.

There is a way in which my mother embodied what Louis Aragon
calls the 'power to blackmail', a power that insinuates itself into the
act of recalling gestures or words from the past. She had a kind of
hold on me: here is what you said back then, here is what you were . . .
And when I replied: 'But no!' or 'What are you talking about?', then
she would insist, with a malicious or an indignant tone in her voice:
'You're not really going to try to deny it, are you?' In reality, she was
trying to go back, and to bring me back, at least in our minds, to a
time when we still lived together, to a time before my departure and
even before the distance and the disassociation that had preceded my
departure.

Except when she was talking about my childhood, everything she
described took place during the period where I began to change, which
is to say no longer to resemble the other boys from my social milieu,
no longer to resemble my older brother. What she was describing were
the outlines – and the first steps – in the journey of a class renegade.

She had no other label for this at the time than words like 'eccentric' or 'lycée fashion'. When does a trajectory of upward mobility, either scholarly or social, begin? Where is the starting point in the trajectory of a class renegade? And how does the transformation manifest? It's a change both produced and demanded by the educational system, if you mean to continue in it and avoid the elimination planned for people like you, but it's also a transformation that you long for and cobble together as best you can – as it's happening to you or as you are making it happen. What are the warning signs – and when and by whom are they perceived? There's a clear connection between the boy of thirteen or fourteen, the one who wore an orange shirt and a purple tie, and the one who at sixteen or seventeen was beginning to play the part of a young intellectual. Despite the evident break, the second is pursuing by other means the path begun by the first, even while he repudiates and reworks the original, gives him a more clearly defined appearance, one that makes more sense socially because it is built on models that are more real, and therefore more appealing.

How did my mother experience the distance I put between us? How did she experience my absence in her life (and, more fundamentally, that empty space between us that she was trying to fill when she came back to memories that, in her eyes, we were supposed to share)? What is it like for working-class parents to live through the rising social trajectories of their children which, in different manners and to different degrees, but nearly inevitably, establish a distance between the generation that lacked schooling (or had only a little) and the one that underwent (or is undergoing) that schooling? The difference in the amount of time spent within the educational system (a shorter time for the first group, a longer time for the second) constitutes one of the most powerful factors of the discordance, the disagreement, the 'conflict', the mutual 'misunderstanding' that is set up between parents and their children.

Psychoanalytic interpretation has long sought to mask or minimise the social reasons for this – the sociological ones – but they are nonetheless obvious. It is crucial to set aside this psychologisation of social relations – even when it comes to the level of intrafamilial relations and the ways they evolve – in order to resituate them within the class structure.

With my mother gone, the continuity with my past that was maintained through her, even if tacitly, implicitly, is broken, or enormously loosened. Who else can still tell me anecdotes about the child I had been, and the adolescent I was in the process of becoming? Who can trace for me the map of my family, its genealogical tree? This very continuity that she did her utmost to remind me of and to rebuild was often uncomfortable for me. I had frequently found annoying her status as the privileged, if not the unique, witness of the person I had been at the moment when I began no longer to be what, socially speaking, I was. What, then, is the explanation for the nostalgia I began to feel for all of that, for my acute awareness that it was now absent? I had made a point of making that past disappear, erasing my family from my mind as much as I possibly could. And the past came back because of the strength of familial obligations – experienced as family feeling – when I had to take care of my mother. And now the archivist and historian of my youth is no longer there to tell the story.

Mother Homer Is Dead, the title of Hélène Cixous's book about her mother's death, is rich in implications. Now that the memorialist of her life, the cartographer of the branches of a family wiped out or dispersed by Nazism (who knew which members of the family were put to death, which succeeded in escaping and in establishing themselves in exile in different countries), now that this woman who could reconstruct the historical chronicle and genealogies of the characters who inhabited this story is gone ... now that this Homer of a mother is gone, and this simultaneously political and personal *Iliad*

is interrupted, how is her daughter to imagine her life, her past, her present? What will she be able to write, if it is not to retrace again and again this German genealogy, her family history, that of her mother and also her own?

My own family history is less tragic, of course, yet I could nonetheless borrow the title of Cixous's magnificent book in order to understand what happens in someone's life when their mother dies: Mother Homer Is Dead. And I must now speak of her so that she may live again. ∎

K Patrick

David Attenborough

The BBC composes a soundtrack
for the interlocking penises
of two hermaphrodite slugs.
Big budget, big moon.
Long entangling penises,
phosphorescent, soaring violins.
The night sky. Below,
a cushioned woodland floor.
So sure of themselves,
these expensive cameras,
these men and women
crouching between British trees,
hoping this will be their week,
that the slugs finally fuck.
Even nature can't improvise any more.
Penises unfurling like flags.
Biologically I essentially find myself
everywhere.
Waves blunted by a riptide,
throbbing baby cuckoo,
rose pollen before the bee.
One hundred per cent anticipation
of want, that's living almost dying,
so on the edge of newness,
a cycle about to be entered.
A robin fluffs behind the boars,
they've been recently reintroduced,
shifting snow with their snouts.

Earth exposed, the robin
shall have his worm.
His breast aflame!
I'm a poet last of all.
My TV licence lapsed months ago.
It feels so unbearably obvious
to be me, I'm shocked to find
the failed translations
dusting a cutting-room floor.
Two male fallow deer lock horns,
a third joins in,
they want us to think of a pub at closing time.
Yes it is important to save the planet
but how, when the planet here
has become so manageable?
Female fallow deer wait for the males,
the capercaillie mounts six hens,
one after the other, his rival's face
puckered and bloody.
Being less handsome
is a natural punishment.
There is a numberless supply of sons.
I look away from the medium screen,
on our windowsill is an eagle feather.
Love inherited from other sources,
kinds of pain that won't back down.
Giant purple butterflies –
I've forgotten the rare name –

draw air like sparklers.
Cameras slow them down
within millimetres of their lives,
each wing buffing,
a surge on the monitor.
Genre has to be toughed out,
left muscly, this is absolutely
a documentary. The butterfly
returns to his broad leaf,
shattered against the green.
If Love's the job then
what can be countered?
The cameramen and camerawomen
self-define as passionate.
An owl stares down an ancient oak,
the dormouse picks honeysuckle
to feed her four identical babies.
A lens slipped inside her nest
to get as close as possible to the fact
to confirm it as a fact:
she is a mother.
Motherhood is this chapter,
we all love a mother,
disastrous as it is.
Care is the defensible impulse.
The BBC chooses glanced piano keys
and was that a harp?
I once pulled a wet dormouse
from the mouth of my dog.
Nothing keeps you safer
than being a visible ruin
writes Fanny Howe

but how to be ruined
when the chances are
fewer and fewer?
Images toggle together:
you can see the dormouse's whiskers
quiver, her fear can be your fear,
easily returned.
Are my desires too weak?
A juvenile sea eagle takes
down a barnacle goose and
drowns it in an estuary.
Perfectionism.
You can't replicate the sound
of a beak tearing beak-sized
portions of meat.
A metaphor won't stand it, like
a shoelace suddenly tugged
through an eyelet, like
a sheet of plastic against the wind, like
a can of red paint prised open.
Blood and flesh are ingenious.
An on-script erotics, how terrible to be
evaded by what I'm made of.
I thought of another obvious one
for flesh leaving itself
for flesh finding other flesh
for flesh finding flesh's mouth:
the first of St Sebastian's arrows
whistling into his chest.
Or even the voice of God landed
behind Joan of Arc's collarbone.
There are noises and then

there are sounds –
it's the lecture of the animal kingdom.
The juvenile sea eagle looks up
from the dying goose, makes
eye contact with nothing.
The BBC's determination
I cannot fathom.
Having beauty is not so easy.

THE WORLD TODAY

CHATHAM HOUSE'S INTERNATIONAL AFFAIRS MAGAZINE, BRINGING RESEARCH TO LIFE SINCE 1945

SIX EDITIONS A YEAR | EXCLUSIVE ONLINE CONTENT INCLUDING
A SEARCHABLE ARCHIVE OF THE PAST 20 YEARS | WEEKLY INSIGHTS
INTO WORLD AFFAIRS | SUBSCRIPTIONS FROM £33

To subscribe go to www.theworldtoday.org. For any enquiries relating to marketing and
subscriptions, please contact Roxana Raileanu by email: RRaileanu@chathamhouse.org

US Senate Minority Leader Mitch McConnell during a 2023 news conference in Washington, DC. McConnell froze and stopped talking at the microphone and was escorted back to his office.

THE TROUBLE WITH OLD MEN

Samuel Moyn

Gerontocracy is as old as the world. For millennia, to greater or lesser degrees, it has been the default principle of governance, from ancient Greek city-states to the Soviet republics. Though there have been exceptions, when you look for gerontocracy today, you find it everywhere – aged men and women at the helms of states the world over.

The presidential contest in the United States this year is likely to pit two decrepit men against each other. Were the incumbent to win, he would be eighty-six by the end of his second term. Nor is the aging of politicians restricted to the chief executive of the country, or even an American syndrome. Paul Biya, president of Cameroon, recently celebrated his ninetieth birthday (he was born the same year as California senator Dianne Feinstein, who died in office in September), making Michael Higgins, president of Ireland, appear sprightly by comparison at eighty-two.

It wasn't supposed to be this way. At the birth of political modernity, the French revolutionaries explicitly targeted the empowerment of the elderly: what came to be known as the 'old regime'. They sought not only to overthrow aristocrats in the name of common people, and fathers in the name of sons, but more broadly to tame the age-old commitment to gerontocracy for the sake of the younger majority.

In the decades that followed, after any revolutionary challenge, one counterrevolution after another has restored the authority of elders, and displaced the youthful pretenders.

The indefinite extension of lifespans since the advent of modern medicine in the nineteenth century, combined with much more impregnably defended property, has made the youthful gains of early modernity all but vanish in our time. This extends far beyond the hoarding of political power. The choicest parts of the world's richest cities, according to demographers, are dense with aged residents. In countries such as the US, where mandatory retirement is lacking, universities have become senior centers and care homes, while a whole generation of younger scholars and intellectuals have been blocked from progressing in the wake of the 2008 financial crisis. Culture may appear to be a bastion of the young, but it hardly compensates for political and financial power.

Men no longer drop dead as readily as they did a century ago, and can remain in charge for what seems like forever. If modernity has meant challenging the elderly, demanding that they share their power and resources, then our postmodern age is one of their most successful re-enthronements.

What was gerontocracy in premodern times? Elders have turned to the forces of magic and mythology to secure deference from those strong enough to challenge them. 'Respect for old age has resulted from social discipline,' observed the sociologist Leo Simmons, an early surveyor of ethnographic literature. 'There are no signs of deep-seated "instinct" to guarantee to elders either homage or pity from their offspring.' Instead, the younger generation have had to be domesticated and manipulated into self-constraint.

In early human societies, this approach was remarkably successful – rarely did any cultures recount mythic traditions that emphasized the decrepitude of the aged. A proverb from the Hebrew Bible holds that 'gray hair is a crown of glory'. In *Works and Days*, the Greek poet Hesiod may have defined his own age – the iron age, fifth in

his scheme of decline – as one of dishonor toward elders, but by and large, culture decreed, longevity brought only gifts of wisdom and experience. When Knud Leem, a Norwegian priest and linguist, visited the Sami people in the eighteenth century, he learned how the old men, when they were too infirm to work, could walk from farm to farm, staying at each for six nights with full bedding and board. Traditions like this span early human history, where cultural programming seems to have almost always resulted in the elderly getting more than their share, until their deaths earned them continuous veneration in the form of ancestor worship.

In 1965, the English social anthropologist Paul Spencer published one of the richest examinations of a thorough-going gerontocracy. For more than two years in the late 1950s, Spencer lived among the Samburu, a group of livestock-herding nomads in north-central Kenya. Samburu males were organized according to 'age-sets', each of which lasted twelve to fourteen years. The cohort of males of a given age-set advanced together up the ladder of power. Before entering your age-set, you were a boy. After circumcision, you became a young man, a member of the *moran* class, and at around thirty years of age – if you had survived that long – you finally became an elder for life. Samburu society was structured for your benefit.

The Samburu age-set system didn't apply to women because society was organized around accumulating them as the basic currency of wealth and power. They were circumcised at the same age as boys, but they were denied marriage partners in their own age group. Men were not allowed to marry daughters of men in their own age-sets, which meant that there was always a generation gap or more between men and their wives.

Spencer told the story of Nirorol, a sixteen-year old girl, who was arranged to be married as a second wife to a man in his early fifties. Nirorol was genitally cut and harangued into accepting her fate. She was 'inert' for most of the time that Spencer observed her. The ritual reminded Spencer of Cold War brainwashing. The men of

Nirorol's own age, barred from marriage themselves, provided the entertainment for the ceremony, performing a mock denunciation of the groom and the elderly class as a kind of youth protest. But Nirorol had no alternative: 'She was nothing more than a pawn in the hands of the elders,' Spencer wrote.

It was also tyranny, Spencer declared, for the young men. Their lives were on hold until their late twenties and early thirties (not unlike, Spencer ventured, deliberately stunted public-school boys of his native England). Before that, Samburu youth whiled away their time on long expeditions or fighting in wars. Curses also guaranteed that they conformed to the social norms. According to Spencer, the Samburu were fixated on the role of fortune (good or ill) in their lives – all the more so when an elder intentionally doomed a young man. He could throw soil toward an insolent upstart, symbolizing anthrax infection, or a piece of string, in the shape of a viper. These curses were universally believed in. In a society as small and cohesive as the Samburu, there were simply no young skeptics prepared to buck the power of their elders.

One of the major differences between the gerontocracies of premodern societies and the gerontocracies of the contemporary West is that our premodern precursors often had a special mechanism for dealing with old people who faltered. Quite simply: they killed them.

In 1890, James Frazer – author of the landmark anthropological study of comparative religion, *The Golden Bough* – came to the conclusion that our ancient predecessors were in many respects wiser than us. They knew that gerontocracy was an age-old form of human organization, and they often embraced it, but they also put limits on rule by the old, especially rule by the faltering and senile, who were not only dispossessed of their power, but also often marked for death at an appointed time.

Frazer focused on the riddle of the 'king of the wood', or *rex nemorensis*, an archaic survival of uncertain origins that lasted through Roman times. According to the poet Ovid and the traveler

Pausanias, the king lived in a pristine sanctuary on the northern shore of Lake Nemi, about twenty miles from Rome. As king, he had to fight all comers, and to lose the combat meant certain death and his replacement by the victor. 'Kings had to be killed so that they could live forever,' Frazer wrote.

Scottish by birth, Frazer would achieve improbable but significant fame from generalizing about 'primitive religion' without ever leaving his armchair. His manic zeal and penchant for conjecture made him an embarrassing forefather for the specialists who followed him. Nevertheless, Frazer amassed a huge trove of anthropological evidence from across the globe, including details of the widespread practice of killing elders, and not merely powerful ones. In 1932, Edward Moffat Weyer Jr, observed that Indigenous hunters living on the Diomedes, two islands in the Bering Strait between Alaska and Russia, would regularly kill off their elderly. He described an older Indigenous man who could no longer contribute 'what he thought should be his share as a member of the group'. The elder proceeded to follow custom: 'He asked his son, then a lad of about twelve years old, to sharpen the big hunting knife. Then he indicated the vulnerable spot over his heart where his son should stab him.' The first try missed, though the knife went deep. The father, teaching one final lesson 'with dignity and resignation', instructed his son to aim higher. It worked. 'The patriarch passed into the realm of the ancestral shades.' The circumpolar people known as the Inuit provide especially rich examples of senicide using methods such as stabbing, hanging or strangling, or simply abandonment in an igloo to freeze or starve to death.

For non-modern peoples, and in many places around the world, unassisted suicide was the most common exit strategy. If elders could not manage to off themselves, they could be put to death by their own family. (Otherwise, an ethical act undertaken for the common good could escalate into endless feuding.) The practice was a kind of socially delivered euthanasia for those who were simply too costly to keep alive. According to a story related to eighteenth-century

Lutheran missionary and merchant Niels Egede, one old woman in Greenland reportedly offered to pay a friend to be taken to the cliff favored by suicides. She could not make it on her own. Generously, her friend – what are friends for? – led her to the precipice for free.

Killing the elderly wasn't just the preserve of peoples in harsh climates. Ancient Greeks believed that in Hyperborea, the blessed and mythical land to the north, old age was not tolerated. It was always sunny there. But unlike Florida – or other collective senior zones where the average age is far higher than the surrounding regions – when anyone in Hyperborea reached the age of sixty, they were taken to the city gates and executed. In the recorded history of the Roman republic and empire, old people were not generally killed, though they began to be stripped of public duties when they, too, reached sixty (which seems to have been the mandatory retirement age in the ancient world). No one has been able to disprove (or prove) the story that it had once been customary in the early years of Roman society for elders no longer fit for life to be led to the Milvian bridge and unceremoniously thrown off.

As long as aging involves the accumulation of power in our families and politics, the problem of entrenched power remains. In recent decades, the problem of old women, too, has appeared as an unexpected by-product of the feminist demand for political agency. Men long ago proved that with great power can come great irresponsibility, and Supreme Court Justice Ruth Bader Ginsburg's decision to remain in office until her late eighties, preventing President Obama of an opportunity to appoint a new, progressive judge, shows that the same is now true of powerful women.

Having long ago given up the old remedies of alleviating the weight of the old on society, we are left with the problem our ancestors solved in what now seem like alien and unacceptable methods. There would seem to be only two ways to counter gerontocratic rule. One is to arrange more predictable and reliable succession schemes. In theory,

democracies are supposed to provide them, but in practice they often feature the same kinds of dynastic and familial incumbencies as the age of chiefs and kings. And even when not conducted through bloodlines, the advantages of incumbency frequently mean election to perpetual office, when no time limits are set. Whether in politics or in private, few give up power if they aren't forced to do so – especially when they fear the alternatives are irrelevance and neglect.

Age maxima for political office, mandatory retirement in the professions, forced transfer of property and wealth: all have been proposed as ways to blunt our descent into deeper gerontocracy. Yet because old people – through voting patterns and parties and organizations that cater to them – have outsized authority to block such changes, only intensified organization among the young will make such changes possible.

There is a more radical approach: to root out the foundations of gerontocracy tooth and nail. Society could be organized to equip children for their future, to encourage youth to make their mark, and to build social support for men and women in their prime. After that, there would be caretaking and memory, playing for time in the face of inexorable decline, necessary death, and ultimate oblivion. ■

Jana Prikryl

Calais to Dover

KENT: But, true it is, from France there comes a power
Into this scattered kingdom . . .
– King Lear, 3.1.30–31

The waves today great polyhedrons.
Through abstractions the ship makes its way.
Here on deck the entire scene is metal
and painted gray on top of the metal's gray.
Word 'clad' keeps bobbing up, coinage of
the Thirties. Cladding means the special bond
between two forms that one may dominate.

A thing like that is strong until it's brittle.
I didn't want to sit inside, depressing
to populate the bar that serves Cold War
cocktails, the *Samizdat*, *Mauerfall*,
Desirable Refugee. The smoking section
defies basic mental function but still,
nobody keeps you from nonsmoking.

Down the way some suits lock eyes to cross-
Channel solidarity, which in certain
anonymous styles (Eurovision)
will linger for one generation.
The carpet is an atrocity
already inviting nostalgia.
We survived this too. The hits were terrible.

The feeling's concentrated in the lounge
that strangers to their senses have returned,
we're drifting to safe harbor.
Desirable worldview. And then out here
the only way to cope with the fresh air
is going fetal on a yoga mat.
I'm aware of whispers among the crew.

The rucksack, which was Regan's, produces
a lee that's almost worse than nothing.
You do expect some sheltering effect.
Speaking English but wanting to be liked,
she patched it with a Canadian flag
that I've unstitched, not waiting to hear
what realm is thought uncomplicated now.

I travel under the banner of France
but he would be the first to call my home
nowhere, as if it's printed on a map.
When I close my eyes the motion of the deck,
first up and then down and then up again,
can promise anything, these twenty miles
intermission.

I know we deserve to take England back.
I know a commercial passenger
ferry circa 1992
presents an imperfect vessel of attack.
I'm aware of whispers among the crew.
Anachronism makes all this possible:
a work that proceeds by digression

will be true only if its leaps are true,
while years of austerity place a cap
on the formal maneuvers available.
First up and then down and then up again.
If you need a renewable resource
then look in the direction of the sea.
It's deep as feelings you didn't know you had.

I often wonder why we go to fight.
Their words that night understandable.
I was the proud, puritanical child.
What if their anger's appropriate
and it's honest to envy their anger?
Anger's like love, both insist on action
and feeling them forces you to choose.

I avoid this wherever possible.
France once looked at me and asked, How are you?
I'm doing my best, I said, not to know.
He didn't seem to find that reassuring.
A story will make you its instrument
especially if you refuse your part.
I'm aware of whispers among the crew.

First up and then down and then up again.
It must be something I can use that English
wasn't taught me by my mother. Crossing
the Channel first time in this direction,
my first time stalking like an animal
the people who were pressed to make these words,
I spend the journey curled up in a knot

not grasping my longing to be where
my home, a place contained in pencil lines,
each curve a skirmish, was scribbled over,
grammar pulled stone from stone generations
had arranged, while here in my own skin
the hunger for England grows and it is wild
that they will stamp my passport, let me in.

Despite the noise and the blast I slept
and had to be awoken for the sight
of land, which silenced everyone. On deck
all eyes now met as the long charcoal mark
of horizon crept up into white rock
that soon stretched all the way across the world,
a line almost legible, asking to be read,

refusing every hesitant translation.
By then I'd run to the bridge for France
who was busy giving instructions. They say
he undertakes this trip for his own sake
or maybe I just worry that they do.
No words are found equal to mixed feelings.
I'm aware of whispers among the crew.

NAN GOLDIN
Clemens lighting Jens' cigarette, Paris, 2001

FIVE O'CLOCK SOMEWHERE

Gary Indiana

It happens when you feel the other parenthesis, the one at the end, as it presses your skin, wraps itself around your chest like a tightening belt. You can still breathe, but not as well. You can still sing, but not with the notes you could hit before. You can still spit, but life has moved past the spitting stage. It's when things fail to return to normal, that finally you get it: this is normal.

It happens as decades of mishaps and malfunctions befalling the bag of water and bones you inhabit add up to an irreversible mess, one that no longer feels entirely like you: it is you. This is what you're told, by doctors, friends, cashiers at the supermarket. This is what you tell yourself, without entirely believing it. This is what you learn when people offer to help you when you don't need any help, when people ask if you're all right when you stop walking to catch your breath or buckle slightly under the weight of it all. It's when good intentions leave a sinister aftertaste. It's also when you entertain the possibility that you do, in fact, need help. If not yet, then soon.

It happens when you realize that your legs are no good anymore. They won't carry you far before they hurt. In a bombardment, you will be the slowest, the others might have to leave you on the trail.

Fortunately, you are safe for now, safe perhaps until the end, but the world is fickle and passing time alters everything. The streets you take no longer resemble the same routes in your memory, and the people on them walk differently, weighted down by days, weeks, months, years of private and personal wranglings that stick like burrs in the run of events. New people rush past you in a frenzy to kill time as recklessly as possible. You want to be like them, reckless and blind to consequence, but you can't be. You may not remember the movie in much detail, but you have seen it before. The residue of everything is what you'd like to get rid of: the old streets, the old faces, the old conversations, the old ways of being known to others, but the facts are inescapable, their adding-up is the busywork of whatever powers that be.

It happens when they can't immobilize you for the surgery because your lungs won't survive the anesthesia, when you know that the final wheeze is closer to you than the last time you actually had fun. It happens when your ability to laugh it all off goes missing for longer and longer spells, when simply existing in time feels like a deflating challenge. It's when your reserves have mysteriously emptied. Complaints take the place that effusions of happiness used to fill. Something is always going wrong, slipping out of control. The sensation of chaos overmasters the most painstaking displays of order. Nothing rings true, or rather, nothing feels true; there is always a foam of corrosion at the edge of any certainty. One thing that isn't there is an expansive view of the future. The future has become little, like a baby bump.

It happens when your center of gravity drops below your spinal column. When your mind collects dust as often as it gleans information. When what is important boils down to what is necessary. To get through the next stretch of days, to clear up ambiguities, to get the bills paid, to keep the engine running. It happens when the outside world corresponds word for word with the panic inside you. When you hear people in authority say what you tell the blank wall at three in the morning, 'These are dark times.' Meaning: dark for everybody,

not just for you. And you, alone, can't fix it. It happens when you understand that you never were in a position to fix anything.

It's the little moments in the day when you cannot remember the name of that actress that author that person you lived with in 1987. Bits of information fly around in your head eluding capture, as if you were drunk, and you're not. You are about to finish telling a funny story with the words 'gluten-free', and suddenly you can't find them, can't find 'gluten-free' in a brain so full of words they become misshapen and stick to each other. Like gluten itself, maybe.

It's discovering that almost everyone you truly liked has died, that you are now engaged in a dire, depressing contest with all those still living, and that winning would be the most inconsolable, loneliest victory anyone could achieve. Alive after all that, and in many areas of life, already dead.

Of any two people, someone always goes first.

It happens when you see yourself in a photograph, no matter when it was taken. Everything recorded is a record of the past, and this is how you looked then, how the world around you looked: these were your friends and this was a room someone lived in and how people were wearing their hair. Even a year ago, you think, 'I looked better.' Or else you think, 'I look better now.' Or else you think, 'That isn't really me.' But the image is something, an entrance into what is secretly known, or repressed, or misremembered, stored in some cerebral cave, a feeling forgotten until this optical encounter. Or it may also be another picture that fills in missing time, the middle-aged face, for example, of this person you were crazy about when they were twenty, a mania that ended very badly; you confront the fate of faces and the shallow depths of your former emotions when you try to imagine feeling the same things again. You couldn't love that face in its current state, it's like a tire with no more tread. And what does that

tell you about how much you loved it in the first place? It was just a face. And here it still is, wised up and cruelly weathered by decades of disappointment. Like your own face in the mirror.

We all live at least one or two lives that we subtract from our biographies. Areas of un-revisited, unhealed pain or such monumental nothingness that they're not worth remembering. Then, infrequently, some evidence turns up, often photographic evidence. You are seized, suddenly, by a grisly species of curiosity. Oh, yes, you were alive then, and had wishes or plans casting shadows on the path ahead, what appeared then as the path ahead, an ambition or two, and back then, when the way things are today could hardly be imagined, you used to do that with your face. Those days. Those plangently hopeless, barren days that felt like sludge. And these people: that one's dead, this one never managed anything, that one is still trying, despite everything. This ended in divorce. That ended in murder-suicide. Most of this just ended, undramatically. How sad any piece of collective evidence really is.

It happens that validation can never be satisfied. With solidity comes decrepitude. The more we become what we intended to be, the less real the earlier versions of ourselves appear to us, and yet there we were, who we were, forever for all time a monad on its travels. Through the dark times, the insoluble passage. An era can be just what it looks like, finally, with everybody's footnotes crammed into the bottom of the frame. Everything begins to feel like an epilogue, or a summing-up, when in fact all you want is, right now, to live in this minute, this world, not ever to go back, never to take up residence in the house of memory, or at the very least to leave some doors and windows open to whatever new breeze might be felt, because there is still time, time left over from time, every minute that you didn't die is time and a half, so to speak. You even have time to learn to bake bread or repair a motorcycle. After time runs out you will persist in someone's memory somewhere, the way alcoholics say, 'It's five o'clock somewhere.' ∎

CONTRIBUTORS

Charlotte Barslund translates books and plays from Norway, Denmark and Greenland. Her translation of *Is Mother Dead* by Vigdis Hjorth was longlisted for the International Booker Prize 2023. She is currently translating *Zombieland* by Sørine Steenholdt.

Joanna Biggs is an editor at *Harper's Magazine* and the author of *A Life of One's Own: Nine Women Writers Begin Again* and *All Day Long: A Portrait of Britain at Work.*

Zoe Dubno's first novel, *Happiness and Love*, will be published in 2025. Her fiction has appeared in *Muumuu House* and *NY Tyrant*. Her non-fiction has been published in the *New York Times Magazine*, the *Guardian*, the *Nation* and *New York Review of Books.*

Didier Eribon is professor of Sociology at the University of Amiens. His books include *Returning to Reims*, the biography *Michel Foucault, Insult and the Making of the Gay Self*, and other works of critical theory.

Eve Esfandiari-Denney is a funded PhD student at Royal Holloway University. Her debut pamphlet *My Bodies This Morning This Evening* was published with Bad Betty Press in 2022.

Lillian Fishman is the author of the novel *Acts of Service*. She writes a monthly column, 'Higher Gossip', in *The Point*. She lives in New York.

Guy Gunaratne's most recent works include the novel *In Our Mad and Furious City*, the play *Ben Gvir Reads Wiesel to Mourners* and another novel *Mister, Mister*. They are the current editor-in-chief at the *Review*.

Sheila Heti is the author of eleven books, including the novels *How Should a Person Be?*, *Motherhood* and *Pure Colour*. Fitzcarraldo will be publishing her new book, *Alphabetical Diaries*, in February 2024.

Vigdis Hjorth is a Norwegian writer. Her most recent novel, *Gjentakelsen (Repetition)*, was published by Cappelen Damm

in August 2023. Her next title in English translation will be *If Only*, published in August 2024.

Rahmane Idrissa is a writer and researcher based at Leiden University's Africa Studies Centre. He is the author of *The Politics of Islam in the Sahel: Between Persuasion and Violence*, and is currently working on a history of the Songhay Empire and a novel on the Sahel's 'generational seasons'.

Gary Indiana is an artist and writer living in New York and Los Angeles.

Anton Jäger is a lecturer at University College, Oxford. He writes for outlets such as the *Guardian*, the *New York Times*, *Jacobin* and *New Left Review*.

Jack Latham is a photographer and film-maker based in the UK. His photobooks include *A Pink Flamingo*, *Sugar Paper Theories*, *Parliament of Owls*, *Latent Bloom* and *Beggar's Honey*.

Kalpesh Lathigra is a London-born photographer. His recent book, *Memoire*

Temporelle, was published in 2021 as part of a trilogy looking at his relationship with India.

Nam Le is the author of *The Boat*, *On David Malouf* and the forthcoming *36 Ways of Writing a Vietnamese Poem*.

Michael Lucey's most recent book is *What Proust Heard: Novels and the Ethnography of Talk*. He is also the translator of Didier Eribon's *Returning to Reims*.

Karan Mahajan is the author of *Family Planning* and *The Association of Small Bombs*. In 2017, he was selected as one of *Granta*'s Best Young American Novelists. He has recently completed his third novel, *The Complex*.

Samuel Moyn is a teacher at Yale and the author of *Liberalism against Itself: Cold War Intellectuals and the Making of Our Times*.

Andrew O'Hagan's new novel, *Caledonian Road*, will be published in the spring of 2024. He is the author of six previous

novels, including *Mayflies*, which was adapted by the BBC.

K Patrick is a poet and fiction writer based on the Isle of Lewis. Their debut novel *Mrs S* was published in 2023. 'David Attenborough' is taken from their forthcoming poetry collection, *Three Births*, published March 2024.

Jana Prikryl's latest book of poems, *Midwood*, will be published in the UK in the summer of 2024.

Phyllis Rose is the author of biographies of Virginia Woolf, Josephine Baker and Alfred Stieglitz, as well as the classic biographical work *Parallel Lives* and the bibliomemoirs *The Year of Reading Proust* and *The Shelf*.

Sam Sax is the author of *PIG, Madness, Bury It*, and the forthcoming *Yr Dead*, published by McSweeney's and Daunt in 2024. He is currently serving as an ITALIC Lecturer at Stanford University.

James Scudamore is the author of the novels *English Monsters, Wreaking, Heliopolis* and *The Amnesia Clinic*. He is working on a novel about the descendant of a famous writer.

Yuri Slezkine is a professor of the Graduate School at UC Berkeley and a senior research fellow at St Edmund Hall, Oxford. His latest books are *The Jewish Century* and *The House of Government: A Saga of the Russian Revolution*.

Brandon Taylor is the author of *The Late Americans* and *Real Life*. He lives in New York.

Nico Walker is the author of the novel *Cherry*. 'Ricks & Hern' is an excerpt from the forthcoming book *The Dark Empath*. He lives in New York City, with his wife.

Ralf Webb is a poet, writer and editor whose work includes the poetry collection *Rotten Days in Late Summer*. His non-fiction debut *Strange Relations* will be published in spring 2024.

The British Museum

Give the gift of Membership

Set someone special on a journey through human history. They'll enjoy 12 months of extraordinary exhibitions as well as an exclusive programme of Membership events.

Buy now

Ways to buy
britishmuseum.org/membership
+44 (0)20 7323 8195

The British Museum Friends is a registered charity and company limited by guarantee which exists to support the British Museum.

Registered charity number 1086080
Company registration number 04133346

Large vase, tin-glazed earthenware (maiolica), from the workshop of Orazio Fontana, made in Urbino, Italy, about 1565–1571, with gilt-metal mounts made in Paris, France, about 1765. Part of the Waddesdon Bequest.